£ 6

MY ITALIAN NOTEBOOK

MY ITALIAN NOTEBOOK

GOUGH WHITLAM

ALLEN&UNWIN

First published in 2002

Allen & Unwin
83 Alexander Street
Crows Nest NSW 2065
Australia
Phone: (61 2) 8425 0100
Fax: (61 2) 9906 2218
Email: info@allenandunwin.com
Web: www.allenandunwin.com

National Library of Australia
Cataloguing-in-Publication entry:

Whitlam, Gough, 1916– .
 My Italian notebook.

 Bibliography.
 Includes index.
 ISBN 1 86508 029 2.

 1. Whitlam, Margaret, 1920– —Journeys—Italy. 2. Whitlam,
 Gough, 1916– —Journeys—Italy. 3. Prime ministers—
 Australia—Biography. 4. Italy—Description and travel.
 I. Title.

945.092

Set in 11/18 pt Fairfield Light by Bookhouse, Sydney
Printed in Australia by Griffin Press, Adelaide

Text design by Liz Seymour

10 9 8 7 6 5 4 3 2 1

To my prima donna
Margaret Whitlam

CONTENTS

PREFACE

IN MARCH 1998 THE Italian Ambassador to Australia invested me with the insignia of a Commendatore nell'Ordine Al Merito della Repubblica Italiana, signed by the President of the Republic, Oscar Luigi Scalfaro, and countersigned by the President of the Council of Ministers, Romano Prodi.

In August 1999 the Ambassador invested me with the insignia of a Grande Ufficiale nell'Ordine Al Merito della Repubblica Italiana, signed by President Scalfaro and countersigned by the President of the Council of Ministers, Massimo D'Alema.

This book gives the background to these awards and is largely the result of some thirty visits Margaret and I have made to or through Italy.

Sydney
January 2002

POLITICS

IN THE EARLY 1930s the history of modern Italy interested me at school in Canberra, the new capital of Australia, and in the 1950s it absorbed me as a member of the Australian Parliament.

My predecessor in the seat of Werriwa, Hubert Peter Lazzarini, died in October 1952; he had been elected in 1919. His brother Carlo Camillo died in November; he had been a member of the Parliament of New South Wales since 1917. A third brother, Herbert Ferdinand, had been mayor of the town of Young in New South Wales in 1931. The brothers Hubert Peter and Carlo Camillo were the first members of the National and State Parliaments to have an Italian surname. Herbert Ferdinand was one of the first Australian mayors with an Italian surname. Their father had fought under Garibaldi in defending Mazzini's Roman Republic. After the fall of the Republic he left Italy for the goldfields of California and then Australia. He settled in Young in New South Wales and gave his sons the Christian names of King Vittorio Emanuele II's father, brother, son and

first Prime Minister. The Young Shire Council has dedicated a Lazzarini Park.

The electorate of Werriwa for which I was elected at the by-election in November 1952 extended from Botany Bay and Stanwell Tops on the coast south of Sydney to the Fairfield and Liverpool municipalities west and south-west of Sydney. I was re-elected at the elections for the House of Representatives on 29 May 1954.

At the general elections in December 1955 Werriwa had new inland boundaries extending from Westmead and Toongabbie in the north to Liverpool in the south. Fairfield was in the middle. Bert Lazzarini's widow and children continued to live in Fairfield. New immigrants from Italy were settling in great numbers in the suburb. They made it Campobello.

Having lost a member with an Italian name, they needed to be reassured that their new representative in the Federal Parliament would be interested in their background. There was an appropriate forum and operation. At all the naturalisation ceremonies, conducted by mayors of Fairfield, I mentioned not only my predecessor Lazzarini but also Raffaello Carboni (Urbino 1817–75 Rome), who had campaigned at the Ballarat goldfields in 1853 for the right of migrants to have a vote and who had been part of Garibaldi's administration at Palermo in 1860.[1]

By 1958 the number of candidates at naturalisation ceremonies had grown so much that the mayor had to move them

from the inadequate old Council Chambers to the new Club Marconi.

I was inundated with applications for family unions or reunions. Men were allowed to nominate a fiancée or a brother in Italy. My friend Alec Downer gave me great assistance during his distinguished service as Minister for Immigration from 1958 to 1963. In his book *Six Prime Ministers*, published in 1982, he revealed Prime Minister Menzies's attitude: 'On immigration policy he usually gave me his blessing, but not without growls of disapproval about the stream of Italians and Greeks we were attracting. Settlers from Asia were even less acceptable.' Downer and I agreed on an informal formula that, if an Italian did not have a brother in Australia to nominate him, he could be admitted if he had three cousins in Australia to nominate him. By 1959 and 1960 I was encouraging the new citizens to help build a new nation as their ancestors had done a century earlier after the victories of Vittorio Emanuele II and Napoléon III in northern Italy and then the victories of Garibaldi in Sicily and southern Italy. Many Australians were forgetting Lazzarini but were reading Lampedusa; *Il Gattopardo* (*The Leopard*) was translated into English in 1960.

Some new citizens exaggerated my influence in the affairs of Church and State. One Sunday morning I received a phone call from a distraught bridegroom on the finger wharf at Woolloomooloo. The bride, who had the romantic name of Stella

Mezzanotte (Star of Midnight), would not leave the ship until a priest married them; I could not find a priest till Monday. The groom was a horticulturist. When Stella's sister Luna arrived a year or so later there were no hitches. Our house at Cabramatta was always well supplied with flowers.

In 1957 the European Community of six nations was formed by the Treaties of Rome. In August 1961 Harold Macmillan's Conservative Government in Britain applied to join the Community. In the elections for the Australian Parliament in December 1961 the conservative Coalition Government led by Robert Menzies was re-elected with an effective majority of only one member in the House of Representatives. (The representatives for the Northern Territory and Australian Capital Territory were both members of the Federal Parliamentary Labor Party but at that time each of them could vote only on a motion to disallow an ordinance affecting his Territory or on a bill that related solely to that Territory.) In February 1962 Menzies, Deputy Prime Minister John McEwen and Harold Holt (the next prime minister) offered the Labor Party four ministerial style visits to Europe. I was now the Deputy Leader and was sent to test the waters.

In 1963 there was an *apertura a sinistra,* an opening to the left, in Italy. In August 1964 I was received in his office in the Villa

Farnesina by the Foreign Minister, Giuseppe Saragat, Leader of the Italian Social Democratic Party. In February 1967 there was an *apertura a sinistra* in Australia; I was elected Leader of the Labor Party. In June I was received in the Palazzo del Quirinale by Saragat as the fourth President of the Republic. In September he visited Australia. He was the first European Head of State to do so, other than Elizabeth II, Queen of the United Kingdom of Great Britain and Northern Ireland and her other Realms and Territories. Australia was one of her realms.

The only time that Australians see and hear a Prime Minister and Leader of the Opposition on equal terms is at luncheons at Parliament House in Canberra. The Prime Minister proposes the toast to the visiting Head of State or Government and the alternate Prime Minister supports the toast. Following Holt at the luncheon for Saragat, I put on a bravura performance. I declaimed:

What people in all history have contributed so much to civilisation over so many centuries and from so many cities and in so many fields? Rome established law and order around the Mediterranean and as far as the North Sea and the Black Sea. Rome transmitted Christianity throughout Western Europe and to the European possessions across the seas. Italy pioneered navigation, revived the arts and set the forms of drama and poetry. Italian, the most musical of languages, became the language of music.

Today, Italy leads in fashions and films, in electrical and highway engineering, and helps to found the new Europe through the Treaties of Rome.

Acknowledging that while I was at school and university Italians went through many levels of Hell and that Saragat himself was exiled from 1926 to 1944, I concluded with the last line of Dante's *Inferno*: *'E quindi uscimmo a riveder le stelle'* ('And thence we emerged to see the stars again').

Only two members of the Australian Parliament at the luncheon, both Labor, had Italian names, Costa and Luchetti, but neither knew Italian, still less Tuscan.[2] Even the ranks of Liberals could scarce forbear to cheer when I quoted the divine poet who made Tuscan the official language of Italy. Many date my ascendancy over Holt to that event.

Billy Snedden, whom Holt appointed as Minister for Immigration, had served as an immigration officer in Italy, where he picked up some Italian words and Cold War attitudes. He was a convivial but divisive minister in migrant circles. In July 1969 he proclaimed that 'We must have a single culture. If migration implies multi-culture activities within Australian society, then it is not the type of culture Australia wants'. In November 1969 Prime Minister John Gorton appointed Phillip Lynch as Minister for Immigration and in March 1971 Prime Minister William

McMahon appointed James Forbes. Lynch and Forbes were divisive without being convivial.

While Gorton was Prime Minister, the Italian Government indicated that it desired to conclude a cultural agreement with Australia and to this end invited the Australian Government to send a mission to Italy. The Italian Government was anxious to maintain cultural links with the many compatriots who had migrated to and become integrated into the Australian community. It was prepared to devote substantial resources to promoting the teaching of the Italian language and the history of the Italian peoples. It believed that there were opportunities to develop cultural exchanges on a wider and more diverse scale from which Australia could profit directly and indirectly.

The invitation was accepted and an impressive mission was assembled of persons involved in education at university, secondary and primary levels, in the Arts (traditional and contemporary), as well as representatives concerned with migration, social security and other governmental functions affecting the welfare of Australian citizens of Italian origin or descent. This mission was headed by Malcolm Fraser as Minister for Education and Science and included Frederick May, the first professor of Italian at the University of Sydney. Extensive preparatory work was undertaken with which Nugget Coombs, as chairman of the Council for the Arts and Chancellor of the Australian National University, was concerned from various points of view.

In *Trial Balance* Coombs recalled:

Unfortunately for the mission, Gorton decided before its departure in April 1969 that while it could explore all the issues which the Italians wished to discuss there could be no cultural agreement. The Government was concerned that such an agreement would establish a precedent making it difficult, without offence, to decline to negotiate a similar agreement with any country seeking one— a possibility felt to be incompatible with our traditional links with the Commonwealth and embarrassing in our 'special' relationship with the United States.

This decision essentially condemned the mission to futility. After the initial exchanges of courtesies senior members of the mission went their various ways seeking to develop effective communication and exchange in their relevant cultural fields. I, myself, was anxious to establish working relationships with Italian opera companies in Milan—to arrange a visit to Australia by the Piccolo Drama Company, a group of great virtuosity who had visited London and New York with great acclaim—and to develop plans for joint ventures between Italian and Australian film producers. I was able to meet and discuss these projects with the relevant executives and encountered enthusiastic interest, provided they could be negotiated within the ambit of a cultural agreement—an arrangement which would ensure some financial support and official endorsement from the Italian Government.

I remember in particular one very exciting film project which could have been organised. There was a mountain village of central Italy which had over some decades migrated almost en masse to Australia, mainly to Victoria. Research had been done to trace the Australian history of the families concerned and it was a history of impressive achievement and warm human interest. The intention was to film this history in fictional but recognisable form. I thought it potentially significant both socially and cinematically. But despite its promise, it too died in the lack of the carapace of a cultural agreement.

Italian ecclesiastical initiatives were more successful. In 1841 Saint Giovanni Melchior Bosco (Becchi 1815–88 Turin), a priest in Turin, started evening training for boys from the poorer parts of the city to equip them for better jobs. His mother set up a dormitory which he called the Salesian Home in honour of the Savoyard Saint Francis de Sales (Annecy 1567–1622 Lyon), Bishop of Geneva. In 1859 Bosco founded the Society of St Francis de Sales (the Salesians). The Blessed Pius IX (1846–78) approved the Order in 1874. St Francis was declared a Doctor of the Church in 1877 and the patron saint of journalists and other writers in 1923. In 1938 Father Joseph Ciantar, a Maltese priest, came to establish the first Salesian school in Melbourne. Father Thomas Vincent Dunlea, inspired by the film starring Spencer Tracy and Mickey Rooney, established Boys'

Town at Engadine in the electorate of Werriwa in 1939. In 1952 Cardinal Gilroy, the Archbishop of Sydney, invited the Salesians to take over the school. One of the first functions I attended as the member for Werriwa was the Cardinal's transfer of Boys' Town to the Provincial of the Salesians in the presence of the founder, Father Dunlea, and the first Salesian director, Father Ciantar.

The *Aged Persons Homes Act 1954,* an idea of Dame Pattie Menzies, encouraged the building of homes for the aged. A great variety of religious, charitable and veterans' organisations built such homes in my electorate from Pendle Hill, through Fairfield, Cabramatta and Hammondville to Glenfield. In the 1973 budget Bill Hayden, my Minister for Social Services, embarked on a review of housing policies for aged persons. He increased subsidies to non-profit organisations which provided approved personal care services in hostel-type accommodation. The reforms attracted Father Nevio Capra, who had migrated from Padua in 1960 to be a chaplain of the Congregation of the Missionaries of St Carlo Borromeo (the Scalabrinians). Giovanni Battista Scalabrini (Como 1839–1905 Piacenza), Bishop of Piacenza (1876) and 'the Apostle of the Emigrants', founded the Congregation in 1887. Father Nevio decided to build the first Scalabrini Village for aged persons in Australia at Austral in my electorate. Snedden, who became Leader of the Opposition after my Government had been elected on 2 December 1972, and I

officially opened and Cardinal Freeman blessed the Village on Sunday 12 May 1974, a week before my Government was re-elected. In Australia there are few marble inscriptions which record bipartisan civility during election campaigns.

In 1974 and 1975 I was asked to open new or rebuilt aged persons' homes in most of the Catholic dioceses in New South Wales. The Scalabrinians have now built many villages in Australia.

MULTICULTURALISM

A Department of Immigration was created by the Chifley Government appointed on 13 July 1945. The first minister for immigration, Arthur Calwell, initiated a large scale program aimed at realising population increases of 2 per cent per year. Assisted passage agreements were then signed with Britain (1947), Malta (1948), the Netherlands (1951), Italy (1951) and the Federal Republic of Germany (1952).

Between 1947 and 1973 migrants from more than 100 different countries came to Australia. Some 300 000 of them migrated from Italy. They changed the face of our nation and, despite Menzies and Snedden, Australia had become a multicultural nation. The case for this change has been cogently stated by Petro Georgiou, who was born in Corfù in 1947 and who,

after five years as Victorian Director of the Liberal Party, was chosen in November 1994 as the member for Kooyong, Menzies's old seat:

Imagine if, in just some 20 years, 300 000 Australians were, at Italy's invitation, to settle in that country. It would be reasonable to expect that such a group would maintain contact with its Australian heritage. They would probably like their children to be able to learn English. They would probably continue to speak English among themselves. They would appreciate being able to follow Australian news, sporting and cultural events through English language newspapers, radio and television. And they would hope that native Italians would respect their Australian identity while still respecting them as valued citizens of Italy.

During my three years as Prime Minister, Australian citizens born in Italy were prominently involved in the statutory and administrative processes for eliminating racial discrimination and promoting portable pensions, language education, ethnic broadcasting and all the arts. In January 1975 I was the first Australian Prime Minister for 24 years to make an official visit to Italy. The fifth President, Giovanni Leone, received me at the Quirinale. Prime Minister Aldo Moro and I signed a cultural agreement at the Villa Madama.[3]

Since the Australian *colpo di stato* on 11 November 1975 I have been to Italy and through Italy on more than twenty

occasions. In the 1980s, as a member of the World Heritage Committee from 1983 to 1989, I visited all the World Heritage sites in Italy, which has the richest national patrimony in the world. As the ambassador to Unesco from 1983 to 1986, I encouraged Australian governments to emulate the support Italian governments have consistently given to Unesco.

By the 1990s Australian cities and institutions were making arrangements with their Italian counterparts. The mayors of Florence and Sydney signed a twin-city agreement, *accordo del gemellaggio,* in the Sala di Clemente VII in the Palazzo Vecchio and other Australians have restored Venetian churches, constructed and operated an Australian pavilion for the Venice Biennale, managed the superb 'Rubens and the Italian Renaissance' exhibition and provided courses of Italian studies at Australian universities.

ITALIAN NAVIGATORS

Italy did not become a nation until 1860, but Italian city-states produced the great navigators and cartographers for the monarchs who sought possessions in the Indian Ocean or across the Atlantic Ocean. Henry VII of England passed up the opportunity of an empire in Central America in February 1488, when

he received the Genoese Bartolomeo Colombo but did not agree to support his brother Cristoforo's Enterprise of the Indies.

For Afonso V of Portugal, Fra Mauro, a Camaldolese monk in Venice, made a vast world map that guided Portuguese navigators to the Cape of Good Hope by 1488. In February 1492 King Fernando II of Aragón and Queen Isabel of Castile captured Granada, the last city held by the Moors in Spain. Six months later an Italian cardinal of Spanish birth, Rodrigo Borgia, was elected Pope Alexander VI.[4] In March 1493 Christopher Columbus was welcomed on his return from the New World by King John II of Portugal and then by Fernando and Isabel. Pope Alexander then issued bulls giving Spain rights to lands west of a line of demarcation from pole to pole 100 leagues west of the Cape Verde Islands and Portugal rights east of the line of demarcation. On 7 June 1494, at Tordesillas, 180 km north-west of Madrid, Spanish and Portuguese ambassadors agreed to a treaty moving the line to 370 leagues west of the Cape Verde Islands; that is, between 48° and 49° west of Greenwich. In 1506 Pope Julius II sanctioned the change.

In March 1496 Henry VII of England opened up the prospects of an empire in North America by granting letters patent to Giovanni Caboto, a Venetian citizen (1476) of Genoese birth (c.1450), and his sons Luigi, Sebastiano and Sante to carry out a voyage of exploration and to enjoy in Bristol a monopoly of the trade which might result. In the small ship *Matthew*,

Caboto made a landfall in June 1497 in Prima Terra Vista. He raised the king's flag and his companion Lorenzo Pasqualigo raised the Venetian flag. Queen Elizabeth II led the commemoration at Bonavista in Newfoundland 500 years later.

The works of the Florentine geographer and cartographer, Francesco Berlinghieri (1440–1500), facilitated the Ottoman and Iberian expansion into the Indian Ocean. In November 1497, Vasco da Gama, commissioned by John II's successor, Manuel I, rounded the Cape of Good Hope into the Indian Ocean. He reached Natal on Christmas Day and Calicut in Kerala on 20 May 1498. The meridian agreed at Tordesillas was then extended to the other side of the world. On this basis Portugal claimed Macao and Dili and Spain claimed the Philippines.

Between 1499 and 1521 Amerigo Vespucci, a Florentine settled in Seville, made four voyages with the Spaniards along the coasts of Brazil and Venezuela. In 1524 another Florentine, Giovanni da Verrazzano, sailed along the coast from Florida to Newfoundland seeking the Northwest Passage for François I of France and made the first firm sighting of the mouth of the Hudson River.

The first Italian to sail around the world was Antonio Pigafetta of Vicenza, the chronicler who set out from Spain with the Portuguese Ferdinand Magellan in 1519 and returned to Spain in 1522 with Jean Sebastián de Elcano, who, like St Ignatius, was a Basque. The expedition used Berlinghieri's maps.

In his voyage in the *Endeavour* (1768–71) Captain Cook was assisted by the researches of the pioneer oceanographer Count Luigi Ferdinando Marsigli (Bologna 1658–1730 Bologna). Cook was accompanied by a Venetian, Antonio Ponto, and one of his midshipmen was James Mario Matra (New York c.1746–1806 Tangier), after whom the Sydney suburb of Matraville is named. A member of a Corsican family from Genoa, Matra wrote in 1783 a 'Proposal for establishing a settlement in New South Wales'. It impressed the British Government.

The first Italian to captain a ship around the world was Alessandro Malaspina (Mulazzo 1754–1810 Pontremoli) in the Spanish naval ship *Astrea*, which sailed westwards from Cádiz to Cádiz between September 1786 and May 1788. In July 1789 he left Cádiz again for the Pacific with two ships, *Descubierta* and *Atrevida*. After visiting the Spanish colonies in South America, California and the Philippines, he visited the new British settlements in Port Jackson and Parramatta between 12 March and 11 April 1793.

In June 1793 Earl Macartney (County Antrim 1737–1806 Chiswick) arrived in Guangzhou with a trade mission from George III to the Emperor Qianlong. As none of the 700 men in the mission could speak Chinese, two Chinese priests were recruited from the Collegium Sinicum in Naples. They could translate Macartney's Latin into Chinese and the Emperor's Chinese into Latin. Macartney avoided kowtowing but his

magnificent presents were accepted as tribute. He was told that the Chinese Empire was self-sufficient and only granted trade as a special favour. Margaret and I arrived in Guangzhou 200 years to the month after Macartney in order to make a private tour of China before travelling to Lausanne for the 100th session of the International Olympic Committee as members of the Australian team bidding for the Sydney Olympics 2000. Our mission was more successful than Macartney's.

THE GARIBALDIS IN AUSTRALIA

The first Italian to bring a ship to Australia was the great revolutionary Giuseppe Garibaldi (Nice 1807–82 Caprera). He had taken refuge in South America in 1834 after being involved in a mutiny in the Royal Sardinian Navy. The Italian Legion, which he formed in Uruguay in 1843, made his name famous throughout Italy. Revolution erupted in Palermo in January 1848 and soon afterwards in most of the capitals of western Europe. Garibaldi took eighty of his legionaries to fight the Austrians in northern Italy. In November Pius IX fled in disguise from Rome to Gaeta. In February 1849 Garibaldi was elected a deputy to the Constituent Assembly in Rome and successfully proposed that Rome should become an independent republic. The republican forces led by Garibaldi held out until July against French

forces sent by Louis-Napoléon Bonaparte, the Prince President of the Second French Republic, to restore papal rule. Pius IX returned to Rome in April 1850.

Garibaldi was not welcome in his native Nice, which was still part of the Kingdom of Sardinia. He found his way back to South America. In the Peruvian port of Callao he took command of the sailing ship *Carmen* for a voyage to Guangzhou. For the return voyage he sailed through the Straits of Lombok and down the coast of Western Australia till he reached the Roaring Forties. In December 1852 he landed on Three Hummock Island off the north-western tip of Tasmania. In his *Memorie Autographiche* he describes his reactions:

We found a small farm lately deserted by an Englishman and his wife, on the death of his partner. This information we obtained from a board erected on the settler's grave, which set forth in brief the history of the little colony. 'The husband and wife', said the inscription, 'unable to bear the loneliness of the desert island, left it, and returned to Van Diemen'.

The most important part of the settlement was a little one-storied dwelling-house, rough, but comfortable, carefully built, and furnished with tables, beds, and chairs—not luxurious, indeed, but all bearing the impress of that comfort which seems so natural to the English. We also found a garden—a most useful discovery, as

it enabled us to take on board an abundant supply of fresh potatoes and other vegetables.

How often has that lonely island in Bass Strait deliciously excited my imagination, when, sick of this civilized society so well supplied with priests and police-agents, I returned in thought to that pleasant bay, where my first landing startled a fine covey of partridges, and where, amid lofty trees of a century's growth, murmured the clearest, the most poetical of brooks, where we quenched our thirst with delight, and found an abundant supply of water for the voyage. [Werner's translation, 1889]

This visit led Garibaldi to purchase in 1856 a similarly idyllic retreat on the island of Caprera off the north-eastern tip of Sardinia. The Three Hummock Island Nature Reserve, 7960 hectares in area, was purchased under the *States Grants (Nature Conservation) Act 1974* and added to the Register of the National Estate under the *Australian Heritage Commission Act 1975*.

Garibaldi's passage passed unnoticed in Australia. His name, however, became increasingly known in the Australian colonies. This was not due to the influence of Italians, who were few in numbers, but to the English influence, which was pervasive. Italian political refugees—Mazzini, Rossetti senior, Panizzi, Lacaita—turned opinion-makers in England against the Austrian puppets who occupied the thrones in central and southern Italy. Garibaldi was given a sword of honour by the citizens of

Newcastle upon Tyne, where he landed in 1854 on his way back from South America to Italy.

On 19 April 1859 Napoleon III, Emperor of the French, and Vittorio Emanuele II, King of Sardinia–Piedmont, declared war on Franz Josef, Emperor of Austria. The allies won all the battles in May and June and occupied Lombardy. The emperors concluded an armistice in July. Lombardy, Tuscany and the neighbouring duchies opted for union with Piedmont. The king opened his enlarged Parliament in April 1860. His kingdom was now as large as the area that Napoleon I, Emperor of the French, ruled as King of Italy from 1805. It was fortunate for the Italian cause that Lord Palmerston succeeded Lord Derby as British Prime Minister in June. Palmerston had mastered Italian in his childhood, his Foreign Secretary, Lord John Russell, had gone to Italy with his father as far back as 1813 and the Chancellor of the Exchequer, W. E. Gladstone, had exposed the treatment of political prisoners in Naples in 1851.

On 6 May 1860 the Expedition of the Thousand set sail from Quarto near Genoa in two ships commanded by Garibaldi and Nino Bixio.[5] On 11 May they arrived off Marsala, from which British wine merchants Woodhouse, Ingham and Whitaker had supplied Marsala wine to the Royal Navy and the British Isles since Nelson's days. Four Neapolitan naval ships were waiting to protect the Kingdom of the Two Sicilies and two ships of the Royal Navy were waiting to protect the British merchants. To

avoid an international incident the Neapolitan ships did not fire on the *garibaldini*. They landed and overran the whole kingdom. At Teano on 26 October 1860 Garibaldi hailed Vittorio Emanuele II as King of Italy and handed over his Sicilian and Neapolitan conquests.[6] Deputies from Sicily and Naples joined the Parliament in Turin in February 1861. The Kingdom of Italy was proclaimed on 17 March. It is most unlikely that the whole of Italy would have been united without the inspiration of Garibaldi and his conquest of Sicily and Naples.

Queen Victoria and her court disapproved of the 'old Italian masters' who formed her government. The English press and people, however, gave wholehearted support to Garibaldi, and that support was conveyed by the English newspapers to Australia. The journalist James Smith (Maidstone 1820–1910 Hawthorn), who had migrated to Melbourne in 1854, produced a successful three-act drama, *Garibaldi*, at the Prince of Wales Theatre in 1860 and organised subscriptions for a ceremonial sword for the hero. The Melbourne Club was one of the institutions canvassed but gave a reply in the same terms it would doubtless use today, namely, that, although individual members may have been sympathetic, the club was unable to give official support to the appeal because, under its rules, demonstrations of a political tendency were not recognised. The sword was sent through the British minister in Turin, Sir James Hudson (1810–85). He was so notoriously pro-Italian during his term

(1851–63) that *The Times of London* commented that he had disobeyed the instructions of two successive governments and acted according to the wishes of the people of England. In July 1861, United States President Lincoln offered Garibaldi a command in the northern forces in the Civil War. The offer was declined because Lincoln was not yet prepared to declare the abolition of slavery.

Garibaldi was no less a hero in the Victorian goldfields than in Melbourne. The use of his name became widespread. In 1860 Garibaldi Gully was opened between Ballarat and Daylesford and the Garibaldi Lead was discovered at Fiery Creek near Beaufort. Buggins Flat near Wedderburn, where gold had been discovered in 1852, was renamed the Garibaldi Goldfield in 1860. In 1862 a new field near Woods Point in Gippsland was named after him and in 1868 a new lead near Beechworth. In Sydney, John Cuneo built the Garibaldi Inn at the corner of Ferry and Alexandra Streets in Hunters Hill. The building has been included in the Register of the National Estate.

Ricciotti, the younger son of Giuseppe and Anita Garibaldi, came to live in Melbourne in about 1874 and stayed for some eight years. He was born at Montevideo on 28 March 1847 and in 1857 joined his father on Caprera, accompanying him to London in 1864. On 2 July 1874 Ricciotti married an Englishwoman, Constance Hopcraft, a minor, according to the rites of the Church of England. Like many at the time, the young couple

sailed to seek their fortune in Victoria. Governor Bowen be-friended them.

The death of the Italian consul-general in Melbourne in February 1879 seemed to open a career appropriate to Ricciotti's great name. Meetings in St Kilda Town Hall, in Sydney and in Adelaide and editorials in *The Age* and *The Argus* put forward his claims. A deputation asked the Governor to cable London asking the Colonial Secretary to inform the Italian government of the public opinion in favour of the appointment of Ricciotti. The plan miscarried when it was reported that his brother, Menotti, was organising an expedition to colonise New Guinea. The events are recorded in the despatches visiting lawyer Dr Ferdinando Gagliardi sent to the *Gazzetta d'Italia* and collected in 1881 in his book *L'Australia*.

The rumour of an Italian colony was plausible. In 1868 Amato Amati had published a memorandum discussing the prospects of Italian colonisation in Australia and New Guinea. In United Italy, as in United Germany, there was much agitation for over-seas colonies. The exploits of the *garibaldino* Luigi Maria D'Albertis (Voltri 1841–1901 Sassari) lent colour to the Italian interest in New Guinea. He took expeditions to Dutch New Guinea in 1872 and to the unclaimed eastern half of the island and up the Fly River in 1875, 1876 and 1877. In Dutch New Guinea he was associated with the Florentine naturalist Odoardo Beccari (1843–1920) and in Papua with the ornithologist

Count Tommaso Salvadori Adlard (1835–1923). For his passage up the Fly River between 23 May and 17 July 1876 he borrowed the New South Wales Government yacht *Neva* and flew the Italian and British flags. He also named the Victor Emanuel Range. D'Albertis's book, *New Guinea: What I Did and What I Saw,* was published in Italian in Turin and in English in London in 1880. At about this time, a shipload of farmers and peasants from the Veneto was brought to New Ireland by a Breton speculator, the Marquis de Rays. About 200 survivors were evacuated to Sydney in 1881 and resettled in 'New Italy' near Lismore, New South Wales.

Ricciotti and his wife left Melbourne to live in Italy where he was elected as a deputy in the Italian parliament from 1887 to 1890. In 1897 he commanded a brigade of volunteers in Greece against the Turks and in 1912, with British concurrence, deployed an international expedition of 12 000 volunteers in Macedonia. He reminisced about his life in Melbourne in an interview he gave in February 1915 in London on a fundraising visit for the Garibaldi Legion which was fighting in France. He died in Rome in 1924 and was given a state funeral. His wife died in 1941.

Ricciotti's eldest surviving son, Giuseppe, born on 29 July 1879 at Cochrane Street, Brighton near Melbourne and known as Peppino, continued the martial traditions and subversive activities of his family at home and abroad. He fought in Greece with his father against the Turks, in the Transvaal with the Boers

against the British, in Mexico with Pancho Villa against Porfirio Diaz and in Venezuela. In 1914 he took command of the Garibaldi Legion in France with the rank of colonel. When Italy entered the war he became a lieutenant-colonel in the Royal Army, was promoted to colonel and in 1918 to brigadier-general. He at first supported Mussolini, taking out a ticket in the Fascist party and participating in a demonstration in Milan which led to a riot with the Socialists. He dissociated himself from the Fascists after the assassination of the Italian socialist leader Matteotti and emigrated to the United States in 1924. However, on the declaration of war against Ethiopia, he reconciled to Fascism and returned to Italy in 1940. In 1944 Giuseppe was arrested by the Nazis and imprisoned, spending two months in Regina Coeli and six months in Via Tasso before being liberated by the Allies. He died in 1950.

ITALY AND THE PACIFIC

Some landmarks were given Italian names in the island of New Guinea by the French navigator Jules-Sébastien-César Dumont d'Urville (1790–1842 in a railway accident near Versailles). (D'Urville is still remembered for his part in obtaining the Venus di Milo from the Turks in 1820.) In 1827, during his

voyage of exploration to the South Pacific, he named the mountains inland from the north-east coast of New Guinea at 142°E after the physicist Evangelista Torricelli (Faenza 1608–47 Florence). During his 1839 voyage to the Antarctic, he named islands off the south-west coast of New Guinea at 133°E after the geographer Ferdinando De Luca (Foggia 1783–1869 Naples) and Carlo Alberto (Turin 1798–1849 Oporto), King of Sardinia (1831–49).

The first Italian ship circumnavigated the world after the unification of Italy. The *Magenta,* a steam corvette of the Royal Italian Navy, set out from Montevideo in February 1866 and returned there in December 1867. It crossed the Atlantic and Indian oceans, visited Singapore, Saigon, Yokohama, Shanghai, Tianjin and Hong Kong and sailed back through the Sunda Strait and round Australia to Melbourne (4–26 May 1867), Sydney (31 May–25 June) and the South American ports of Callao and Valparaiso. In October 1866, Austria ceded Venetia to Italy and the ships of the Imperial and Royal Venetian Navy joined the Royal Italian Navy.

Subsequent circumnavigating naval ships left or returned through the Suez Canal. Australia was on the itinerary of the *Vettor Pisani* and *Garibaldi* in 1873, the *Colombo* in 1878 and the *Caracciolo* in 1883. Accounts of the voyages have been left by Enrico Hillyer Giglioli (London 1845–1909 Florence), the naturalist on the *Magenta,* and by Giuseppe Lovera dei Marchesi

di Maria (Nice 1836–1903 Rome), Felice Napoleone Canevaro (Lima 1838–1926 Venice), and Carlo De Amezaga (Genoa 1835–99 Castellotto d'Orba), the captains of the *Vettor Pisani*, *Colombo* and *Caracciolo*. The ships were named after naval heroes from Venice, Genoa and Naples. Vettor Pisani (Venice 1324–1380 Manfredonia) commanded the Venetian fleet which compelled the surrender of the Genoese fleet at Chioggia in 1380.

Francesco Caracciolo (1752–99), Duke of Brienza and the greatest Italian admiral of the 18th century, served with the British in the American War of Independence between 1779 and 1781 and under Nelson in defending Toulon in 1793. In December 1798 Nelson and Caracciolo evacuated the Bourbons and their court from Naples to Palermo. Returning to Naples in March, Caracciolo was made director-general of the Parthenopean Republic's fleet. Royalist reactionaries arrested him on 25 June. Nelson had him tried and convicted in the morning of 28 June on his flagship HMS *Foudroyant* and hanged in the afternoon from the yardarm of the Neapolitan frigate *Minerva*. His body was dumped at sea. Nelson returned to Palermo to the arms of Emma Hamilton, the wife of the British Minister and an intimate friend of Queen Maria Carolina. King Ferdinando IV of Naples and III of Sicily promptly donated the dukedom of Bronte to Nelson.[7] In December 1816 he renamed himself Ferdinando I, King of the Two Sicilies.

The *Garibaldi* had been launched at Castellammare in 1859 just after the accession of Francesco II, the last King of the Two Sicilies (1859–60). The latest and largest ship in the royal navy, it was originally named *Borbone* after the royal family but was renamed after incorporation in the Royal Italian Navy. Among its midshipmen was Vittorio Emanuele II's nephew, Tommaso Alberto (1854–1931). He succeeded his father as Duke of Genoa in 1855 and was trained for a naval career at Brighton and Harrow in England. Having welcomed the Duke of Edinburgh, Queen Victoria's second son, in 1867, Victorians were impressed by the arrival of another royal duke. They named Genoa Peak, Genoa River and the town of Genoa in Victoria after him. The Duke sat next to Governor Bowen at the opening of the 7th Victorian Parliament in May 1873.

In 1880, when Americans were taking over islands in the Pacific, King Kalakaua of Hawaii appointed an Italian as his foreign minister. Celso Cesare Moreno had served with the Sardinian forces in the Crimean War and afterwards as an adviser to Nana Sahib during the Indian Mutiny. Robert William Wilcox (Maui 1855–1903 Honolulu) was hailed as 'the Hawaiian Garibaldi' on his return from training at the Royal Military Academy in Turin from 1881 to 1887. In 1895 he led an insurrection against the American usurpers in favour of Liliuokalani, the last Hawaiian monarch, and was elected the delegate of the Territory of Hawaii to the Congress of the United States in 1900.

GERMANY AND THE PACIFIC

Germany was united and the German Empire was proclaimed in January 1871. In 1884 Germany acquired Kaiser Wilhelmsland and the Bismarck Archipelago. At the plantation mansion of 'Queen Emma', Emma Eliza Forsayth (Samoa 1850–1913 Monte Carlo), on Blanche Bay, opposite Rabaul, there is still a monument to her lover and the captain of her merchant fleet, Agostino Stalio, who was born to an old Venetian family at Stari Grad on the island of Lesina, now Hvar, in 1854 and killed in a punitive expedition to Nugarbe Island in 1892.

In 1885 a dispute arose between Germany and Spain over ownership of the Carolines. They agreed that Pope Leo XIII (1878–1903) should arbitrate. He settled in favour of Spain. Then, in 1893, four centuries after the Catholic monarchs of Portugal and Spain had settled the boundaries between their empires, Portugal and the Netherlands became apprehensive that Germany would attempt to extend its empire to include the island of Timor. In June they signed a Convention relative to Commerce, Navigation, Boundaries and Mutual Rights of Preemption in the Timor and Solor Archipelago. The Calvinist Queen of the Netherlands and the Catholic King of Portugal gave each other first option to purchase half of Timor if the Lutheran German Emperor approached either of them to sell

it. Germany purchased the Carolines from Spain in 1899 after Spain lost the Philippines to the United States.

COMMUNICATIONS BETWEEN ITALY AND AUSTRALIA

The great Italian sailors and navigators to the Pacific were followed by the aviators. Vincenzo Lunardi (Lucca 1759–99 Lisbon) was described as the first aerial traveller in the English atmosphere when he flew in a hydrogen-filled balloon 32 feet in diameter from Moorfields to Ware on 15 September 1784. He was the secretary of Francesco Maria Venanzio d'Aquino (Naples 1738–95 Naples), who was a Fellow of the Royal Society (London) (1783), Principe di Caramanico, and the ambassador of the Kingdom of Naples in London. The balloon ascended in the presence of 200 000 spectators. Lunardi made later ascents in Edinburgh and Glasgow.

After World War I, Australia, the most distant country from Europe other than New Zealand, was an obvious goal for aviators who had flown with the British and Italian forces. Captain Ross Macpherson Smith (Adelaide 1892–1922 Weybridge near London), Lieutenant Keith Macpherson Smith (Adelaide 1890–1955 Adelaide) and Sergeants Walter Henry Shiers (Adelaide 1889–1968 Adelaide) and James Mallett Bennett (Melbourne

1894–1922 Weybridge) shared the Australian Government's £10 000 prize for the first aviators to fly from England to Australia within 30 days. They left Hounslow on 12 November 1919 and reached Darwin on 10 December. En route they landed in Pisa, Venturini (near Elba), Rome, Naples and Taranto. The first aircraft I saw was their Vickers Vimy bomber as it flew over Middle Head to land at Mascot, still Sydney's only international airport. In his will Sir Keith Smith provided for the erection of a museum to house the famous aircraft at Adelaide airport. There is a sculpture of the four aviators.

On 31 May 1925, the Marchese Francesco De Pinedo (Naples 1890–1933 New York), an officer in the Regia Aeronautica, and his mechanic, Ernesto Campanelli, arrived in Broome, Western Australia, in a single-engined Savoia 16 seaplane. They had left Italy on 20 April. After flying around Australia and to Tokyo, they arrived back in Italy on 7 November. Their aircraft was the first seaplane and first non-British aircraft to visit Australia, and the first aircraft to return from Australia to its country of origin. In 1927 there was speculation that De Pinedo might marry Princess Giovanna of Italy. Promoted to general in 1929, he was killed at Long Island airport when taking off to set a long distance record by flying to Bagdad.

Herbert John Louis Hinkler (Bundaberg 1892–1933 Pratomagno) was posted in July 1918 to a Royal Air Force Squadron in Italy, where he ground strafed Austrian troops. In May 1920

he set out from Croydon in the United Kingdom to fly solo to Australia. He flew non-stop to Turin, setting a long-distance record, but did not proceed further because fighting continued in Syria. In February 1928, again flying through Italy, he made the first solo flight to Australia, taking slightly over fifteen days. We pupils at Telopea Park school in Canberra were taken to see him welcomed at Parliament House, which was decorated with the Australian Red Ensign on the House of Representatives side and the Union Jack on the Senate side. On 7 January 1933 he set out from Heathrow to fly solo round the world. His body was found beside his plane, which had crashed in the Apennines between Florence and Arezzo, on 27 April. He was buried with full military honours in Florence on the orders of the Mussolini Government. A monument stands at the crash site.

On 22 September 1918 the first radio messages were transmitted between Britain and Australia. At his house at Wahroonga near Sydney, Sir (1937) Ernest Fisk (Sunbury-on-Thames 1886–1965 Sydney), who had been trained by Guglielmo Marconi (Bologna 1874–1937 Rome), exchanged messages in Morse code with the Marconi Transatlantic station at Carnarvon in Wales. (Vittorio Emanuele III created Fisk a knight in the Order of the Crown of Italy in 1933.) Marconi had good British connections through his mother, Annie Jameson of the whiskey family, and his wife, Beatrice O'Brien, from an Irish baronial family created by Henry VIII. In 1896 Marconi had come to England

where there was more scope than in Italy for his pioneering experiments in radiotelegraphy. He returned to Italy in 1914 and was made a senator. George V created him a GCVO in 1914 and Vittorio Emanuele III a marchese in 1929. On 26 March 1931 Marconi illuminated the Sydney Town Hall by a radio signal from his yacht *Elettra*, which was at anchor in the port of Genoa.

In 1963 the Marchesa Maria Cristina Marconi and her daughter Elettra came to Sydney on the maiden voyage of the liner *Guglielmo Marconi*. They were welcomed at the Club Marconi. The daughter, now the Princess Elettra Giovanelli Marconi, and her son, Don Guglielmo Marconi, were the guests of honour at the 30th anniversary celebrations of the club in 1988.

The most recent Italian circumnavigation, *periplo del mondo*, was made by the guided missile destroyer *Durand de La Penne* and the guided missile patrol ship *Bersagliere* between July 1996 and April 1997. The ships visited Sydney in January. Marchese Luigi Durand de la Penne (Genoa 1914–92 Genoa), a vice-admiral, rode one of the human torpedoes which crippled two British battleships at Alexandria in December 1941. Modern torpedoes were invented and developed by Robert Whitehead (Lancashire 1823–1905 Berkshire) under Austrian rule at his shipyards in Fiume, now Rijeka in Croatia, between 1856 and 1896.

—◦◦—

Year Book Australia 2001 estimates the countries of birth of Australia's population in 1998 as Australia 14 484 800, United Kingdom and Ireland 1 227 200, New Zealand 361 600, Italy 244 600 and China (including Hong Kong and Macau) 218 800. There are now six Members of the House of Representatives with Italian names: Anthony Albanese, Phillip Barresi, Steven Ciobo, Janice Crosio, Teresa Gambaro and Con Sciacca, three Labor and three Liberal. John Horace Panizza was the first person of Italian parentage to sit in the Senate, representing Queensland from 1987 to 1997.

The Labor and Liberal campaigns for the New South Wales elections on 27 March 1999 were conducted by two men of Italian pedigree who attended schools in my electorate. John Della Bosca was a pupil at the De La Salle College at Cronulla and Remo Nogarotto was a pupil at the Patrician Brothers College at Fairfield.

It was in the New Parliament House in Canberra designed by Romaldo Giurgola, an Italian–American architect who later took out Australian citizenship, that Oscar Luigi Scalfaro, the eighth president of the Italian Republic, was honoured with a luncheon on 8 December 1998. On 10 December 1998 President Scalfaro was rapturously acclaimed at the Club Marconi.

SANTAMARIA

IT IS FITTING TO place a chapter on Bob Santamaria, the most famous Italian name in Australian history, between the chapters on politics and religion. He distorted politics and religion in Australia for many years. In the 1950s he was thought to be covertly taking over the Australian Labor Party in Victoria. When the Howard Government in February 1998 accorded him a State funeral it seemed that he had taken over the Liberal Party of Australia. He and I never met and we never communicated.

Batholomew Augustine Santamaria (1915–98) was born in Melbourne a year before I was. He was a protégé of Daniel Mannix (1864–1963), the Archbishop of Melbourne.[1] His parents had come to Victoria from the Aeolian Islands. He first came to public notice as one of the three protagonists of Franco in a notorious debate on the Spanish Civil War in the Public Lecture Theatre at the University of Melbourne on the night of 22 March 1937. Some of those present were members of the Federal Parliamentary Labor Party when I was elected to it.

On 3 May 1937, seven days after more than 2000 people had been killed by German planes in a raid on Guernica, questions were asked in the British House of Commons about Franco's lobbyist, the Marqués del Moral.[2] The Under-Secretary of State for the Home Department answered:

This gentleman, I understand, was born in Australia but acquired Spanish nationality in 1928. A great part of his life has been spent in this country where his children were born, and, according to his statement on registration with the police, he has seen several years' service in the British army, including service during the Boer War and the last War.

The Times reported Opposition laughter and cheers when a Labour MP followed with a rhetorical question: 'Is the Under-Secretary aware that one word from a marquis counts for more than a thousand from an ordinary man with members of the Tory Party?' The British Labour Party was less inhibited than the Australian Labor Party in opposing Franco.

With the assistance of Mussolini's Italy and Hitler's Germany, Franco achieved a complete victory on 1 April 1939. On the external wall of the choir to the Cathedral within the Mesquita of Córdoba a plaque lists the priests of the diocese who were 'assassinated in the Communist revolution of 1936'. In the Cathedral of Granada there is still a monument erected in 'the year of victory' to 'our priests immolated by Marxism'. Many of

the priests have been beatified by Pope John Paul II. More than all other 20th century popes put together, he has used the procedures for canonisation and beatification inaugurated by Sixtus V in 1588 and settled by Urban VIII in 1634.

Franco died on 20 November 1975. His funeral was attended by only one Head of State, Augusto Pinochet of Chile, and by the wife of another, Imelda Marcos of the Philippines. I made my first visit to Spain in the following June. On subsequent visits I have witnessed an astonishing reconciliation in Spanish society.

—⁕—

After World War II I did not realise how much the bishops from Ireland had resisted the efforts of the Apostolic Delegates to introduce ideas from other Catholic countries in Europe. In 1937 Archbishop Simonds of Hobart, educated at the Catholic University of Louvain, was the first Australian to be consecrated as a Catholic archbishop. In 1947 Archbishop Gilroy of Sydney, educated in Rome, was the first Australian to be appointed a cardinal. In *Against the Tide* (page 224), Santamaria described Archbishop Giovanni Panico, the Apostolic Delegate from 1935 to 1948 and later a cardinal, as 'a quite intransigent enemy of Mannix' who was 'guilty of a needless act of venom' in having Pius XII (1939–58) appoint Simonds as co-adjutor to Mannix.

Researching the archives in the Irish Department of Foreign Affairs, Richard Hall wrote in the Jesuit publication *Eureka Street* in March 1995 that Ireland's first High Commissioner (1946) and Ambassador (1950) to Australia, T. J. Kiernan, blamed the Italian Panico for having Pius XII appoint the Rome-educated Gilroy a cardinal instead of the Irish Mannix. Calwell, as one of Chifley's ministers, took it on himself to write to the Papal Secretary of State and the Superior General of the Jesuits to have Panico recalled and Simonds appointed in his stead. Since Australia did not have diplomatic relations with the Holy See, Calwell persuaded Chifley himself in 1948 to ask Ernest Bevin, the Foreign Secretary in the Attlee Government, to request Pius XII to appoint Mannix a cardinal. Calwell deluded himself that he could influence Mannix and James Duhig, Archbishop of Brisbane (1917–65), and that he and not Evatt would succeed Chifley as Leader of the ALP. After he criticised the 'anti-communist' obsession of Santamaria's Movement at the Victorian ALP Conference in 1948, Calwell did not anticipate that in 1949 he would be dumped from the Victorian central executive, Duhig would support the Liberals in the Federal elections and Mannix would be non-committal during and after the elections.

After Chifley's death in June 1951 Calwell succeeded Evatt as Deputy Leader of the Opposition and in October Churchill replaced Attlee as Prime Minister. Calwell immediately asked

Richard Casey, Minister for External Affairs in the Menzies Government, to ask Anthony Eden, the Foreign Secretary in the Churchill Government, to request the Pope to appoint Mannix a cardinal. Hall sums up:

Within a few years Calwell was to be divided for ever from Daniel Mannix, the man in whose interests he had so tirelessly laboured. When the chips were down, Mannix chose the Italian–Australian, B. A. Santamaria, over the Irish–Australian, Arthur Calwell.

I came under Santamaria's scrutiny for my views on China, not Spain. He strongly supported the United States crusade against China and made regular visits to Casey. No records were kept of their discussions. In August 1954 I was the first member of the Parliament to urge Australian recognition of the Government in China. Santamaria promptly took me to task, just as four months earlier Casey had taken me to task for questioning the US decision to intervene in Viet Nam. Santamaria remained the most determined supporter of the US crusade against Viet Nam but had less influence and access under Casey's successors.

Santamaria foretold the Menzies Government's first reverse in the post-Imperial Pacific when, in November 1959, he informed Sir Frank Packer's hatchetman Alan Reid that: 'If America feels that in the end she can get an anti-communist Indonesia by the gift of West New Guinea, she will use her pressures in that direction.'[3]

Menzies succeeded Casey as Minister for External Affairs on 4 February 1960. In September he invited President Kennedy's brother to visit Australia after a trip Kennedy was intending to make to Indonesia in January 1962; Robert Kennedy replied that it would not be possible. On 27 November 1961 the US and Australia supported two UN General Assembly resolutions concerning Netherlands New Guinea. Both failed to secure the necessary two-thirds majority; no Asian country supported them.

At the elections on 9 December 1961 the ALP Opposition, led by Calwell, came close to winning government with a single seat the difference. On 11 December the US Assistant Secretary of State for Far Eastern Affairs, Averell Harriman, told the Australian Ambassador, Howard Beale, that the US would no longer support the Menzies Government's position on Netherlands New Guinea. The newly appointed Minister for External Affairs, Garfield Barwick, told Cabinet on 12 January 1962 that the Dutch inevitably must go. At the same time Robert Kennedy was meeting Sukarno and addressing university students in Jakarta and central Java, Calwell, without consulting anyone in the ALP, used the *Sydney Morning Herald* to compare President Sukarno's sabre-rattling with Hitler's before Munich. In his book, *Just Friends and Brave Enemies*, Kennedy recalls the evening at Sukarno's palace where he and his party enjoyed the private dance exhibition given by the President's 'fourteen-year-old daughter, Megawati, a lovely and talented girl'. After his bellicose

bombast Calwell was never a threat to Menzies. On 1 May 1963 Netherlands New Guinea was transferred to Indonesian administration and at the elections on 30 November 1963 Menzies regained ten of the seats Calwell and I had won in 1961.

Santamaria pronounced that Calwell was under the shadow of Quisling, in other words, that he was a traitor to his Church; Paul VI, however, created Calwell a Knight Commander of the Order of St Gregory the Great.[4] I cited the ALP's attitude at page 140 of *The Whitlam Government*. In *Against the Tide* Santamaria set out the reaction by the poet James McAuley (1917–76). McAuley protested to the Apostolic Delegate Domenico Enrici at the award of an honour to 'an Australian politician whom great numbers of Australians consider to be guilty of cowardice and naked opportunism in regard to both the fight against communism and the fight for educational justice for Catholics'. McAuley dismissed Enrici's justification as an admission that the citation was 'the sort of routine compliment that a Caribbean banana republic may hand out'. He captiously suggested an official statement 'assuring all Catholics that Papal Honours have no significance'.

McAuley and I were contemporaries at the University of Sydney, where his lifestyle was considerably more bohemian than mine. He was converted to Santamaria's causes in 1955 but became frustrated when the Holy See ordered the church in Australia to stop supporting the underground and underhand

methods Santamaria had used to split the ALP in Victoria and had attempted to use to split the New South Wales Labor Party. In two stanzas of McAuley's epic *Captain Quiros* (1964), published three years after he was appointed Professor of English at the University of Tasmania, he disparaged Cardinal Gilroy, Archbishop of Sydney, and his auxiliary James Carroll, then Titular Bishop of Atenia (1954). McAuley continued his anticommunist activities and informed ASIO on the activities of the opponents of the war in Viet Nam. I refer to him in *The Truth of the Matter* at page 156. In August 1999 I launched the biography by Cassandra Pybus, *The Devil and James McAuley*.

Santamaria resumed his attacks on me over China after a meeting of the ALP Federal Executive in April 1971. On the suggestion of the Federal Secretary, Mick Young, I cabled Premier Zhou Enlai suggesting a visit by an ALP delegation for discussion on 'matters of mutual concern'. On 10 May I received an invitation from the People's Institute of Foreign Affairs to visit China to discuss issues relating to the two countries. I was to be the first Australian political leader to visit the People's Republic of China. Santamaria pontificated, 'Australia has gained a Chinese candidate, if not a Manchurian candidate, for the Prime Ministership'.

A month later the foundations of America's policies on China and Viet Nam were undermined when, on 13 June, the *New York Times* began to publish the Pentagon Papers leaked by

Daniel Ellsberg. These massive documents concerning US policy on Viet Nam had been prepared for President Johnson's Secretary of Defense, Robert McNamara.

At the ALP Federal Conference held in Launceston on 30 June, the Federal President Tom Burns, Young and I arranged to take Stephen FitzGerald, a research fellow at the Australian National University, and Rex Patterson MP, the Shadow Minister for Agriculture, with us to China. Before the end of the Conference my press secretary, Graham Freudenberg, left to make arrangements with representatives of the People's Republic of China in Hong Kong for the formidable press contingent which might accompany us. We arrived in Beijing on 3 July with Alan Barnes (*The Age*), David Barnett (Australian Associated Press), Philip Koch (Australian Broadcasting Commission), Laurie Oakes (Herald and Weekly Times group), Eric Walsh (News Ltd) and John Stubbs (*Sydney Morning Herald*).

Santamaria was discomfited when President Nixon announced on the morning of 16 July 1971 (Australian time) that his advisor on national security affarirs, Henry Kissinger, had been to China and had arranged with Zhou Enlai for the President to visit Beijing. Kissinger's party had arrived in Beijing six days after mine and left Beijing one day before mine.

In October 1971 the UN General Assembly recognised the People's Republic of China, which took Taiwan's place as a

permanent member of the Security Council. My Government assumed office on 5 December 1972.

Despite Santamaria, I established diplomatic relations with the People's Republic of China on 22 December, with the Democratic Republic of Viet Nam on 26 February 1973 and with the Holy See on 5 March. My Government retained diplomatic relations with the Republic of Viet Nam and maintained an Australian ambassador in Saigon, Geoffrey John Price-Pontifex ('Minimus'), the subject of the last unsigned obituary in the *Sydney Morning Herald*. In November I was the first Australian Prime Minister to visit China. Diplomatic relations between the US and China were achieved under President Carter. Santamaria died on 25 February 1998. Later that year William Bundy's *A Tangled Web: The Making of Foreign Policy in the Nixon Presidency* revealed that a handwritten note from Zhou Enlai suggesting a high-level American visit had been delivered to Nixon through Pakistan on 8 December 1970.

Robert McNamara's *In Retrospect: The Tragedy and Lessons of Viet Nam* exposed the other American crusade. President Clinton established diplomatic relations with Viet Nam on 11 July 1995. McNamara and General Vo Nguyen Giap appeared together at a four-day symposium on the Viet Nam war in June 1997. In March 2000 US Secretary of Defense, William Cohen, visited Viet Nam, and in May the Vietnamese Foreign Minister was received in the Vatican by the Secretary for Relations with

States. The Clinton Administration signed a trade agreement with Viet Nam in July 2000 and in November the President visited Viet Nam. Nobody in Australia's media, bureaucracy, academia or politics will now justify Australia's military involvement in Viet Nam.

The predominantly Buddhist population of Viet Nam owes its high rate of literacy to the dedication of Alexandre de Rhodes (Avignon 1591–1660 Isfahan), who perfected the romanised Vietnamese script as a Jesuit missionary between 1619 and 1630 and again between 1640 and 1646. In 1658 the Holy See adopted his ideas of replacing politically dominated Portuguese priests with francophone Vietnamese priests controlled by the church alone. Australians have played a major role in the preservation and restoration of Hanoi (see William Logan's *Hanoi*).

—ev∂—

Had he been alive, Santamaria, who died on 25 February 1998, would have remembered the 17 000 Australian troops committed to the Korean War and the 50 000 committed to the Viet Nam War, and would have ridiculed Prime Minister Howard's triumphalist assertion on 7 March 2000: 'The service by Australian troops in East Timor represents Australia's most significant commitment of troops since World War II.'

Santamaria never contemplated a crusade in East Timor. Nor did the Pope. In his 44th International Pastoral Visit to the

Republic of Korea, Indonesia and Mauritius, John Paul II spent half a day, 4 October 1984, in East Timor. He did not accept Portugal's pleas that he should kiss the ground on his arrival, as he customarily did on arriving in any new country for the first time.

Santamaria's fellow protagonist for Franco in the 1937 debate, Kevin Kelly, was sent by the Gorton Government at the end of 1970 to Lisbon as Australia's first resident ambassador. Kelly was surprised by the Carnation Revolution in Lisbon on 25 April 1974, when the dictator Salazar's successor, Marcelo Caetano, was overthrown. I describe his reaction in *Abiding Interests* at page 68. He was replaced in August.

The Australian published a weekly column by Santamaria. In his first piece, on 5 March 1976, he mentioned the Whitlam 'revolution'. After the deaths at the Santa Cruz cemetery in Dili on 12 November 1991, which he said were between 50 and 100 in number, he wrote on 4–5 January 1992:

Of all the nations caught up in the East Timor issue, Portugal's role is the least creditable. Throughout the period of Portuguese dominion, it did next to nothing for the Timorese. The present tragedy, furthermore, stems largely from the collapse of Portugal's overseas empire following the seizure of power in Portugal by the communist/Maoist junta in April 1974 . . . In East Timor the Portuguese military not only decamped but handed the armouries

over to the largely communist Fretilin forces... Portugal no longer has any role to play in South East Asia, and its present attempt to restore the pre-Indonesian situation in East Timor cannot succeed and is simply mischievous.

On 15–16 July 1995 he wrote:

The tragedy of East Timor might well have been averted... if the Australian government of the day, heuded by Gough Whitlam, had committed Australia to join with the Indonesians in establishing a trusteeship over East Timor. The project was perfectly feasible in 1975, when the then Portuguese communist government ran out on its responsibilities to East Timor and attempted to transfer power to Fretilin.

Santamaria was not the first commentator, inside or outside the Parliament, to ignore authoritative and contemporary documents. The memorandum on East Timor that Barwick had given to the Menzies Cabinet on 21 February 1963 had been made available under the 30-year rule and were kept in the National Archives established by my Government. In it Barwick referred to correspondence between Menzies and Salazar. In a letter to Menzies on 1 March 1963 Salazar raised the possibility of an Australian dominion or condominium in Portuguese Timor. On 15 October 1963 Menzies replied: 'Let me say that this is not a solution that we have ever contemplated or would contemplate.

It is a solution which in my view would appeal neither to the Timorese nor the Australian people.'

On 1 September 1975, after the Portuguese had abandoned the territory, a Portuguese minister called on me and revived the possibility of a condominium. I gave him the same answer that Menzies gave Salazar. Santamaria's articles petered out at the end of 1997. Only Santamaria ever suggested a joint Australian–Indonesian trusteeship over East Timor. He made the suggestion after a lapse of twenty years. The Portuguese were brilliant explorers but contemptible exploiters.[5]

Santamaria and my Minister for Labour and Immigration, 'Diamond Jim' McClelland (1915–99), were schoolmates at St Kevin's in Melbourne. After not speaking for 40 years they appeared together on the ABC program *Lateline* in October 1996. The apparent reconciliation was so remarkable that the ABC repeated the episode several times. Some months later, Jim and his wife Gillian Appleton lunched with Santamaria at the headquarters of his National Civic Council in Melbourne. In her affectionate memoir *Diamond Cuts*, Gil records 'the strong dislike that Santamaria expressed for Prime Minister Howard and policies of his Government, which Santamaria saw as socially divisive'.

Santamaria's State funeral was conducted by Archbishop George Pell. In his eulogy he spoke not only *nil nisi bonum* but

nil nisi optimum. In *Santamaria: The Politics of Fear* more balanced assessments were made by our contemporaries Max Charlesworth, Xavier Connor, James Griffin, Val Noone, Paul Ormonde and Colin Thornton-Smith. In 2001 Archbishop Pell was translated to Sydney to be Australia's cardinal.

RELIGION

WHEN ST GREGORY THE GREAT (590–604) was told that the fair-haired boys he saw for sale in a Roman market were called Angles, he agreed that they were of angelic appearance and should be joint heirs of the angels in heaven. This happy Northumbrian legend was recorded in the *Historia Ecclesiastica gentis Anglorum* (Ecclesiastical History of the Race of Angles) that the Venerable Bede (673–735) completed in 731.[1]

Gregory had mentioned English slaves in a letter to one of his agents who collected revenues from the Roman Church's estates in southern Gaul. The revenues were not to be sent in the debased local currency but in the form of English slaves or clothing for the poor. The slaves could be trained in the Christian way at Roman monasteries. Gregory converted his family's palace on the Caelian hill into a monastery in 596, his sixth year as Pope. He chose Augustine, prior of the monastery, as head of a mission of 40 monks to refound the Church in England. In 601 he sent reinforcements and made Augustine

the first archbishop of Canterbury. It would be many centuries before the Italian and English languages took a form which would be recognised today, but by 600 AD the ecclesiastical links were established through which relations developed between the inhabitants of Italy and England for nearly 1000 years.

For 47 years after the arrival of Augustine, every bishop in England was either Italian or Irish. Bede records the processes by which the practices of the westernmost parts of Europe were brought into accord with the practices of the Catholic Church. Until the Synod of Whitby in 664, Northumbria preferred Celtic to Roman practices, such as the date of Easter. Disputes continued between the rival Anglo-Saxon kings on the appointment of bishops and abbots. In 668 the Pope, St Vitalian (657–72), sent St Theodore from Tarsus (c.602–90) to be Archbishop of Canterbury. He also sent St Hadrian the African, who established an outstanding school in Canterbury at the Abbey of Saints Peter and Paul, later St Augustine's.

In 669 Theodore put Wilfrid (634–709), who had studied in Rome and had won at Whitby, in possession of the bishopic of York. Theodore presided at the first council of the whole English church in 672 and divided the diocese of York in 678 without Wilfrid's agreement. In 679 Wilfrid made the first appeal by an English bishop to a pope, St Agatho (678–81); he won the appeal but, despite a third visit to Rome and pronouncements in his

favour by three more popes, St Benedict II, St Sergius I and John VI, he never recovered the diocese. The Church in England and the Church of England are indebted to Theodore for their diocesan structure and to Hadrian for their intellectual tradition. Wilfrid is ultimately responsible for the Archbishop of Canterbury being the Primate of All England and the Archbishop of York being merely the Primate of England.

English-born saints in turn evangelised new areas in Europe after visiting Rome. Willibrord (658–739), the Apostle of Frisia and patron saint of the Netherlands, was in Rome in 690 and 695. Wynfrith (c.675–754), the Apostle of Germany, was commissioned to preach to the heathen and was renamed Boniface by St Gregory II in Rome in 719. He was given the rank of archbishop by St Gregory III in 732. Walburga (c.710–79, of Walpurgisnacht) and her two brothers, Wynnebald and Willibald (700–86), the first known English pilgrim to the Holy Land, went to Rome in 720 and later joined Boniface's missions in Germany. Willehad dedicated the cathedral of St Peter in Bremen where he died in 789.

The highest recognition of England's Latin and Christian scholarship was accorded in 781 when Charlemagne met Alcuin (York 735–804 Tours) at Parma and invited him to be principal of the Italian, Irish and English scholars whom he was recruiting for his Palatine school in Aachen. Alcuin was at the heart of

the Carolingian Renaissance. American Anglicans regard him as a saint.

The martyred Oswald (c.605–42), King of Northumbria, is widely venerated in northern Italy. Among Irish saints commemorated in Italy are St Columban (d.615) in Bobbio, San Cataldo in Otranto and San Donato (d.876) in Arezzo. The site of Dublin was settled by Anglo-Saxons about 780 and by Norsemen 60 years later.

Under William the Conqueror (1066–87) England was made the most centralised state in Europe and the Church was subjected to continental standards of discipline and vigour. Stigand, who had been Archbishop of Canterbury and Bishop of Winchester since 1052, was deposed by a papal legate in 1070. The next two archbishops of Canterbury were Italians, Lanfranc from Pavia (1070–89) and Anselm from Aosta (1093–1109). Great monasteries were rebuilt under Italian abbots, St Alban's under Lanfranc's nephew Paul (1077–93), Abingdon under Henry I's doctor, Faricius (1100–17), and Bury St Edmund's under Anselm's nephew and namesake (1121–48), later bishop of London.

In the time of King Stephen (1135–54), the son of the Conqueror's daughter Adela, Englishmen achieved prominence at the papal *curia*. The first English cardinal (1144), Robert Pullen, was chancellor of the Roman Church from 1144 to 1146; the second cardinal (1146), Nicholas Breakspear, became the

only English pope as Adrian IV (1154–59); and the third cardinal (1149), Bosone, fulfilled missions for Adrian IV and his successor Alexander III (1159–81). Hilary, later bishop of Chichester, was employed in the Roman chancery in 1146.

There were fewer ecclesiastical contacts between England and Italy after the *curia* moved in 1309 from Rome to Avignon, where it stayed in the 'Babylonian captivity' till 1377. The impositions by the fourth Avignon pope, Clement VI (1342–52), were so burdensome that England enacted the Statutes of Provisors and Praemunire to prohibit appointments by the Popes and appeals to them.

Pius II (1458–64) was the first pope to have visited England and Scotland. As Enea Silvio Piccolomini (Corsignano 1405–64 Ancona) he was already a singularly learned and eloquent man when he was employed by Cardinal Niccolò Albergati (Bologna 1375–1443 Florence), one of the legates sent by Pope Eugenius IV (1431–47) to preside at the Council of Basel (1431–49). In 1435 Albergati sent Piccolomini to London ostensibly to reconcile Charles VII, King of France (1422–61), and Henry VI, King of England (1422–61), but probably to conceal a shift of alliance from England to France by Philip III, Duke of Burgundy (1419–67). Piccolomini crossed to England from Calais and asked Henry VI for a safe-conduct to Scotland. When he was Pope he wrote his memoirs, the *Commentarii*, in the third person in Latin. He recalls:

Aeneas was forced to return much against his will, having braved the perils of the sea to no purpose. Still he was glad to have seen the rich and populous city of London, the famous church of St Paul, the wonderful tombs of the kings, the Thames which is swifter at the flow than at the ebb of the tide, the bridge like a city, the village where men are said to be born with tails, and, more famous than all the rest, the golden mausoleum of Thomas of Canterbury covered with diamonds, pearls, and carbuncles, where it is consid-ered sacrilegious to offer any mineral less precious than silver. [Translation in Smith Studies in History, *October 1936–January 1937*]

Piccolomini then sailed from Holland for Scotland. His ship survived two violent gales which drove it to Norway and even-tually landed him at the Scottish port of Dunbar. He may have been sent to incite James I, King of Scots (1406–37), against England; if so, he did not succeed. He recalls his audience with the king cryptically and his impressions of Scotland vividly:

When he was at last admitted to the King's presence, he obtained all he had come to ask. He was reimbursed for his travelling expenses and was given fifty nobles for the return journey and two horses called trotters.

The following facts about Scotland seem worth recording. It is an island two hundred miles long and fifty wide, connected with Britain and extending toward the north. It is a cold country where

few things will grow and for the most part has no trees. Below the ground is found a sulphurous rock, which they dig for fuel. The cities have no walls. The houses are usually constructed without mortar; their roofs are covered with turf; and in the country door-ways are closed with oxhides. The common people, who are poor and rude, stuff themselves with meat and fish, but eat bread as a luxury. The men are short and brave; the women fair, charming and easily won. Women there think less of a kiss than in Italy of a touch of the hand. They have no wine except what they import. Their horses are all small and natural trotters. They keep a few for breeding and castrate the rest. They do not curry them with iron or comb them with wooden combs or guide them with bridles. The oysters are larger than those in England. Leather, wool, salt fish and pearls are exported from Scotland to Belgium. There is nothing the Scotch like better to hear than abuse of the English. It is said there are two Scotlands, one cultivated, the other wooded with no open land. The Scots who live in the latter part speak a different language and sometimes use the bark of trees for food. There are no wolves in Scotland. Crows are rare and therefore the trees in which they nest are the property of the royal treasury. At the winter solace (Aeneas was there then) the day in Scotland is not more than four hours long.

In 1442 Piccolomini was sent from Basel to Frankfurt where he so impressed Frederick III, the Holy Roman Emperor (1440–

93), that he crowned him poet laureate. Piccolomini abandoned his dissolute life and offspring and was ordained priest in 1446, consecrated Bishop of Trieste in 1447 and Siena in 1450 by Nicholas V, raised to the cardinalate by Callistus III in 1456 and elected Pope in 1458. He took his papal name from Vergil's description of Aeneas (Enea in Italian) as *pius Aeneas* in Rome's imperial epic, the *Aeneid*. His mission to James I is depicted in the second of Pinturicchio's ten frescoes of his life in the Piccolomini Library initiated by his nephew Pius III (1503) in Siena Cathedral.

Pupils in Australian government and church schools still learn something, but not much, about the schism under Henry VIII, the Spanish Armada despatched against Elizabeth I and the Gunpowder Plot hatched against James I. The relations between the five Tudor kings and queens and the eighteen popes of the 16th century affected relations between England and Italy for many centuries. For the first quarter century, Henry VII (1485–1521) and Henry VIII and the popes were extraordinarily close. They manoeuvred to allocate English dioceses and their revenues for the benefit of collectors of Peter's pence in England and royal envoys in Rome. Lay men and women were alienated by the clerical absenteeism and pluralism which resulted.

Giovanni Gigli (Bruges 1434–98 Rome) was appointed collector of Peter's pence and pontifical nuncio in England in 1476 and granted English citizenship in 1477. He was arch-

deacon of Wells when the king sent him in 1497 as his representative in Rome, the first Italian churchman to hold the post. In 1497 Alexander VI (1492–1503) appointed Gigli to the vacant see of Worcester. His nephew Silvestro Gigli (Lucca 1463–1521 Rome) succeeded him as envoy and bishop. In 1505 he brought the king a sword and cap from the new pope, Julius II (1503–13), the Warrior Pope. He stayed in England until 1512. Neither Gigli visited his diocese.

In 1490 the tempestuous Adriano Castellesi was appointed by Innocent VIII to succeed Giovanni Gigli as collector. In 1500 he was sent by Alexander VI to seek help from Henry VII in a war against the Turks. Castellesi's relative Polidoro Vergilio was made his subcollector in 1501. Castellesi himself was made bishop of Hereford in 1502 and cardinal in 1503, taking Gigli's place in seeking a dispensation from Julius II for the future Henry VIII to marry his deceased brother's widow, Catherine, daughter of Fernando II of Aragón. Castellesi was translated to the richer diocese of Bath and Wells.

Henry VII was never, but Henry VIII was soon and often, embroiled in wars. The new king had the delusions of military grandeur prevalent among monarchs of his era. He is more remembered for splitting the Church in 1533 than for earlier defending it. In 1512 he landed in France ostensibly to protect his father-in-law and Julius II from French aggression. In 1513 the next pope, Leo X (1513–21), son of Lorenzo il Magnifico,

sent a sword to the king. In 1514 he made the king's almoner Thomas Wolsey (c.1472–1530) bishop of Lincoln and archbishop of York. The king reciprocated by making the pope's brother Giuliano the 274th Knight of the Garter. Richard Pace, who had served the king in Rome under Julius II, wrote an Erasmian satire entitled *Julius Exclusus*, in which the late pope was excluded from Heaven because St Peter did not recognise him in full armour and the triple tiara.

Wolsey became convinced that Castellesi was working against his interests in Rome and he imprisoned Polidoro Vergilio. In 1515 Andrea Della Rena (Lucca 1476–1517 London) was appointed the collector and Wolsey a cardinal.[2] With Wolsey's ascendancy confirmed, Vergilio was released. In 1517 Castellesi was implicated in a conspiracy to poison Leo X and fled Rome to Venice. The pope was about to despatch his experienced diplomat Lorenzo Campeggi (Milan 1474–1539 Rome) as *legate a latere* to seek Henry VIII's support for a general crusade against the Turks. He was not allowed to cross the Channel until 1518, after Wolsey had also been nominated as *legate a latere*, Castellesi's diocese of Bath and Wells had been transferred to Wolsey and Castellesi had been deprived of his cardinalate.

Campeggi impressed the king and the cardinal but did not persuade them. In April 1521 he wrote to them that Silvestro Gigli was dying and applied for the diocese of Worcester until Salisbury became vacant. The king, however, offered Worcester

to the pope's cousin Giulio de' Medici. On 11 October 1521 the pope rendered a last service to Henry VIII by conferring on him the title 'Defender of the Faith'; the title is used to this day by Queen Elizabeth II in the United Kingdom, Canada and New Zealand. Leo died on 1 December and Castellesi immediately set out from Venice for Rome but was murdered by a servant on the way.

Giulio de' Medici resigned as bishop of Worcester in order to be a candidate, with Wolsey and others, for the papacy. They were defeated by Adrian VI (1522–23). In January 1523 the new pope accepted Henry VIII's nomination of Campeggi as cardinal protector of England. The pope died in September. Giulio de' Medici was elected to succeed him as Clement VII (1523–34), the only holder of an English See to have become pope. Girolamo Ghinucci (Siena 1480–1541 Rome) succeeded the new pope in Worcester, and Campeggi was appointed to Salisbury in 1524.

In 1528 Campeggi was sent to England to study with Wolsey the question of the legal validity of the king's marriage to Catherine. The next year, after protracted and inconclusive hearings and consultations, the matter was recalled for decision in Rome. Wolsey lost all his offices other than the archdiocese of York in 1529. In 1530 the Earl of Wiltshire, the father of the king's prospective bride Anne Boleyn, took the learned Thomas Cranmer to Bologna to seek legal opinions in favour of the annulment of the king's marriage to Catherine. In Bologna Cranmer

met the pope and Catherine's nephew Charles V. He went on to Rome, where the pope appointed him grand penitentiary of England. In 1532 he accompanied the Emperor to Mantua, whence he was recalled to become Archbishop of Canterbury. The last pallium sent from Rome to an archbishop of Canterbury was for Cranmer. Not since Chichele, who had been enthroned in 1414, had an archbishop visited Italy before his appointment. Not until 1966 did a successor of Cranmer visit Rome.

THE CHURCH OF ENGLAND

In January 1533 Henry VIII married Anne Boleyn. Cranmer was consecrated and installed as Archbishop in March; Cranmer declared Catherine's marriage invalid in May, Clement VII declared it valid in July and Queen Anne gave birth to Princess Elizabeth in September.

In 1534 the king appointed Thomas Cromwell (c.1485–1540), who had worked for Wolsey, as his principal secretary. He proved a most effective parliamentary instrument for severing all legal and official links between England and the papacy. Parliament deprived Ghinucci and Campeggi for absenteeism in 1535. Unlike Wolsey, who had never visited Italy, Cromwell had spent many years there in his youth; he had fought at the battle of the Garigliano in 1503. In 1533 Englishmen were

impressed at the lavish welcome and reimbursement Francesco Frescobaldi was given for having restored Cromwell's early fortunes in Florence. The pseudo-Shakespearean play *Thomas Lord Cromwell* (1602) features the character Friskiball. The story of Friscobald in Drayton's *The Legend of Great Cromwell* (1607) comes from the *Novelle* (1554) by Bishop (1550) Matteo Bandello (Castelnuovo Scrivia 1485–1561 Agen).

After January 1547, when Henry VIII was succeeded by his nine-year-old son Edward VI, the Church of England became Protestant. By the end of the year, three refugee reformers from Italy had responded to Cranmer's appeal for learned men to establish a complete system of true doctrine. A former vicar-general of the Capuchins, the eloquent Bernardino Ochino (Siena 1487–1564 Austerlitz, now Slavkov), secured a prebend of Canterbury and a royal pension. A former Augustinian, Pietro Martire Vermigli (Florence 1500–62 Zurich), was appointed Regius Professor of Divinity at Oxford. Giovanni Emanuele Tremellio (Ferrara 1510–80 Sedan), a Jew converted by Vermigli, was made King's reader of Hebrew at Cambridge. In his lectures at Oxford, where he was known as Peter Martyr, Vermigli was responsible for giving the Eucharist a Reformed interpretation, which was unacceptable to Lutherans and Catholics. The three Italian reformers were allowed to return to the Continent after the accession of Mary I, the only child of Queen Catherine, in July 1553. In July 1554 she married Philip, her mother's grand-

nephew and the future King of Spain. On November 1554 Cardinal (1536) Reginald Pole, whose mother was the first cousin of Henry VIII's mother and had been beheaded in 1541, arrived from Rome as legate and received Mary's kingdom back into the Church. On Saturday 20 March 1556 Pole was ordained priest of Greenwich. Next day, he celebrated mass for the first time and Archbishop Cranmer was burned at the stake in Oxford. On 22 March Pole was consecrated Archbishop of Canterbury.

Mary and Pole died on the same day in November 1558. On Mary's death her consort, King Philip, saved their ambassador in Rome, Edward Carne, who had been knighted by Charles V, by persuading the pope to detain him; he died in 1561 and is commemorated by a plaque in the atrium of S. Gregorio Magno in Rome. Next to it is the plaque to Robert Peckham, knighted by Mary, who went into exile in 1564 and died in Rome in 1569. England did not again have Catholic monarchs till 1685, when Charles II was converted on his deathbed and James II succeeded him.

Princess Elizabeth succeeded Queen Mary. On 25 February 1570 St Pius V (1566–72) published a bull excommunicating and deposing her. Later, however, Sixtus V (1585–90) conceded that she was an effective monarch: 'She certainly is a great Queen, and were she only a Catholic she would be our dearly beloved. Just look at how well she governs.'

While not immune from Catholic plots until the defeat of

the Spanish Armada 30 years into her reign, she was well protected by the head of her secret service Sir (1577) Francis Walsingham (c.1532–90), who had stayed out of England during Mary's reign studying the languages and politics of the Italian States. In 1569 he detained and interrogated the Florentine banker Roberto de Ridolfi, who had been operating in England since 1555. In 1571 he intercepted Ridolfi's correspondence with Philip II of Spain. They had been planning to supplant Elizabeth with the Catholic Mary Queen of Scots (Linlithgow Palace 1542–87 on the block at Fotheringay Castle), the grand-daughter of Henry VII's daughter Margaret and a refugee and prisoner in England since 1568.

In 1362, while the popes were in Avignon, an English hospice was established for English pilgrims in Rome. By the time of Henry VII the hospice was directly controlled by the English Crown and became known as 'The King's Hospice'. In 1579 Gregory XIII (1572–85) established the Venerable English College in the hospice buildings to equip English priests to bring their country back to the Church.[3] The College was entrusted to the Jesuits. (St Ignatius, their founder, had collected alms in London in 1530 to continue his studies at Paris University). Two Jesuit martyrs, Edmund Campion (1540–81) and Robert Southwell (1561–95), who was a student at the College, were writers worthy of the Elizabethan age.

Many Italian doctors and functionaries established themselves

under the Tudors and adjusted readily enough to fluctuations of faith. Agostino Agostini, a Venetian physician who treated Wolsey, played an ambiguous role in his fall. He was an agent for Henry VIII in Europe between 1531 and 1534 and became his doctor in 1537. He probably died in Venice about 1560. John Caius, who succeeded Thomas Linacre as president of the College of Physicians and endowed the Cambridge college, graduated MD from Padua in 1541. A contemporary Italian surgeon in London, Andrew Guersi, was the grandfather of John Marston, the dramatist and satirist who turned Anglican priest. In 1555 Cesare Adelmare from Trevigno, an MD educated in Padua, was appointed doctor to Queen Mary, under whom he became a citizen. He remained as doctor to Elizabeth, under whom he became an Anglican. His sons used the surname Caesar. Sir Julius (1558–1636) and Sir Thomas (1561–1610) became judges and Henry (1562–1636) Dean of Ely. Sir Charles (1590–1642), the son of Sir Julius, was also a judge.

Elizabeth's capital was enriched by an influx of Protestant refugees from Italy. The theologian Iacopo Aconcio (Ossana 1492–1567) arrived in 1559 and practised as an engineer. Giulio Borgarucci from Canziano was court physician in the 1560s and 1570s. His brothers, Bernardino, jurisconsult, and Prospero, anatomist, were with him during the plague in London in 1565. Alberico Gentile (San Ginesio 1552–1608 London) lectured at Oxford from 1581 and wrote many pioneering works on the law

of nations. Lodovico Bruschetto (1546–1612), naturalised as Lodowick Bryskett, served the queen in Ireland.

Venice and England were brought closer by the temporal claims of the young Camillo Borghese (1552–1621), who was elected Pope Paul V in May 1605. When Venice rejected his claims, he placed the city under an interdict from 17 April 1606 to 21 April 1607. Pamphlets on behalf of the city and the papacy were published by two brilliant controversialists, the Servite Father Paolo Sarpi (1552–1623) and the Jesuit Cardinal Roberto Bellarmino (1542–1621).

Paul V wrote to James I urging him not to make Catholics suffer for the Gunpowder Plot by Guy Fawkes against Parliament on 5 November 1605. In 1606 Parliament required Catholics to take an oath of allegiance rejecting the right of a pope to depose monarchs. The pope denounced the oath. There were hopes in Britain and fears in Rome that Venice might become aligned with the Protestant powers. Sir (1604) Henry Wotton (1568–1639) was a singularly able ambassador to Venice and England's only resident envoy in Italy. William Bedell (1571–1642) became Wotton's chaplain in 1607 and immediately became a confidant of Sarpi. In 1612 Wotton gave Sarpi an invitation from the king to settle in England; it was declined.

In 1614 Marc'Antonio De Dominis (Arbe, now Rab 1560–1624 Rome), Archbishop of Spalato (now Split), accompanied Bedell to England. James I made him Dean of Windsor, ranking

immediately after the Archbishops of Canterbury and York. In London in 1619, he published in Italian Sarpi's *History of the Council of Trent* and dedicated it to the king. A Latin translation was published in London in 1620. In 1622 De Dominis reverted to Rome, where his denunciation of the Anglican church did not save him from the Inquisition; his body and books were posthumously burned. He was blamed in England for instigating Prince Charles's fruitless suit for the hand of Philip II's granddaughter. In the popular comedy by Thomas Middleton (1580–1627), *A Game at Chess* (1624), he is the Fat Bishop, and the White Knight (the Duke of Buckingham) bundles him up with the Black King (Philip IV of Spain), the Black Queen and the Black Knight (Spanish Ambassador Gondomar). The White King is James I and the White Duke is Prince Charles. When Charles became king he promoted Bedell to an Anglican diocese in Ireland.

Whatever punishments were inflicted on Edward Campion and his colleagues, and on Guy Fawkes and his conspirators in London, as well as on Giordano Bruno and De Dominis in Rome, it was soon safe for English scholars to visit Italy. In 1635 Thomas Hobbes was received by Galileo Galilei (1564–1642) on his small estate at Arcetri, near Fiesole, where he was kept under house arrest after being condemned by the Inquisition for supporting the heretical Copernican theory. In 1638 John Milton was welcomed in Naples by Giambattista Manso, marchese di Villa

(the patron of the poets Torquato Tasso and Giambattista Marino), in Rome by Cardinal Francesco Barberini (Florence 1597–1679 Rome), to the English College and at Arcetri by Galileo.

Half a century later, Charles I's grandchildren, William III (1689–1702) and Mary II (1689–94), succeeded to their thrones under the terms of the Bill of Rights, which required incumbents and their consorts and their heirs to be and remain Protestants. This religious discrimination still applies in the countries where the British monarch remains head of state. Under the *Act of Settlement 1701* Prince Charles would be excluded from the succession if 'he should hold communion with the See or Church of Rome, or should profess the popish religion, or marry a papist'.

By the middle of the 18th century the relations between the papacy and the Hanoverian dynasty were so benign that in 1752 Britain and British America caught up with the Gregorian calendar. In 1582 Gregory XIII reformed the Julian calendar by ordaining that 5 October should be deemed 15 October and that only the centennial years exactly divisible by 400 should be leap years. Before Lord Chesterfield's act of 1751, passed by the Parliament in the reign of George II, the legal beginning of the year was not 1 January, but Lady Day, 25 March. Under the 1751 act, the day after 31 December 1751 was 1 January 1752 and the day after 2 September 1752 was 14 September 1752. In Russia the Julian calendar survived until the fall of the

Romanovs in 1917 and in Greece until the First Republic in 1924. The year 2000 was the first centennial in which all the republics, monarchies and churches around the world counted 29 February.

Immediately after the Napoleonic wars relations improved between the popes and the British monarchs. During the Congress of Vienna (1814–15) the Prince Regent arranged for Ercole Consalvi, the superb secretary of state under Pius VII (1800–23), to be escorted through London in his cardinal's robes. The masterly diplomat secured the restoration of the Papal States. Prussia, the largest Protestant state on the continent, absorbed Catholic territories on the Rhine and achieved parity with Protestant Britain, Catholic France and Austria and Orthodox Russia.

The Papal States, other than Rome itself, were incorporated in the kingdom of Italy in September 1860. In September 1870 Rome was occupied by Italian forces and in October, after a plebiscite, incorporated in the kingdom. Pius IX and Leo XIII took a consistent interest in the anglophone world. A Catholic hierarchy was established in England in 1850, in Scotland in 1878 and in India in 1886. The Archbishop of Westminster was created a cardinal in 1850. The next anglophone cardinals were created in Ireland in 1866, the United States in 1875, Australia in 1885 and Canada in 1886. In 1892 the first apostolic delegate was appointed to the United States.

The first major international conference attended by United

Italy and United Germany was the Congress of Berlin between 13 June and 13 July 1878. It preserved the western border of the Ottoman Empire on the Adriatic Sea. On the eve of the Congress, Turkey gained the support of Britain by secretly agreeing to hand over Cyprus on a perpetual lease. The Congress made further disastrous decisions which still have repercussions around the world, including Australia; Austria–Hungary was given permission to occupy Bosnia–Herzegovina and Italy was given a free hand in Albania. In Appendix 4 I recount Italy's relations with Albania during World War II.

CATHOLICS IN AUSTRALIA

Until the middle of the 20th century the vast majority of settlers in Australia came from the British Isles and the relations between Australian Catholics and Protestants were mostly affected by the relations between British Catholics and Protestants.

In the third quarter of the 19th century, however, a significant number of settlers from continental Europe came to Australia and their attitudes were affected by the relations between Church and State in Italy.

The Catholic Church in Australia benefited from the recruitment of missionaries who came through or from Italy. Two Spanish Benedictines, Joseph Benedict Serra (1810–86) and

Rosendo Salvado (1814–1900), were trained in Naples and consecrated in Rome. They named New Norcia, 100 km north of Perth, after the place where St Benedict was born, and Subiaco, a suburb of Perth, after the place where he founded his Order. In 1851 in Rome, Salvado published the first book in Italian on the Australian colonies. Constantine Rossolino was the first parish priest of Bundaberg in the 1870s. John Cani (Castel Bolognese 1836–98 Rockhampton), who came to Brisbane in 1861, was consecrated as the first bishop of Rock-hampton in 1882. Elzéar Torregiani (Porto Recanati 1830–1904 Armidale), a Capuchin, was consecrated in London in 1879 as the second bishop of Armidale. Henri Stanislas Verjus (Oleggio 1860–1892 Oleggio), one of the Congregation of the Mission-aries of the Sacred Heart, arrived from Thursday Island at Yule Island, near Port Moresby, in 1885 and named Port Leo after Pope Leo XIII. In 1887 he was appointed vicar apostolic and in 1890 coadjutor bishop of British New Guinea. In 1892 he presented the pope with a triple tiara of bird of paradise head-dresses from converted native chiefs.

POPE PAUL VI

In Australian government and church schools pupils do not learn much about religious and political imperialism between the

Mediterranean and Baltic Seas and in the Indian and Pacific Oceans that arose from the 1878 Congress of Berlin.

After his election in June 1963, Pope Paul VI reinforced the initiatives of his predecessor, the lovable and Blessed (2000) John XXIII (1958–63), in reuniting the separated brothers and sons in Christendom and in meeting Orthodox patriarchs. He travelled to Jordan to meet Athenagoras I, the Ecumenical Patriarch, in Jerusalem in January 1964.

In an address to the cardinals on 23 June 1964 he announced that the inestimably valuable reliquary containing the sacred head of St Andrew the Apostle would be returned from St Peter's in Rome to the Orthodox Metropolitan of Patras. It had been given to Pius II on 12 April 1462 by Thomas Palaiologos, despot of Morea and youngest brother of the last Byzantine emperor, Constantine XI.[4] Thomas had fled with the relic to Corfù in July 1460 and then to Rome in 1461. He lived on a papal pension until his death in 1465. His donation is depicted in relief on the tomb of Pius II in the Roman church of Sant' Andrea della Valle, the setting for the first scene of Puccini's Tosca. St Andrew's body and occiput were taken from Constantinople to Amalfi in 1204 by Cardinal Pietro Capuano, one of the legates of Innocent III (1198–1216) on the Fourth Crusade; they rest in the crypt of the Cathedral of Sant' Andrea under an altar designed by Domenico Fontana.

Venice was the chief beneficiary when the Fourth Crusade

was sidetracked to install a Catholic Emperor in Constantinople. Not only did it get most of the loot, such as the four bronze horses, but it detached Crete from the Empire. In 1261 Michael VIII Palaiologos retook Constantinople and restored the Byzantine Empire. The Ottoman Turks conquered Constantinople in 1453 and in 1648 they began the siege of the capital of Crete, Candia, the last Christian fortress in the Eastern Mediterranean.[5] In September 1669 the Venetians surrendered the city and were allowed to take the sacred relics from the Cathedral Church of St Titus, named after the disciple and correspondent of St Paul. The reliquary containing the head of St Titus was deposited in the treasury of St Mark's in Venice in 1670. Crete was granted autonomy in 1898 and was incorporated in Greece in 1913. The city of Candia is now Iráklion. In 1966, encouraged by Paul VI, the Patriarch of Venice agreed to return the reliquary to the Metropolitan of Iráklion. It was carried by aircraft to Athens and by a Greek torpedo-boat to Iráklion. Vast crowds and moving speeches marked the installation of the reliquary in the rebuilt Cathedral of St Titus on Sunday 15 May 1966.

Between March 1964 and November 1969, while Billy Snedden and Nigel Bowen were attorneys-general, the Australian Security Intelligence Organisation collaborated with the Croatian Ustasha in Australia. I describe the circumstances in *The Whitlam Government 1972–1975*, pages 168–9. Paul VI's

initiatives on the return of the reliquaries to Pátras and Iráklion. enabled me to mitigate the tensions between my Catholic and Orthodox constituents.

The Menzies Government had included the Leader of the Opposition, Arthur Calwell, in Australia's Extraordinary Mission to Paul VI's coronation. Having succeeded Calwell in February 1967, I was received in private audience by the pope on 28 June 1967, the day before the feast day of Saints Peter and Paul.[6] Speaking in English, he made it clear that the American crusade in Viet Nam was supported by Cardinal Spellman of New York, but not by himself. This must have been brought home to President Johnson when he visited the Pope on the way home from the memorial service for Harold Holt in Melbourne in December 1967. In an article in *Paris Match* in January 1969 the editor of the Vatican newspaper, *Osservatore Romano*, quoted the Pope's comment to the President: 'It takes courage to wage war, but it takes greater courage to make peace.'

In 1969 Paul VI addressed the World Council of Churches in Geneva. On 25 October 1970 he impressed the English-speaking world by canonising the Forty Martyrs of England and Wales who were executed between 1535 and 1679. Thomas Becket, Archbishop of Canterbury, assassinated under Henry II in 1170, had been canonised by Pope Alexander III in 1173.[7] Cardinal John Fisher, Bishop of Rochester, and Sir Thomas More, a humanist and former Lord Chancellor, who were

beheaded in 1535 under Henry VIII, had been canonised by Pius XI (1922–39) in 1935.[8] Others were hanged, disembowelled and quartered under Elizabeth I. The Pope also elevated the first women to Doctors of the Church, Saint Catherine (Siena 1347–80 Rome) and Saint Teresa (Ávila 1515–82 Alba de Tormes).

In November and December 1970, Paul VI visited the Philippine Islands and Australasia. He was the first pope to travel outside Europe. Prime Minister Gorton presented me to him at Admiralty House in Sydney on Tuesday 1 December 1970. On 12 October 1975 Paul VI canonised Oliver Plunket, the 52-year-old Catholic Primate of All Ireland, who was hanged, disembowelled and quartered at Tyburn on 1 July 1681 under William III and Mary II. Anglicans should apologise for his martyrdom. Catholics should apologise for the martyrdom of Thomas Cranmer, the 66-year-old Anglican Primate of All England, who was burned at the stake in Oxford under Philip and Mary.

My father, the Commonwealth Crown Solicitor and an adviser to the Australian Council of Churches, was a member of the Australian delegation to the Conference of Paris in 1946. He was among those responsible for including freedom to change religion or belief, as well as freedom to manifest and teach them, in the early drafts of Article 18 of the 1948 Universal Declaration of Human Rights that was adopted and proclaimed by the

United Nations General Assembly on 10 December 1948 with H. V. Evatt in the chair. As the Australian member of the United Nations Commission on Human Rights from the sixth session (1950) to the tenth session (1954), and particularly as the rapporteur for the seventh session (1951) and eighth session (1952), my father helped to develop the principles of the Universal Declaration into the 1966 International Convention on the Elimination of All Forms of Racial Discrimination (ICERD) and the 1966 International Covenant on Civil and Political Rights (ICCPR). After my father's time, the word 'change' was omitted from Article 18 of the ICCPR. On 10 December 1972 I informed the Secretary-General of the United Nations that my Government would ratify the ICERD, which had come into force generally on 4 January 1969. The ICCPR did not come into force generally until 23 March 1976.

The Catholic Church has the oldest and most experienced diplomatic service in the world. Its headquarters are in a Roman enclave established by the 1929 Lateran Treaty as an independent sovereign state called the State of the Vatican City. Italian is the working language. In diplomatic circles the State is called the Holy See. I had noticed that the Holy See constantly and constructively participated in the work of the United Nations and its specialised agencies and many international governmental organisations. Paul VI made a plea for peace at the United Nations General Assembly on 4 October 1965, the feast of St

Francis of Assisi, and he addressed the International Labour Organization in Geneva in June 1969 during the 50th anniversary celebrations of its establishment by the Treaty of Versailles. I had noticed that there were apostolic pro-nuncios in many neighbouring countries, even where their populations were predominantly Muslim (Indonesia, Bangladesh, Pakistan) or Hindu (India) or Buddhist (Sri Lanka, Thailand). There were also pro-nuncios in Japan and Korea.

The Holy See is one of the few States in the world and the only State in Europe to retain diplomatic relations with Taiwan. In 1934, together with Germany, Italy and Japan, it recognised the puppet Emperor of Manchukuo. When Russia delivered Manchuria to the Chinese Communists at the end of the Pacific War, Chiang Kai-shek accepted an apostolic pro-nuncio, who moved to Taipei after the fall of Beijing. The senior Australian at the Vatican, Cardinal (1991) Edward Cassidy, was the pro-nuncio from 1970 to 1979 and accepted a Taiwanese decoration. I have met the Bishop of Shanghai, a Jesuit, at civic receptions in Shanghai, at his residence and seminary in the suburbs of Shanghai and at St Ignatius' College in Sydney. The Church appears to maintain informal contacts with him through Jesuits in Belgium.

Since the prime ministers of the United Kingdom and, with the exception of J. F. Kennedy, the presidents of the United States had not been Catholics, those countries, and therefore

Australia, had never established diplomatic relations with the Holy See. To the Church in those countries the Holy See sent representatives called apostolic delegates. On 17 February 1973, on a flight from Canberra to Melbourne, I raised the subject with the Archbishop (1961) of Baltimore, Cardinal (1965) Lawrence Joseph Shehan.[9] I was proceeding with two Polish members of my staff, Peter Wilenski and Jim Spigelman, to a scientific congress celebrating the 500th anniversary of the birth of Copernicus. The cardinal was proceeding as Paul VI's legate to the 40th International Eucharistic Congress, the second to be held in Australia. Among those attending were Mother Teresa, an Albanian Catholic born in 1910 in Skopje, and Cardinal (1967) Karol Wojtyla, the Archbishop (1964) of Kraków, born in 1920 in Wadowice, 50 kilometres southwest of Kraków and 30 kilometres south of Oswiecim (Auschwitz). He is now Pope John Paul II.

An Apostolic Delegation to the Catholic Church in Australia had been established by Saint Pius X (1903–14) on 16 April 1914. Archbishop Bonaventura Cerretti, the first Apostolic Delegate (1914–17), returned in September 1920 as a cardinal and legate of Pius XI for the 29th International Eucharistic Congress, held in Sydney in association with the dedication of the completed St Mary's Cathedral. Like all his successors, except the Dutch aristocrat Cardinal (1967) Maximilien de Furstenberg (1960–62), he was an Italian. On 5 March 1973 Paul VI

changed the Apostolic Delegation to an Apostolic Nunciature to Australia.[10]

At that time, 69 states had diplomatic relations with the Holy See; 176 states have them now. Nuncios were accredited to states which recognise them as deans of the diplomatic corps and pro-nuncios to states which do not so recognise them. This distinction was abolished for appointments after 1993.

The Holy See refuses to accept credentials from an ambassador who is also accredited to Italy. When the Department of Foreign Affairs recommended John McMillan, our ambassador to Turkey, I endorsed the papers: 'Let McMillan have the Sublime Porte and the Holy See. Give him letters to the Caliph and the Pontiff.' The Fraser Government reduced McMillan's travel vote and thus precluded him from carrying out his duties in Rome. In 1983 the Hawke Government accredited the admirable Sir Peter Lawler as ambassador to both Ireland and the Holy See. My Government had appointed him as head of the Department of the Special Minister of State in 1973; in the previous 23 years, Liberal–Country Party Governments had never appointed a Catholic as head of a department.

On Good Friday 1973 Margaret and I dined and stayed at Windsor Castle with Elizabeth II, the Head of the Church of England on earth. (The Queen had visited John XXIII in 1961 and would visit John Paul II in 1980 and 2000.) On Holy Thursday I was received in private audience by Paul VI, Supreme

Pontiff of the Universal Church. When we exchanged gifts, his was the splendid facsimile edition of the Vatican's oldest manuscript of the *Divine Comedy*, published in 1965 to mark the 700th anniversary of Dante's birth. He gave it to me because, as he said, 'We are told you are a humanist'. The word was a considerable consolation to me. During the 1972 election campaign, the DLP, having seen the futility of describing me and other Labor leaders as communist stooges, had taken to condemning us as humanists. The Pope, of course, used the term in the correct and original sense. His gift is now in the National Gallery of Australia.

On 29 March 1975, in view of the cordial relations between the Holy See and the Orthodox churches, Margaret and I thought it appropriate to invite Dr T. V. Cahill, the Catholic Archbishop of Canberra and Goulburn, to lunch at the Lodge in Canberra with Archbishop Stylianos, the newly appointed Primate of the Greek Orthodox Church in Australia.

During the Second Vatican Council Paul VI ordered a new edition of the *Vulgate*. While I was studying Latin at the University of Sydney I had bought a *Vulgate* New Testament edited in 1911 by John Wordsworth (1843–1911), Bishop of Salisbury and grand-nephew of the poet William Wordsworth. I then bought the edition of the complete Bible published in 1590 by Sixtus V and corrected by Clement VIII (1592–1605) in 1592. My copy was produced with the imprimatur of Georges Darboy

(1813–71), the Gallican Archbishop of Paris who, while a hostage of the Communards, was shot by a firing squad of teenagers. The new edition of the *Vulgate* was published by John Paul II on 25 April 1979. On 20 May, Australia's ambassador to Italy met Margaret and me at Rome airport on our way through to Palermo. I asked him if he would mind getting me a copy of the new edition on our return. He seemed to take some satisfaction in reminding me that I had established an embassy to the Holy See and would be happy to pass my request on to it.

There is anecdotal evidence that Catholics in Australia and Europe disregard Paul VI's encyclical *Humanae vitae* (1968), but they should honour and pursue his work in reconciling Catholic and Orthodox Christians.

POPE JOHN PAUL II

John Paul II is the first non-Italian to be elected pope since Adrian VI, who came from the Spanish Netherlands, and the youngest to be elected since Pius IX. While Paul VI visited most of the English-speaking parts of the world, in 1982 John Paul II made the first visit by a reigning pope to England itself. He made a second visit to Australia in 1986, when he issued a notable pronouncement on Aboriginal rights in Alice Springs, and a third visit in 1995.

John Paul II's name recalls John XXIII and Paul VI, but, as an aggressively Catholic Slav, he is scarcely as well qualified or disposed as they were to pursue reconciliation between the Western and Eastern churches. In October 1998 he beatified Aloysius Stepinac, who was Archbishop of Zagreb during World War II.[11] The popes claim to be Supreme Pontiffs of the Univeral Church and Patriarchs of the West. In Eastern Europe more emphasis is given to the latter claim. After the disintegration of the Soviet bloc and the Socialist Federal Republic of Yugoslavia, the greatest religious tension in Australia was between families who migrated from eastern Europe. Catholics and adherents of religious bodies which have descended or deviated from the Catholic Church forget, but should acknowledge, that the Orthodox churches prevented most of Eastern Europe being converted to Islam.

John Paul II has reigned longer than any pope since Pius IX. I would not be alone in deploring many of the population policies he has advocated but in admiring many of the initiatives he has taken with other faiths, with other Christians and in many countries. In February 1984 he revised the Lateran Treaty which Pius XI (1922–39) had negotiated with Mussolini in February 1929; Catholicism ceased to be the official State religion in Italy. He joined the Chief Rabbi at prayer in a synagogue in Rome in April 1986, and the Holy See engaged in discussions with Israel. (Diplomatic relations were established between the

Holy See and Israel in December 1993.) In 1992 the Church formally acknowledged its error in condemning Galileo Galilei. The Anglican–Roman Catholic International Commission issued its most recent report, *The Gift of Authority*, in May 1999. In October that year, Catholics and Lutherans signed an International Joint Declaration on the Doctrine of Justification in Augsburg, the scene of protracted disputes between 1539 and 1555. The pope himself has protested at the imposition of the death penalty in many countries.

In January 2000, as part of his 81st International Pastoral Visit, the pope forthrightly condemned the excesses in the relations between Cuba and the US. He received Yasser Arafat in the Vatican in February and an agreement was signed between the Holy See and the Palestine Liberation Organization. In preparation for the Third Millennium and as the highlight of the Jubilee Year 2000, on 7 March the International Theological Commission issued the statement Memory and Reconciliation: the Church and the Faults of the Past. Between 20 and 26 March John Paul II visited sites sacred to Jews, Christians and Muslims in Jordan, Israel and Palestine.

On 21 February 2001 the pope created the largest number of cardinals in history; among them was Professor Avery Dulles SJ, son of John Foster Dulles, US Secretary of State (1953–59). Between 4 and 9 May the pope followed the steps of St Paul in Athens, Damascus and Malta. In Athens he made

a common declaration with the Archbishop of Athens and all Greece and delivered a homily in the Sports Palace in the complex of the Olympic Centre. In Damascus he delivered a homily in Abbassyin Stadium and met the Greek–Catholic Patriarchate, the clergy, religious and laity of the Orthodox and Catholic churches and the Muslim leaders. He visited the Omayyad Great Mosque, where there is a shrine of St John the Baptist, a precursor of Christ and one of the Prophets recognised by Islam. At the Greek–Catholic church on the Golan Heights he gave an address with the prayer: 'May all believers find courage to forgive one another, so that the wounds of the past may be healed and not be a pretext for further suffering in the present.' In June the pope visited Ukraine to encourage the Eastern rite Catholics. In September he visited Armenia to celebrate its 1700 years as the world's first Christian State. In November he expressed the unreserved apologies of the bishops of Oceania for the shameful injustices done to indigenous people, especially where children were forcibly separated from their families.

UNESCO

I presented my letter of appointment as Australia's permanent delegate to Unesco in August 1983. Angelo Giuseppe Roncalli

had been the Holy See's permanent observer at Unesco from 1952. He went on to be a cardinal and Patriarch of Venice in 1953 and Pope John XXIII in 1958.

At the General Conference of Unesco in November 1983, I supported a report on educational and cultural institutions in the Occupied Arab Territories. I urged Israel to remember the book of Jeremiah (Chapter 7, Verses 6 and 7): 'If ye oppress not the stranger, then will I cause you to dwell in this place, in the land that I gave to your fathers, for ever and ever.' Monsignor Renzo Frana, the Holy See's permanent observer at Unesco, warmly congratulated me. I realised that representatives of the Catholic Church, the only church with a significant number of adherents in all continents, could especially help in promoting Unesco's charter in education and culture. Frana was the observer at the 1985, 1986 and 1987 sessions of the World Heritage Committee.

Between 12 and 16 December 1983, I chaired the international conference in Bangkok which adopted the Regional Convention on the Recognition of Studies, Diplomas and Degrees in Higher Education in Asia and the Pacific, the sixth and last of the Unesco regional conventions on higher education. Before going to Bangkok I discussed the procedure with Frana, since the Holy See had acceded to the 1974 convention for Latin America and the Caribbean and had ratified the 1979 convention for the States belonging to the Europe Region. After

Bangkok, he pointed out to me that countries outside Europe could accede to the Europe Convention as soon as twenty States in Europe had ratified it. This number was achieved in May 1985. Australia acceded to the Asia and Pacific Convention in September 1985. The United Kingdom ratified the Europe Convention in October 1985. Susan Ryan, the Australian Minister for Education, authorised me to attend the Regional Committee for Europe in Bucharest in May 1986 and she authorised Australia's accession to the Europe Convention in August 1986.

While not a churchgoer, I have visited hundreds of cathedrals, abbeys and monasteries. On 5–9 December 1983, I attended the seventh session of the World Heritage Committee, which implements Unesco's 1972 Convention for the Protection of the World Cultural and Natural Heritage. The Convention is the origin of all the national laws on heritage and environment in Australia. In August 1974, on my initiative, Australia became the seventh State to ratify the Convention, the United States having been the first to do so. Italy ratified the Convention in June 1978 and the Holy See acceded to it in October 1982. In 1983 the Committee met in the favourite country villa of Lorenzo il Magnifico at Poggio a Caiano outside Florence. It had already inscribed four Italian sites on the World Heritage List: the Rock Drawings in Valcamonica in 1979, the Historic Centre of Rome and the buildings with *The Last Supper* in Milan in 1980, and

the Historic Centre of Florence in 1982. In Florence in 1983 the observer from the Holy See, Archbishop Ernesto Gallina, discussed with me the proposal to nominate Vatican City for inscription on the List. It was the beginning of a fruitful friend- ship which gave me access to the museums, institutes and academies in Rome and the Vatican City throughout my time at Unesco.

I was a member of the Committee from 1983 to 1989. Gallina and I attended the eighth session in Buenos Aires in October 1984, when the Vatican City was inscribed. He was also the observer at the 12th session in Brasilia in 1988 when the Com- mittee noted that the four great Roman basilicas were the property of the Holy See, which has extra-territorial rights over them. They were not covered by the earlier inscriptions of the Historic Centre of Rome and the Vatican City.

Gallina was the Holy See's observer at the 14th session in Banff in December 1990. It was the only session to which Australia has not sent a delegate or an observer. At that meeting the Committee amended the 1980 inscription of the Historic Centre of Rome to include the eleven properties of the Holy See enjoying extra-territorial rights in Rome together with San Paolo fuori le Mura (St Paul's Outside the Walls). This church is of especial interest to the Anglican community because, before the Reformation, the King of England was *ex officio* a canon and the abbot was invested with the Order of the Garter. It was also

here that the first encounter between the leaders of the Catholic and Anglican churches since their separation in 1534 occurred in March 1966, when Paul VI and Archbishop Michael Ramsey of Canterbury performed a service and issued a joint declaration of amity. The Anglican–Roman Catholic International Commission was established as a result of this declaration.

In Bangkok, between 12 and 15 February 1990, I chaired the first session of the Regional Committee responsible for promoting the application of the Regional Convention on Higher Education in Asia and the Pacific. Gallina was the Holy See's observer. The Holy See acceded to the Convention in July 1995.

On 24 February 1958 the Holy See acceded to Unesco's first cultural property instruments, the Convention and Protocol for the Protection of Cultural Property in the Event of Armed Conflict (The Hague, 1954). Italy ratified them on 9 May 1958. At the Unesco General Conference in October 1983 Susan Ryan announced that Australia proposed to become a party to the 1954 instruments. (Australia ratified the Convention alone on 19 September 1984.) There are now 101 States party to it. Due to bungling by other ministers and their bureaucrats Australia is one of 18 countries which have not become parties to the Protocol.

A Second Protocol to the Hague Convention of 1954 was adopted at The Hague on 26 March 1999 and was opened for signature between 17 May and 31 December 1999. The Holy

See and Italy were among the first States to sign on 17 May; 39 had signed by 31 December. Anticipating pressure from the United States and the United Kingdom, the Howard Government has not signed it. Since Australia has contributed to many peace-keeping forces, its absence from both Protocols is conspicuous and unconscionable.

OPERA

ON 19 JUNE 1843, at Sydney's Victoria Theatre, Rossini's *Barber of Seville* was the first Italian opera performed in Australia. It was one of the first operas performed in the Sydney Opera House 130 years later.

Under *le nouveau régime* Elizabeth II, by the Grace of God of the United Kingdom, Australia and Her Other Realms and Territories Queen, Head of the Commonwealth, Defender of the Faith, arrived in Australia to open the Sydney Opera House. She was welcomed by Governor-General Sir Paul Hasluck and Lady Hasluck and Margaret and me on her arrival by Qantas Boeing 707 at Canberra airport on Wednesday afternoon 17 October 1973. On Friday the Queen lunched at The Lodge. That afternoon she attended a meeting with the Executive Council and assented to the *Royal Style and Titles Act 1973*. In the evening Elizabeth II, by the Grace of God Queen of Australia and Her other Realms and Territories, Head of the Commonwealth, was met by Margaret and me at the Canberra Theatre,

where we attended a performance of *Carmen* by the Australian Ballet Company.

On Saturday afternoon the Queen opened the Sydney Opera House on Bennelong Point and attended a performance of Beethoven's Ninth Symphony by the Sydney Symphony Orchestra in the Concert Hall that evening. Together with her lady-in-waiting and her assistant private secretary, the Australian William Heseltine, she lunched with Margaret at Kirribilli House on Monday. In the evening the Queen attended a performance of Mozart's *The Magic Flute* by the Australian Opera in the Opera Theatre. After the performance she was farewelled at Sydney airport by Premier Sir Robert Askin and Lady Askin, the Whitlams, Governor Sir Roden Cutler VC and Lady Cutler and the Haslucks before leaving for home in her Qantas aircraft.

There is no site in Australia more recognised around the world than the Sydney Opera House. There is no more historic site in Australia. To the west in Circular Quay Arthur Phillip, the first governor of New South Wales, pledged his allegiance to George III, King of Great Britain, France and Ireland and raised the combined flag of St George and St Andrew in January 1788. In February 1954, to the east in Farm Cove, our first reigning monarch landed in Australia. Premier Cahill proposed to meet her when she came ashore and to present to her his ministers, the archbishops and the Supreme Court judges, including my father-in-law. Prime Minister Menzies intercepted

her at a pontoon, where he presented his ministers before Cahill made his presentations. Thereafter Cahill conducted the Queen from the pontoon across a bridge to the shore.

In 1973 the Queen could not fail to have noticed the changes in Sydney since her visit in 1954. In 1973 she arrived in a Federal Territory. In Australia her title named only Australia. There was the Sydney Opera House and the Australian Opera. She may not have realised how much her 1954 visit had caused the changes which came about before her 1973 visit. The idea of an Australian Opera arose from questions in Parliament about the Musica Viva Society and the National Theatre Movement in 1951 and 1952.

—ഐൊ—

At question time on 20 November 1951 the leader of the Opposition, Dr H. V. Evatt, asked Menzies whether it was possible to enable the important work of the Musica Viva Society to continue. Menzies replied:

This matter has been mentioned to me recently. I shall examine it and discuss it with the Treasurer. I cannot profess to be very familiar with it and I am not aware of any specific request that has been made, but I shall certainly look into the matter.

On 28 November Menzies arranged for a Liberal backbencher, Fred Osborne, to ask him a question on the subject.

Evatt, however, being the Leader of the Opposition, was entitled to the first call in question time. *Hansard* records the sequence:

Dr Evatt—*Will the Prime Minister tell the House, if possible before the Parliament goes into recess, whether he and the Treasurer have been able to consider the case of the well-known musical society, Musica Viva, and the desirability of giving aid to it in order to enable it to continue its activities? I mentioned this matter on a previous occasion. I trust that the Prime Minister will be able to make a positive announcement in respect of it before the House adjourns for the recess.*

Mr Menzies—*Although I hope that I shall be able to make a statement on the matter to which the right honorable gentleman has referred, I cannot definitely undertake to make it within the period he has suggested but I shall have something to say about it within the next few days.*

Mr Osborne—*I ask the Prime Minister a question supplementary to one that has just been asked by the Leader of the Opposition concerning the future of the Musica Viva Society. Will the Prime Minister give consideration to the fact that this society is now the only notable group regularly engaged in the performance of chamber music in the eastern States, and possibly in Australia? Consequently, if it is allowed to disband, the Australian Broadcasting Commission will probably be obliged to form another such*

group in order to fulfil its obligation to present balanced musical programmes, and it could only do so at a considerable cost and probably at a lower standard than that maintained by the Musica Viva Society. Will the Prime Minister consult the chairman of the Australian Broadcasting Commission on this subject and bear in mind the widespread requests for help to be given to this very meritorious group to save it from disintegrating?

Mr Menzies—*Earlier today the Leader of the Opposition asked me a similar question, and, of course, I thoroughly appreciate the interest in this matter of the honorable member himself. As far as I know, the Government has had no communication from the Musica Viva Society. We therefore have no detailed information of any description about the position of the society, so far as I am aware. I have indicated that the Government will give consideration to such material as it has before it, but I think that it may not be inappropriate to say that the music lovers of this country have themselves some responsibility which is quite independent of the responsibility of the Government.*

Later a Victorian asked Menzies about the National Theatre Movement:

Is the Prime Minister aware of the fine work that the National Theatre Movement is doing in Victoria by providing opportunities for young Australian artists to develop their talents and by promoting public interest in ballet, the opera, and the theatre generally?

Menzies replied:

The remarks that I have already made in respect of the Musica Viva apply to the National Theatre Movement. I have had the opportunity of receiving certain representations on that matter and I have told the House that the Government will give due consideration to them, but I believe that it would be a grave misfortune for the arts in this country if it were thought that they depended entirely upon government patronage.

Menzies never made the statement he foreshadowed in his answer to Evatt on 28 November 1951. On 10 October 1952 a New South Wales member asked Treasurer Arthur Fadden about the establishment of a cultural grants committee on a national basis for the encouragement of art, culture and music and for the ultimate establishment of a national theatre and opera, such as already operated in the Australian Capital Territory. Fadden undertook to bring the matter to the notice of the Prime Minister. On 21 October Menzies provided a written answer:

On the recommendation of the Australian Capital Territory Cultural Development Committee, the Government makes available yearly small grants to cultural organisations in the Australian Capital Territory. The Government has accepted this responsibility for fostering cultural activities in the National Capital, but considers that the extension of assistance of this kind throughout the

Commonwealth is a matter more for the local governments concerned. Various proposals have been received for Government assistance in the establishment of a national theatre and opera, but no decision on this matter has yet been reached.

Where members from both sides of politics, from both Sydney and Melbourne, could not move Menzies, Nugget Coombs could and did. In January 1949 the Chifley Government appointed Coombs Governor of the Commonwealth Bank, the reserve bank. In December the Menzies Government replaced the Chifley Government. Coombs found that Menzies had little interest in any of the arts. Coombs himself, inspired by the example of such bankers as Keynes and the Medici, was interested in the arts. Some of the most fascinating passages in his autobiography *Trial Balance* describe how he persuaded Menzies to endorse the establishment of the Australian Elizabethan Theatre Trust to commemorate the Queen's visit in 1954.

Coombs was appointed chairman of the Trust. By 1965 it was involved in theatre, opera and ballet and received an annual Commonwealth subvention of £460 000, representing 23.67 per cent of its total income from governments, private donations and membership subscriptions.

In November 1954, nine months after the Queen's visit, the Cahill Government called a meeting of all persons and organisations interested in establishing an opera house for Sydney.

The Opera House Committee was elected and considered thirty sites. It recommended Bennelong Point in March 1955. In September Cahill announced an international competition for the design of an opera house and in January 1957 he declared Joern Utzon of Denmark the winner. Construction commenced in March 1959. Opera House lotteries were introduced in November to help meet the cost of construction, and in 1961, the Opera House Trust was created to manage and operate the Opera House.[1] In May 1965 the Askin Coalition Government was elected in New South Wales and in February 1966 Utzon resigned.

In 1962 Margaret and I were at last able to see an Italian opera in Italy. The Australian ambassadors posted to Rome in the 1950s did not take the posting seriously. When the Department of External Affairs was arranging the program for our visit in June 1962 I said we would like to spend an evening at the Baths of Caracalla. Our embassy, assuming that we wanted to see a revue at a nightclub, sent back a cable to ask where it was on. On our last night in Rome we went to the Baths for *Aida*. The stage could comfortably accommodate both horses and elephants, both of which behaved impeccably. The first adequate Australian ambassador arrived in Rome in September. There have been very good ones ever since and we have enjoyed performances

in most of the opera houses from Milan and Venice through Florence and Rome to Naples and Palermo.

In 1965 the great theatrical entrepreneur, J. C. Williamson Ltd, aspired to repeat the triumph of the Melba–Williamson operatic tours of 1924 and 1928 in a Sutherland–Williamson season. I can remember the visit of Toti Dal Monte (1893–1975), the coloratura soprano who excelled in the roles of Gilda in Verdi's *Rigoletto*, Lucia in Donizetti's *Lucia di Lammermoor* and Amina in Bellini's *Sonnambula*, in all of which Melba herself had excelled. Dal Monte's wedding to the tenor Enzo de Muro Lomanto at St Mary's Cathedral in 1928 was the most spectacular in Sydney's history. She wrote an autobiography in 1962, *Una voce del mondo*. Joan Sutherland's autobiography, *A Prima Donna's Progress*, was published by Random House 35 years later.

Joan Sutherland had left Sydney for London in 1951 and married the pianist Richard Bonynge there in 1954. He was an outstanding trainer of voices. Under his guidance she developed the coloratura possibilities of her voice, securing enormous success in Franco Zeffirelli's production of *Lucia* at Covent Garden in 1959. She had similar success in her debut at La Scala in Milan in 1961. (Every diva must learn Italian, and she did.) Richard Bonynge made his debut as a conductor in Rome in 1962.

Years of triumphs followed in Paris, Vienna, Milan and Hamburg and throughout the United States. For the 1965 tour of Australia, Sutherland took Melba's and Dal Monte's roles of

Gilda, Lucia and Amina as well as Violetta in Verdi's *La Traviata* and Marguerite in Gounod's *Faust*. Bonynge had assembled a formidable cast of young English, American and Australian singers and a sole Italian, Luciano Pavarotti. Sutherland sang in 43 performances in Melbourne, Adelaide, Sydney and Brisbane. She was more rapturously received in Melbourne than anyone since Melba. I first met Sutherland and Bonynge during the 1965 tour in Sydney, their birthplace, at a reception given in their honour by my friend John Armstrong, the Lord Mayor and former Senator (1938–62). Unfortunately, the five performances when she did not sing and the two operas in which she did not appear were unsuccessful.

In January 1966 Menzies retired and was succeeded by Harold Holt, the son of a theatrical entrepreneur. Holt enthusiastically responded to the Trust's decision to recommend the establishment of a Federal agency to assume those of its functions most closely involved with government.

Coombs persuaded Claudio Alcorso, who had been a director of the Australian Elizabethan Theatre Trust since 1965, to become the foundation chair of the Australian Opera. Alcorso (Milan 1913–2000 Hobart), was a highly qualified businessman who had migrated from Italy to Sydney in 1937 and had been interned as an enemy alien from 4 July 1940 to the end of 1943.[2] His first task after being appointed chairman was to put together a

board with professional skills and international links. He recruited the Queen's cousin, Lord Harewood, who had become an enthusiast for Italian opera when he was wounded and taken prisoner of war in Italy.[3] Lord Harewood, who had edited and revised *The Complete Opera Book* of Gustav Kobbé since 1954, was the ideal person to bring professional competence to the board and at the same time provide a window on the world of opera.

On 1 November 1967 Holt established the Australian Council for the Arts as the Government's 'financial agent and adviser on the performing Arts and other activities connected with the Arts in general'. Holt drowned on 17 December 1967 and on 10 January 1968 the Liberal Party chose John Gorton to succeed him.

Coombs retired as Governor of the Reserve Bank and was appointed Chairman of the Council for the Arts. He soon discerned Gorton's belief in the political importance of the arts but his interest in films alone. Alcorso asked Coombs to arrange a meeting between Gorton and Lord Harewood which he hoped would enable the Prime Minister better to realise the kind of support necessary to reach international standards of excellence. Coombs discussed the request with Dr Jean Battersby, executive officer of the Council, and they invited Mr and Mrs Gorton to dine with Lord and Lady Harewood. The unhappy outcome is recorded by Coombs in *Trial Balance* and by Alcorso in his autobiographical memoir *The Wind You Say*, which I launched in April 1993.

William McMahon replaced Gorton as Prime Minister on 10 March 1971. He and his wife Sonia accepted Alcorso's invitation to the opening of the Opera season with Verdi's *Nabucco* at the Elizabethan Theatre in Newtown and to supper afterwards. Alcorso planned to take the opportunity to plead for an increase in subsidy. He asked Sir Ian Potter, who had succeeded Coombs as chairman of the Trust in 1963, and Jean Battersby and their spouses to join the party and help the cause. The star bass Donald Shanks, scheduled to sing the role of the High Priest, was struck by laryngitis and mimed in the centre of the stage while a chorister sang at one side of the proscenium. Alcorso records that the result was pathetic. At supper he was inspired to say to the Prime Minister:

Mr McMahon, within eighteen months we shall open the Sydney Opera House. All the world's critics will be there. The attention of the world will focus on it, as this unique building has captured the imagination of millions. Should something happen, similar to what happened tonight, the world would not laugh at me, it would laugh at you, the Prime Minister of Australia. His answer was immediate: 'come to see me tomorrow morning at nine o'clock, at my office at the Commonwealth Bank'.

The following morning Alcorso and Battersby were promptly ushered into McMahon's office. Alcorso stated the Australian Opera's case and Battersby supported it on behalf of the Australia

Council. They left ten minutes later with a promise that their request would be met. Their subsidy was doubled. On 20 September 1972 McMahon informed the House of Representatives that the Queen had accepted his invitation to make a short visit to open the Opera House on 20 October 1973.

Alcorso did not recruit Lord Harewood alone. He secured Tito Gobbi during the first two years of the Australian Opera's independent life and Carlo Felice Cillario as guest conductor for four years. He brought several good Australian voices back to Australia and staged Gilbert and Sullivan operas, which had sustained the firm of J. C. Williamson Ltd. He employed good accountants and staff, increased the membership and canvassed for sponsorships. The Australian Opera had attained good international standards when he retired in July 1974.

In 1973 Alcorso conveyed a message to Sutherland that the significance of the Sydney Opera House would not be complete if the voice of Australia's most renowned singer did not resound under its vaults. He realised it was too late for her to make arrangements for the opening season, but she could be the star of the following season. The company would stage an opera of her choice. She selected Offenbach's *Tales of Hoffman* and volunteered to sing the four soprano roles. Bonynge was to conduct the eight performances. On 24 April they performed *La Traviata* in the circus arena of the Teatro Nacional de São Carlos in Lisbon. At two o'clock the following morning the Carnation

Revolution broke out and detained them for some days. Their first performance in Sydney was on 13 July 1974. After her concluding performance on 27 July the star and the conductor crossed the harbour to have supper with us at Kirribilli House. In June 1975 Joan Sutherland was appointed one of the initial Companions in the Order of Australia. (Menzies had made her a CBE in 1961, Fraser made her a DBE in 1979 and the Queen gave her the Order of Merit at Admiralty House, next to Kirribilli House, in 1992.)

The opportunities for future performances by Joan Sutherland and Richard Bonynge in Australia were soon apparent. In 1976 she sang and he conducted eleven performances of Delibes's *Lakmé* in July and August in the Sydney Opera House. They gave a recital in Government House, Sydney, and he gave a piano recital in Adelaide and Canberra. In 1977, they presented Verdi's *Lucrezia Borgia* and Puccini's *Suor Angelica* in the Opera House in June and July. They gave a concert benefit for the NSW Societies for Crippled Children and Deaf and Blind Children. In 1978 they presented Lehar's *The Merry Widow* in the summer season and Bellini's *Norma* in the winter season in Sydney. In 1979 they were in Australia from 9 February to 9 April and from 4 July to 18 August. They performed five operas, *The Merry Widow* (Sydney, Adelaide and Melbourne), *Norma* (Brisbane), *La Traviata* (Melbourne and Sydney) and Mozart's *Idomeneo* (Sydney) and *Don Giovanni* (Melbourne). In the

Sydney Opera House on Australia Day 1980 they gave an opera concert in which she appeared with other Australian singers in the highlights from Bellini's *I Puritani*, Donizetti's *Maria Stuarda*, Coward's *Bitter Sweet, Rigoletto* and Rossini's *Semiramide*. They performed *Lucia* in February, and Verdi's *Masnadieri* in Sydney and *Lucia* in Sydney, Melbourne and Adelaide between July and November. In 1981 they performed Verdi's *Otello, La Traviata* and Meyerbeer's *Les Huguenots* in Sydney and *Otello* in Melbourne. In 1982 they made their first appearance in the Sydney Domain in *La Traviata*. In the Opera House they presented *Lucrezia Borgia* in February and March and Johann Strauss II's *Die Fledermaus* from June to August. Bonynge gave a concert in Perth in March.

By 1983 the Sydney Opera House was a focus of attention for Australians and visitors to Australia. Not only Australian singers but talented European and American singers were eager to appear with Sutherland and Bonynge. In January they presented *Die Fledermaus* in the Domain and the Opera House and a concert with Pavarotti and Handel's *Alcina* in the Opera House. Australians now realised, as Europeans had known for over two decades, that Sutherland excelled not only in Rossini, Donizetti, Bellini, Verdi and Puccini but also in Handel.

Georg Friedrich Händel (Halle 1685–1759 London) studied and prospered in Florence, Rome, Naples and Venice between 1706 and 1710. In Rome in 1709 he tied in a harpsichord

contest with his contemporary Domenico Scarlatti (Naples 1685–1757 Madrid). He brought oratorio and opera to England when London was the most populous city in the world. He was naturalised in London as George Frideric Handel in 1727. His operas depended on two unique Italian contributions, libretti and castrati (see Appendix 3). (In England there were more Italian castrati under George I and II than Italian ecclesiastics under Henry VII and VIII.) *Alcina* was first performed at Covent Garden in 1735 with the castrato Giovanni Carestini as Ruggiero. It was staged often during the following two years. The next performance in England did not take place unitl 1957 with Sutherland as Alcina. She had enormous success in Franco Zeffirelli's production of *Lucia di Lammermoor* at Covent Garden in 1959. In 1960 Zeffirelli produced *Alcina* at La Fenice in Venice with Sutherland as Alcina. Bonynge made his Italian debut playing the harpsicord on stage in period costume. After three triumphant performances Sutherland was hailed throughout Italy as La Stupenda. In 1961 she made her debut at La Scala in Milan in *Lucia*. At the Albert Hall in London in July 1968, Sutherland and Bonynge performed in Handel's *Messiah* in aid of the National Portrait Gallery's appeal for funds to purchase Handel's portrait by Thomas Hudson (1701–79). The Gallery presented La Stupenda with a framed lithograph of Handel's statue in Vauxhall Gardens.[4]

In March 1983 the Australian Labor Party won the Federal

elections. At the suggestion of the Foreign Minister, Bill Hayden, Prime Minister Bob Hawke invited me to be Australia's permanent delegate to Unesco in Paris. It was not long before I comprehended the standing of Handel and Sutherland in Europe. The member states of Unesco often propose the international commemoration of the centenaries of great cultural figures. At the General Conference in October–November, Italy and the German Democratic Republic proposed the tercentenaries of the birth of the composers Scarlatti, Handel and Johann Sebastian Bach (Eisenach 1685–1750 Leipzig). At all international gatherings the delegates of Australia sit next to the delegates of Austria (Autriche). The Austrian delegate to Unesco, a grandson of the Emperor Franz Josef, enthused about Joan Sutherland's superlative versions of *Die Fledermaus* and *The Merry Widow*. There were many Handel seasons in the world's opera houses in 1985. The Australian Opera presented his *Giulio Cesare* (1724) in 1993 with the Australian counter tenor Graham Pushee in the title role.

Sutherland and Bonynge later introduced a number of operas to the Australian Opera's repertoire. Cilea's *Adriana Lecouvreur* (the first with surtitles) and Verdi's *Il Trovatore*, with a set designed by Sir Sidney Nolan, were staged in 1983, Poulenc's *Les Dialogues des Carmelites* in 1984, Bellini's *I Puritani* in 1985 and Donizetti's *La Fille du Régiment* in 1986. They performed

The Merry Widow in Sydney during the Australian Bicentennial Celebrations in January and February 1988.

In June 1989, Sutherland appeared in and Bonynge conducted *Lucrezia Borgia* at the Théâtre des Champs Elysées in Paris. As the Président d'Honneur du Conseil National Australien pour la Célébration du Bicentenaire de la Révolution Française I was in attendance when the French Government made Joan Sutherland a chevalier de l'Ordre des Arts et des Lettres.

In October and November 1989, I led the Australian delegation to the General Conference of Unesco for the last time. The Austrians urged an international commemoration of the bicentenary of the death of Mozart (Salzburg 1756–91 Vienna). Accordingly, in 1991 the Australian Opera presented his three operas with libretti by Lorenzo Da Ponte (Ceneda 1749–1838 New York), *Le Nozze di Figaro*, *Don Giovanni* and *Così fan tutte,* and his *La Clemenza di Tito* with the libretto by Pietro Metastasio (Rome 1698–1782 Vienna).

Joan Sutherland and Richard Bonynge retired from the opera stage after performing Meyerbeer's *Les Huguenots* in the Sydney Opera House between 3 September and 2 October 1990. The public gave overwhelming ovations to the Australian singer who had made as great an impact in the world of opera as Melba and had given sustained support to the Australian Opera. My final appearances with her took place in Monte Carlo two years later in support of Sydney's bid for the Olympic Games 2000.

—ᐸᔊᐳ—

The first opera on an English historical theme was *Riccardo Primo, Re d'Inghilterra*, composed by Handel for the coronation of George II in 1727. A patriotic opera on the conquest of Cyprus, the libretto was written by Paolo Antonio Rolli (Rome 1687–1765 Todi), who had an illustrious career in England between 1715 and 1744. Like Pietro Metastasio, he was one of the great Italian poets of the eighteenth century. He was tutor to the children of the Prince of Wales, later George II, and the Italian secretary to the Royal Academy of Music and wrote libretti for Handel, Scarlatti and other composers. In England he edited many Italian classics, such as Boccaccio's *Decameron* and Guarini's *Pastor Fido*, and translated English works, such as Milton's *Paradise Lost*, a play by the essayist Richard Steele, and Hamlet's soliloquy 'To be or not to be', the first Italian translation of Shakespeare. The first Italian opera on an English literary theme was *La buona Figliuola* (1760), composed by Niccolò Piccinni (Bari 1728–1800 Passy). The libretto was written by Carlo Goldoni (Venice 1707–93 Paris) and based on Samuel Richardson's epistolary novel, *Pamela, or Virtue Rewarded* (1740).

Britain's participation in Italian politics during the Revolutionary and Napoleonic wars revived an interest in British history and literature among Italians. Gioachino Rossini responded with his operas *Elisabetta, regina d'Inghilterra* (1815),

Otello (1816), based on Shakespeare's play, and *La donna del lago* (1819), based on Sir Walter Scott's poem *The Lady of the Lake*. Vincenzo Bellini's *I Capuleti e I Montecchi* (1830) was freely adapted from Shakespeare's *Romeo and Juliet* and his *I Puritani* (1835) was derived from Scott's *Old Mortality*. Gaetano Donizetti composed eight operas with British themes: *Alfredo il Grande* (1823); *Elisabetta al castello di Kenilworth* (1829) based on Scott's *Kenilworth* (1821); *Anna Bolena* (1830) about the second wife of Henry VIII and mother of Elizabeth I; *Rosmonda d'Inghilterra* (1834) about Henry II's mistress; *Lucia di Lammermoor* (1835) based on Scott's *The Bride of Lammermoor* (1819); *Maria Stuarda* (1835) based on a play by Johann Christoph Friedrich von Schiller; *L'assedio di Calais* (1836) about Edward III's siege of Calais; and *Roberto Devereux, ossia Il conte d'Essex* (1837) about the suitor of Elizabeth I. In the 1950s Maria Callas and Joan Sutherland triumphantly restored *Anna Bolena* and *Lucia di Lammermoor* to the world's opera houses.

Giuseppe Verdi's first and lost opera *Rocester* (1836) is thought to have featured Charles II's rakish courtier and the paragon of English erotic poets, John Wilmot (1647–80), the second Earl of Rochester, who was in Italy from 1661 to 1664. The hero of his *Aroldo* (1857) is an English knight returning from the Third Crusade. *Macbeth* (1847, revised 1865) is based on Shakespeare's play and *Il Corsaro* (1848) on Byron's poem. His last operas, *Otello* (1887) and *Falstaff* (1893), had superb libretti adapted

from Shakespeare by Arrigo Boito (Padua 1842–1918 Milan), who received honorary doctorates in music from both Cambridge and Oxford.

French and German dramatists often took liberties with the historical characters who feature in Italian operas. In Verdi's *Les Vêpres Siciliennes,* commissioned for Napoleon III's Universal Exposition in Paris in 1855, the librettist Eugène Scribe (Paris 1791–1861 Paris) embellished the story of the rising against the French in Palermo on 30 March 1282. He cast Guy de Montfort, the grandson of King John of England, as governor of Palermo under Carlo I (1226–85), who had been the Angevin King of Sicily since 1266. (In the Italian version, *I Vespri Siciliani,* first performed in Parma later in 1855, he is Guido de Monforte.) Guy de Montfort would not have been governor of Palermo in 1282. He had murdered another of John's grandsons in Viterbo in 1271 and—under pressure from a third grandson, King Edward I of England, and King Carlo—had been excommunicated and outlawed by the Blessed (1713) Gregory X (1272–76) in Orvieto in 1273. He was pardoned, however, in 1283 by Martin V (1281–85), the fifth Pope after Gregory X. Some basic distortions were also written into two dramatic operas by Donizetti. *Lucrezia Borgia* is based on a tragedy by Victor Hugo. Lucrezia was never involved in an *orgia* and never had a child out of wedlock.[5] In *Maria Stuarda* Mary Queen of Scots calls

Elizabeth Tudor a bastard to her face. The two queens never met. All of them, however, are great operas.

That Australians of all backgrounds can enjoy the great operas is largely due to the talented Australians who have become famous overseas and to talented Italians who settled in Australia before the end of the 20th century.

ARTS AND ARCHITECTURE

ANCIENT GREEK SCULPTURE AND architecture were embraced by the Romans. Italians are responsible for the style of most of the European art and architecture with which Australians are familiar. The art and architecture mostly came to Australia through Britain.

THE ENGLISH CONNECTION

England's connection with Italian art begins in the 13th century. The earliest Italian art work in England was installed in Westminster Abbey in London by two Cosmati workers, the Roman Oderisio and his son Pietro, whom Henry III commissioned in 1268 to erect the shrine of Edward the Confessor and the tomb-chests for himself and his children. The finest Renaissance monuments in England are the effigies of Henry VII and his wife which Henry VIII commissioned the Florentine

Pietro Torrigiano to make for their tombs in Westminster Abbey (1512–18). Brilliant portraits of the king and his family and courtiers were made between 1526 and 1528 and after 1532 by Hans Holbein the Younger (Augsburg 1497/98–1543 London), who had visited the Italianate French court in 1524 and may have visited northern Italy. Cardinal Wolsey commissioned two Florentine sculptors, Giovanni da Maiano to embellish his palace at Hampton Court and Benedetto da Rovezzano to fashion his tomb. The former's terracotta heads of Roman emperors are still in place and the sarcophagus by the latter is incorporated in Nelson's monument in St Paul's Cathedral, London.

Since Leonardo da Vinci spent his last years, 1516 to 1519, as the guest of François I (1515–47), and since French influence was strong at the court of James V of Scotland (1513–42), Italian architectural designs reached Scotland before England. The first Italian architect in England may have been John of Padua, who is said to have designed the original Renaissance-style home for Protector Somerset in London in 1547–52. John Shute, the first English architect to visit Italy, in 1550, wrote *The First and Chief Groundes of Architecture* (1563) based on Sebastiano Serlio's *Regole Generali di Architettura* (1537–51). Shute's was the first English book to be written on architecture. As Surveyor-General of the Royal Works (1615–43) Inigo Jones inaugurated the architectural profession and, having studied in Italy, brought the Palladian tradition to England. Conspicuous

among his surviving works are the Queen's House at Greenwich and the Banqueting House in Whitehall.

No Italian painters seem to have visited England in the reigns of Henry VIII's children except Federico Zuccari (S. Angelo in Bado 1540–1609 Ancona). In 1574–75 he was able to make a drawing and probably a painting of Elizabeth I but he made very few of the other portraits which are attributed to him. Charles I recruited Orazio Gentileschi (Pisa 1563–1639 London) as his court painter in 1626. His daughter Artemisia (Rome 1593–1653 Naples), the most important woman artist before modern times, spent the last two years of her father's life in London and, like him, made wall paintings for the Queen's House; they are now at Marlborough House, Westminster.

The Baroque portrait and decorative painting styles of Italy were made fashionable in England by the two great Flemish painters. Sir (1630) Peter Paul Rubens, who had worked in Italy between 1600 and 1608, visited London on a diplomatic mission in 1629–30 and received the commission to paint the ceiling of the Banqueting House. His chief assistant, Sir (1632) Anthony Van Dyck, who had spent the winter months of 1620–21 in London and worked in Italy between 1621 and 1627, painted Charles I (1625–49) and his family and courtiers from 1632 to 1634 and again from 1635 till his death in London in 1641. In 1636 he executed a triple portrait of the king as a model for a bust by Gian Lorenzo Bernini. The bust was given by

Urban VIII to Charles I's Catholic queen Henrietta Maria and was destroyed in the Whitehall Palace fire in 1698. A plaster cast has survived.

Judged by their portraits, Charles I, who was only 5'4", and Henrietta Maria, who was even smaller and had buck teeth, would have to be acknowledged as Britain's greatest king and queen. Charles spent more on acquisitions than commissions. In 1627 he confirmed his reputation as a connoisseur by purchasing Mantegna's *Triumphs of Caesar*, still at Hampton Court, and the choicest cameos, paintings and sculptures from Mantua. Patronage of the arts and architecture lapsed in Britain when civil war broke out in 1642 and Charles withdrew from London to Oxford.

In the four years after Charles I's martyrdom in 1649 his art collection, one of the finest in Europe, was disposed of by private sale. Remains of it are still to be found in the principal galleries of Europe and some of the paintings were acquired for the collection of Queen Christina of Sweden. Swedish troops had occupied parts of Prague in 1648 and taken 570 paintings to Stockholm. Queen Christina took 750 paintings and her books and manuscripts when she defected to Rome in 1655. She died in her palace, now the Corsini, in 1689 and left all her property to her lover, Cardinal Decio Azzolini.

Charles I's younger son James (both as Duke of York and King) and his wife Mary of Modena employed Benedetto

Gennari the Younger (Cento 1633–1715 Bologna) as painter-in-ordinary in London and Saint-Germain-en-Laye from 1674 to 1692. In this period Gennari produced a very large number of paintings of religious, mythological and regal events. Antonio Verrio (Lecce 1639–1707 Hampton Court) was appointed Court Painter in 1684. He and his French assistant, Louis Laguerre (1663–1721), decorated many famous country houses. From 1699 James II's son-in-law and successor, William of Orange, King William III of England and Ireland (1689–1702) and King William II of Scotland, employed Verrio to decorate Windsor Castle and Hampton Court.

The English had also become interested in Italian gardens. Between October 1644 and May 1646 the diarist John Evelyn (1620–1706), later famous for his gardens at Deptford and Wotton, recorded the splendors of the gardens in Genoa, Florence, Rome, Tivoli, Frascati, Padua and Verona. His gardening encyclopaedia, *Elysium Britannicum*, was first published in 2000.

In 1708 Matteo Ripa, an Italian Jesuit, took ship to China from London. Italian Jesuits, who distanced themselves from the policy of conquest and conversion which had been followed by the Spaniards and Portuguese in the Americas, viewed the Chinese and Japanese as white people, *gente bianca*, who might be treated as equals and trained as priests. Ripa spent a month in London on his way home in 1724. In two three-hour audiences with George I and in conversations with leading citizens

his descriptions of Chinese gardens and pavilions influenced the development of garden landscapes in England.

The English landscape garden was virtually created by William Kent (1685–1748) and his patrons. Kent began studying painting in Rome in 1709. He became interested in architecture in 1714 when he met Richard Boyle (1694–1753), 3rd Earl of Burlington and 4th Earl of Cork (1704), and Thomas Coke (1697–1759), later Baron Lovel (1728) and Earl of Leicester (1744), on their Grand Tours. In 1719 Kent returned to England for life-time employment with Burlington. Nicknamed the 'signior' and Kentino, he soon turned from decorative painting in town houses (Burlington House and Kensington Palace) to Palladian architecture for country houses (such as Chiswick House for Burlington and Holkham Hall in Norfolk for Coke).[1] Thereafter the country house was designed to harmonise with the landscape rather than to dominate it.

On 14 December 1731 Alexander Pope wrote an epistle in 102 couplets to Burlington on 'the Use of Riches'. A friend of Burlington and Kent, he felicitously compared the style and tastes of the Italian and French architects, landscape gardeners and decorative painters employed by the royalty and nobility of England:

On painted ceilings you devoutly stare,
Where sprawl the saints of Verrio and Laguerre.

In 1718 Pope took a lease of a house beside the Thames at Twickenham. In the following year his fellow Catholic, James Gibbs (1682–1754), Fellow of the Royal Society (1729), remodelled the front of the house in the Palladian style. Gibbs had entered the Pontifical Scots College in Rome as a candidate for the priesthood in 1703. Within a year he had been driven out by a tyrannical rector and became a pupil of Carlo Fontana (1638–1714), the leading architect in Rome. Suspect as a Tory, a Scot and a Jacobite, Gibbs secured few commissions from the Crown but many from the nobility. In the 1730s a first-floor portico was added to Pope's villa on the advice of Kent and Burlington. A grotto was built under the Hampton Court Road to link the villa to the five-acre garden on the other side. Pope wrote a poem of seven couplets on his 'Grotto composed of Marbles, Spars, Gemms, Ores and Minerals'; the walls were even decorated with lava from Vesuvius. The great English landscapist Turner painted the demolition of Pope's villa by Baroness Howe in 1807. The site is now occupied by St Catherine's School. Two and a half centuries after the grotto was constructed I walked through it from the school to the other side of the road.

In the 18th century the Grand Tour afforded a better education than Oxford or Cambridge. The nobility and the gentry sent their sons to Italy in the company of a tutor. Rome was the goal, but Venice and Florence were highly diverting and beguiling. The largest city, Naples, came to justify a visit as more and more

antiquities were unearthed at neighbouring Herculaneum and Pompeii. The range and distinction of visitors to Italy are recorded in the 200 glamorous portraits of three of George III's brothers and of English, Scots and Irish noblemen, gentlemen and their ladies painted in Rome between 1740 and 1785 by Pompeo Batoni (Lucca 1708–87 Rome).

By the middle of the 18th century artistic, antiquarian and architectural links between Britain and Italy were being promoted by Rome's leading collector and art patron, Alessandro Albani (Urbino 1692–1779 Rome). His career illustrates the process by which the Holy See abandoned the Stuart monarchs and accepted the Hanoverian monarchs. Albani was nominated an ambassador-at-large in 1720 by his uncle Clement XI (1700–21) and a cardinal in 1721 by Innocent XIII (1721–24). Clement XI had accommodated the Old Stuart Pretender with royal trappings in Avignon, Urbino, Rome and Albano. By contrast Albani provided information on Stuart supporters between 1722 and 1731 to Baron Philipp von Stosch, the agent of George I and George II.

From 1744 to 1772, through correspondence with Sir Horace Mann (1701–86), the British minister in Florence, Albani acted as an unofficial British representative in Rome and greatly contributed to English collections of Roman antiquities and the protection of English artists in Rome. In 1749 he helped the architect Matthew Brettingham (1699–1769) acquire statues for

Holkham Hall, Norfolk, which he was designing for the Earl of Leicester. In 1750 he secured statues for Eastbury Park, Dorset, designed by Sir John Vanbrugh and owned by George Bubb Dodington (1691–1762), later Lord Melcombe (1761). Among his other beneficiaries were the sculptor Joseph Wilton between 1747 and 1755, the architect William Chambers from 1750 to 1755, the painter Richard Wilson from 1750 to 1756, the architect Robert Adam (1728–92) from 1754 to 1758, the engraver Robert Stranger from 1761 to 1765, the painter James Barry (a protégé of Edmund Burke) from 1766 to 1771 and the banker, antiquary and excavator Thomas Jenkins, who settled in Rome in 1750 and remained till the French occupation in 1798. From 1753 to 1755 Cardinal Albani superintended the copying of pictures for the Duke of Northumberland.

In 1760 George III succeeded his grandfather George II. The following year, Albani was made director of the Vatican Library and an honorary member of the Society of Antiquaries of London. In 1762, through the intercession of the architect James Adam (1732–94), the younger brother of Robert, he sold the king the vast collection of watercolours, drawings and prints which had been accumulated by Cassiano Dal Pozzo (1588–1657) and Carlo Maratta (1625–1713) for Cardinal Francesco Barberini and was later acquired by Clement XI. Albani needed the purchase price for his daughter's dowry. The bulk of the collection remains in Windsor Castle.

In 1762 George III purchased Buckingham House. In 1763 he augmented his collection by buying the Italian books collected by Joseph Smith (1682–1770), 'the merchant of Venice', who had settled in Venice in 1709 and had been the British consul in Venice from 1740 to 1760. When Smith died in Venice, George III bought his unrivalled collection of the Venetian art of his time, including more than 50 paintings and over 140 drawings by Giovanni Antonio Canaletto (Venice 1697–1768 Venice). (Canaletto, who made three visits to England in 1746–50, 1751–53 and 1753–54, had been managed by Smith since 1730.) The Royal Collection contains the largest and best collection of Canaletto's works in the world. In 1823 George IV presented to the nation the library collected by his father. The King's Library of 65 000 volumes is now housed in a glass-walled tower at the heart of the British Library opened at St Pancras by Elizabeth II in 1998.

In December 1768 George III agreed to give royal patronage to the first regular school of art in England, the Royal Academy of Art. Among the 40 foundation academicians were two Italian painters, Francesco Zuccarelli (Pitigliano 1702–88 Florence) and Giovanni Battista Cipriani (Florence 1727–85 Hammersmith), and an Italian engraver Franceso Bartolozzi (Florence 1728–1815 Lisbon). They had settled in England in 1752, 1755 and 1764 respectively. (Cipriani prepared the drawings for many of the plates in the books of Cook's voyages.) Another foundation

academician, the portraitist William Hoare (1707–92), had been in Italy from 1728 to 1737, the first English artist to complete his studies in Rome. Sir (1769) Joshua Reynolds (1723–92), the leading English portraitist and first president of the Academy, studied in Rome and visited Florence, Bologna and Venice between 1750 and 1753. On 2 January 1769 he delivered his opening address at the Academy. In his fifteen subsequent *Discourses* he gave expression to the Grand Manner.

Reynolds's main rivals were Allan Ramsay (1713–84) and Thomas Gainsborough (1727–88). Ramsay, the son and name-sake of the author of the Scots pastoral comedy *The Gentle Shepherd* (1725), was a pupil of Francesco Fernandi (1679–1740), also known as 'Imperiali', in Rome in 1736 and of Baron Francesco Solimena (1657–1747) in Naples in 1737. The following year he returned to England through Rome, Venice, Bologna, Modena, Parma, Milan and Turin and in 1739 settled in London. He made further visits to Italy in 1754–57, 1775–77 and 1782–84. Appointed Principal Painter to George III in 1767, he was never elected to the Royal Academy. Gainsborough was among the foundation academicians but was the only signifi-cant British painter of portraits or landscapes in the 18th century who never visited Italy.

British painters had little taste for pagan themes and none for religious themes and devoted themselves to portraiture and landscape. Reynolds was too much a man of his age and his

country to admit that the Church of England produced no saints. Two hundred years after his death, there are some women priests in most Anglican dioceses around the world but not in the richest Anglican diocese, Sydney. Priestesses would have struck Reynolds as pagans.

The moral reaction after the Napoleonic wars inspired Pope Leo XII, who reigned from 1823 to 1829, to make some small changes in the Vatican's immense art collections. The male statues were mutilated and decorated with fig leaves. Queen Victoria's subjects were converted to this Catholic procedure. In St Peter's in Rome Leo XII's monument is placed opposite Queen Christina's monument.

PAINTERS IN AUSTRALIA

After the fall of Napoleon two watercolourists who were born in England and had painted in Italy came to Australia. Augustus Earle (London 1793–1838 London) visited Sicily, Malta and the Western Mediterranean from 1815 to 1817. Between January 1825 and October 1828 he painted in Hobart, in Sydney and its hinterland, and in New Zealand. The Rex Nan Kivell Collection in the National Library of Australia holds 160 of his watercolour drawings. John Glover (Houghton on the Hill near Leicester 1767–1849 Deddington near St Leonards, Tasmania)

spent some months in Italy in 1818. He arrived in Hobart in 1831 and in Launceston in 1835, in which year 68 of his paintings were exhibited in London.

In 1852 the painter Johann Joseph Eugen von Guérard (Vienna 1811–1901 London) joined the gold rush to Victoria and spent 30 years in Australia. He was the son of a court painter to Franz, the first Emperor of Austria. He studied under Giovanni Battista Bassi after his father took him to Rome in 1826. In 1832 he settled in Naples, where his father was appointed court painter to Ferdinando II, King of the Two Sicilies. For six years he painted landscapes in southern Italy and Sicily. After his father died of cholera he left for Düsseldorf where he studied until 1845 before continuing his travels in Europe and then to Australia. In 1854 he moved from Ballarat to Melbourne.

Von Guérard received many commissions from wealthy landowners in Victoria, Tasmania, New South Wales, South Australia and New Zealand for landscapes and views of their newly built homesteads. In 1870 he was appointed master of the painting school and curator of the National Gallery of Victoria. A collection of his grand landscapes is among the treasures of the Gallery. His work appeared at many international exhibitions, including those at Paris (1867, 1878), Vienna (1873) and Philadelphia (1876). Awarded the Cross of the Order of Franz Joseph in 1870, he went back to Düsseldorf in 1882.

Two of Earle's works, eight of Glover's and eight of von Guérard's were included in the exhibition 'New Worlds from Old: 19th Century Australian and American Landscapes' organised by the National Gallery of Australia, Canberra, and the Wadsworth Atheneum, Hartford, Connecticut. The exhibition was shown at the National Gallery of Australia, the National Gallery of Victoria and the Wadsworth Atheneum in 1998, and at the Corcoran Gallery of Art in Washington DC and in Lausanne in 1999. It proceeded to the Hermitage in St Petersburg and the Reina Sofia in Madrid in 2000.

Adelaide Eliza Ironside (Sydney 1831–67 Rome) was the first Australian-born artist to study abroad. Encouraged by John Dunmore Lang, the first Presbyterian minister in Sydney, she reached Italy in 1856 and was received by Pius IX in 1861 and allowed to copy works in the papal collections. Like Lang she was a republican. Her most famous work, *The Marriage at Cana of Galilee*, hung at the Great Exhibition in London in 1862, depicts both Jesus and the bridegroom with the features of Garibaldi. It used to hang in the dining hall of St Paul's College within the University of Sydney. After the College was given a portrait of William McMahon, its first Prime Minister, the Council commissioned a portrait of its second Prime Minister by Clif Pugh. Pugh's first portrait of me won the Archibald Prize in 1973 and hangs in Parliament House, Canberra. When I unveiled the second portrait in 1989 I observed:

There might be ideological inconsistencies in classifying Garibaldi, McMahon and me as a triumvirate or a troika. There might be theological impropriety in calling us a trinity. It is not inappropriate for all three of us to be revered as a triptych at an Anglican college.

In 1992 the College gave the painting to the Art Gallery of New South Wales.

Charles Rolando (Florence 1844–93 St Kilda) arrived in Melbourne in mid-1885. He painted many Victorian landscapes in oils and watercolours and conducted a fashionable art school in St Kilda.

The National Gallery of Australia in Canberra and the State galleries in Melbourne, Sydney, Perth and Brisbane have paintings by Girolamo Ballati Nerli Pieri Pecci (Siena 1860–1926 Nervi), a follower of the Macchiaioli group of painters in Florence. His father was a patrician of Siena and his mother was a daughter of Thomas Medwin (1788–1869), a member of Shelley's and Byron's circle in Tuscany. Medwin's wife was a Swedish baroness. Nerli was active in art circles in Melbourne, Sydney, Apia, Dunedin, Auckland and Perth between 1885 and 1903 and influenced Australia's younger painters. During World War I he was engaged at the Italian embassy in London on work for prisoners of war.

In the first half of the 20th century there were two rival art schools in Sydney. One was owned by Julian Rossi Ashton, the

grandson of an Italian, and the other by Antonio Salvatore Dattilo Rubbo, who was born in Italy.

Julian Ashton (Addlestone, Surrey 1851–1942 Bondi, near Sydney) migrated to Melbourne in 1878 and to Sydney in 1883, where he founded the Sydney Art School in 1896. His father had married Henrietta Rossi, the daughter of a Sardinian diplomat, Count Carlo Rossi, and the great soprano Henriette Sontag (Koblenz 1806 54 Mexico City), who excelled in the leading roles in the operas of Weber and Rossini in the opera houses of Prague, Vienna, Berlin, Paris and London. The count fell in love with the great soprano while he was representing King Carlo Alberto of Sardinia at the court of King Frederick William III of Prussia, but he could not marry her because she was not of noble birth. The King of Prussia assisted by giving her a title of nobility. (The romance was the subject of Auber's *opéra comique L'Ambassadrice*, for which Scribe wrote the libretto.) After their marriage the countess retired from the stage but continued concert work. In 1848, the year of revolutions, the count had to leave the Sardinian diplomatic service and the countess supported their family by returning to opera. (Théophile Gautier wrote her biography, also called *L'Ambassadrice*, in 1850.) Henriette Sontag's triumphs in London were followed by successful tours of the United States and Mexico. She died of cholera in Mexico City. Her Australian descendants continue to contribute to Sydney's artistic and musical life. Auber's work

continued to hold the stage in Paris till 1873, with a total of 417 performances.

Dattilo Rubbo (Naples 1870–1955 Mosman, near Sydney) migrated to Sydney in 1897 and founded his art school in 1898. He was naturalised in 1903. Created a Knight of the Order of Merit of the Crown of Italy in 1932, he was briefly interned when Italy entered the war in 1940. In 1947 he was commissioned to paint the posthumous portrait of Prime Minister Curtin for Parliament House in Canberra. He was survived by his elder son, Sydney Dattilo Rubbo (1911–69), Professor of Bacteriology in the University of Melbourne, who was created a knight of the Order of Merit of the Italian Republic in 1968.

SCULPTORS IN AUSTRALIA

The sculptor Charles Summers (Somerset 1827–78 Paris) was admitted as a student of sculpture at the Royal Academy in London in 1850. He won medals for the best model from life and for the best group of historical sculpture. He joined the 1852 goldrush to Victoria and, in Melbourne, directed the sculpture work in the Legislative Council chamber. He made the bronze group of the explorers Burke and Wills, with his figure of Burke being the largest ever cast in one piece and the first ever poured in Australia. In 1867 he moved to Rome,

where he established a successful career. His last work was the marble group of Queen Victoria, the Prince Consort and the Prince and Princess of Wales in the National Gallery of Victoria. Summers's son Charles Francis, born in Melbourne in 1857, joined him in Rome in 1868 and made many of the statues in the Ballarat Gardens, the largest collection of Italian statues in Australia. The most famous is *The Flight from Pompeii* after Giovanni Maria Benzoni (Clusone 1809–73 Rome), which he brought to Ballarat in 1887. He copied Canova's *Venus* for Bendigo's Rosalind Park in 1900. He died in Melbourne in 1945.

In 1871 Bishop Quinn (to be called O'Quinn a few years later) encouraged the religious sculptor Achille Simonetti (Rome 1838–1900 Sydney) and the portrait painter Giulio Anivitti (Rome 1850–81 Rome), pupils of the Accademia Nazionale di San Luca, to emigrate to Brisbane. In 1874 they moved to Sydney. Anivitti taught at the NSW Academy of Art, bought works which formed the collection of the Art Gallery of New South Wales and painted portraits for institutions. Because of ill health he returned to Rome in 1879. Simonetti became the most fashionable sculptor in Sydney. In Sydney many of his busts and allegorical figures are in official buildings. For Queen Victoria's Jubilee in 1897 he created the heroic statue of Governor Phillip at the entrance to the Botanic Gardens. It was cast in Florence.

Tomaso Sani (Florence 1839–1915 Sydney) migrated to Melbourne in the late 1870s and in 1880 exhibited in the Italian sculpture section of the Melbourne International Exhibition. During the 1880s he was engaged to carve explorers and symbolic figures for the facades of the Lands Department building and the General Post Office in Sydney. They caused considerable controversy in official circles. In 1893 he was commissioned to cast *Footballer* in bronze for Centennial Park. It was removed in the 1950s.

In the Great Hall of the University of Sydney there are statues of William Charles Wentworth I by Pietro Tenerani (Torrano di Carrara 1789–1869 Rome) and of John Henry Challis by Simonetti and busts of three knights, Edward Deas Thomson, Peter Nicol Russell and Arthur Renwick, by Odoardo Fantacchiotti (Rome 1809–77 Florence), and one of the Benzoni family and Simonetti respectively.

Mario Raggi (Carrara 1821–1907 Farnham) left his mark in Australia as a sculptor but never visited. He settled in London in 1850 and in 1883 made the statue of Prime Minister Disraeli in Parliament Square, London. Later he cast a statue of Dr William Lodewyk Crowther (Haarlem 1817–85 Hobart), Premier of Tasmania. Raggi never saw Crowther but worked from a photograph. The statue, erected by public subscription, was unveiled in Franklin Square, Hobart, on 4 January 1889 by the next Premier but three, Philip Oakley Fysh (Highbury near London

1835–1919 Hobart). Later still, Raggi made a statue of Prime Minister Gladstone for Manchester.

The monumental sculptor Francis Philip Rusconi (Braidwood 1874–1964 Cootamundra), the son of a Swiss–Italian goldminer, made many tombstones, altars and war memorials in New South Wales and, in 1932, the bronze *Dog on the Tuckerbox* near Gundagai. Pietro Giacomo Porcelli (Bisceglie 1872–1943 Perth), apprenticed to Simonetti in Sydney and trained at the Royal Academy of Naples, sculpted the memorials to C. Y. O'Connor in Fremantle and to Alexander Forrest in St George's Terrace, Perth, in 1902 the Jewish Memorial in King's Park, Perth, and other war memorials in Western Australia after World War I. He created the twelve panels in the inner Shrine of Remembrance in Melbourne. Dora Ohlfsen (Ballarat 1878–1948 Rome), on the other hand, studied sculpture in Italy and worked for the Red Cross in Italy during World War I. In 1926 she created the colossal war memorial in Formia near Gaeta.

In front of Sydney Hospital there is a replica of *Il Porcellino*, the bronze boar by Pietro Tucca (1577–1640) in the Mercato Nuovo in Florence. The original was copied from an ancient marble in the Galleria degli Uffizi. The bronze replica was presented by Marchesa Clarissa Torrigiani of Florence in 1967 in memory of her father, Thomas Henry Fiaschi (Florence 1853–1927 Sydney), and brother, Piero Francis (Windsor, NSW 1879–1948 Sydney), who were celebrated surgeons at the

hospital. The marchesa was named after her father's English mother, Clarissa Fisher.

GALLERIES IN AUSTRALIA

In 1937 Andrew William Mellon (1855–1937), the Pittsburgh banker who had been secretary of the US Treasury under Republican Presidents Harding, Coolidge and Hoover, gave his art collection valued at $25 million to the US Government and donated $15 million to build a National Gallery of Art in Washington to house the collection. The gallery was inaugurated by President Roosevelt II in March 1941. Andrew Mellon had two children, Paul and Ailsa. Paul (1907–99) was one of the most consistent patrons and philanthropists in the history of the United States. Ailsa was the mother of Richard Mellon Scaife, a major sponsor of the discredited Heritage Foundation and the notorious Kenneth Starr.

When Prime Minister Fisher laid the foundation stone for Canberra in March 1913 he announced that, once Parliament House and the necessary buildings connected with the public services had been finished, the next building would be a public library and art gallery. Once Washington secured a National Gallery, it was clear that the Australian Government would have to build a National Gallery in Canberra. In 1945 the Historical

Memorials Committee, with Prime Minister Chifley in the chair, decided that architectural plans could be made for a gallery.

Menzies took even longer to approve plans for a national gallery than he had taken to approve plans for a national opera. He had been scarred by the miscarriage of his plans for a Royal Australian Academy of Art. On a visit to London in 1935 he was so impressed by the Royal Academy of Art that on his return he persuaded the Lyons Government to take steps to request the granting of a Royal Charter for an Australian Academy of Art. In an article in the Melbourne *Argus* on 28 April 1937 Menzies provocatively wrote:

Experiment is necessary in establishing an academy, but certain principles must apply to this business of art as to any other business which affects the artistic sense of the community. Great art speaks a language which every intelligent person can understand. The people who call themselves modernists today speak a different language.

Menzies launched the Academy in June 1937. The other arts societies petitioned the Governor-General, Lord Gowrie, against the granting of a Royal Charter. The British High Commission presented Prime Minister Lyons with a deprecating memorandum from the Dominions Office. In April 1938 the Academy held its inaugural exhibition and asked Lyons to secure for it the right to add the prefix 'Royal' to its title. In May Lyons rejected

the application. The Academy met for the last time in November 1949 and transferred its assets to the Victorian Artists Society.

In May 1965 the Menzies Cabinet agreed to establish a national art gallery and in September Menzies appointed the National Art Gallery Committee of Inquiry. The chairman, Sir Daryl Lindsay, presented the Committee's report to Prime Minister Holt in March 1966. In February 1968 Lindsay resigned because of 'frustrations and delays over the past two years'. The McMahon Government finally appointed James Mollison as acting Director in October 1971.

At the elections for the House of Representatives on 2 December 1972 the ALP undertook to establish a building, a collection and a statute for a National Gallery. I appointed the Art Acquisitions Committee in February 1973, signed the contract for the construction of the building in April, approved the Committee's recommendation to purchase *Blue Poles* by Jackson Pollock (1912–56) in July, and appointed an Interim Council with Richard Crebbin as chairman and Mollison as a member in September.

The purchase of *Blue Poles* (a 1952, 210.4 x 486.8 cm work of oil, enamel and aluminium paint on canvas) made an immediate impact at home and abroad. Exceptional crowds came to see it at the Art Gallery of NSW (2 April–2 June 1974), the Brisbane City Hall (7 June–2 August), the National Gallery of

Victoria (5 August–5 October) and the Art Gallery of South Australia (7 October–7 November).

The first question in Parliament concerning the purchase of *Blue Poles* had been directed to me on 24 October 1973 by Doug Anthony, the Leader of the Country Party, who asked how the choice was made but not 'how the painting was made or about the merits of it, which I cannot comprehend'. I was compelled to reply: 'If Australian galleries were limited by the comprehension of the right honourable gentleman they would be very bare and archaic indeed.'

W. C. Wentworth IV pored over the myths of the painting's creation to produce the last question, which was directed to the Speaker on 4 December:

Do you agree that the aesthetic impact of a work of art is increased by the contemplation of it in the circumstances in which it was created? When the bargain-priced masterpiece Blue Poles *reaches its fortunate purchasers in Australia, will you discuss with the President of the Senate the possibility of having the painting laid out on the floor of Kings Hall so that honourable members and senators can view it from the viewpoint of its inspired creator? Will you further arrange for free drinks to be served in King's Hall so that honourable members and senators can share to the full in the inspiration of the artist or artists? If the painting is so exhibited, will you ensure that it is securely fenced off in order*

to shield us from the temptation to take off our shoes and affix addendums to it in the same manner in which the basic painting was allegedly done.

Speaker Jim Cope answered in his best style: 'I will do so, providing the honourable member agrees to sit on the biggest pole for some time.' Silly Billy was knocked off his perch.

American critics derided the purchase. The Australian connoisseur Daniel Thomas dismissed their remarks as sour grapes, 'a desperate American excuse for allowing Australia so unexpectedly to steal one of their great national treasures', and he urged people to go and see the painting for themselves.

My coeval Bernard Smith wrote an article, 'The way of the Sun King or the Czarina', in *The Australian* in March 1974 attacking the National Gallery, and resurrected it in *The Antipodean Manifesto* in 1976. He believed that the National Gallery would have been better if I had listened to him rather than Daryl Lindsay and Nugget Coombs, or if I had aped Louis XIV rather than Catherine the Great. Smith was Power Professor of Contemporary Art and Director of the Power Institute of Fine Arts in the University of Sydney from 1967 to 1977 and had been a member of the Interim Committee of the National Gallery from 1968 to 1970. His 1964 *Meanjin* article on the Power Bequest was also exhumed for his Oxford book. He did not prevent the gross laches of the University of Sydney

in dissipating the Power Bequest and undermining the Museum of Contemporary Art.[2] When it comes to galleries I have rather less to answer for than Bernard Smith. The *National Gallery Act* received assent in June 1975.

In 1986 I had arranged for Australia's new Permanent Delegate to Unesco to take over from me at the end of the year. With Hawke's permission Barry Cohen, his Minister for Arts, Heritage and the Environment, appointed me as chairman of the Council of the National Gallery from 1 January 1987. One of the Council's first acts was to commission *The Aboriginal Memorial* for the Bicentennial in 1988. Dedicated to all indigenous Australians who defended their land and perished in the 200 years of white settlement, it consists of 200 poles inspired by the painted hollow log coffins of the type used in second burial ceremonies in Arnhem Land. The poles were carved and decorated by 43 senior artists from Ramingining.

I remained a member of the Executive Board of Unesco until the end of the General Conference in November 1989. Mollison, who was about to retire as Director of the National Gallery and become Director of the National Gallery of Victoria, urged me to proceed to my last General Conference through Prague in order to pursue proposals for both galleries to borrow works from the National Gallery of Czechoslovakia, which had lent works to the Royal Academy in London in 1986. He arranged for David Jaffé, a former curator at the National Gallery in Canberra, to

come from London to accompany me. (I describe the visit in *Abiding Interests* at page 132.)

At the end of 1989 the Council of the National Gallery selected Betty Churcher, the Director of the Art Gallery of Western Australia, to succeed Mollison. In May 1990 she and I pursued possibilities of exchanges with art museums and galleries in Washington, New York, London, the Netherlands and Prague.[3] Jaffé met us in Rome. Duncan Campbell, our ambassador, had arranged not only for us to visit the central authorities in Rome but also for some of the regional authorities to travel to Rome to meet us. With Australian Government indemnities, more than 40 great works were secured not only from the Holy See and the Eternal City but also from Bologna, Florence, Mantua, Milan, Modena, Naples, Parma and Turin for the superb 'Rubens and the Italian Renaissance' exhibition. Conceived and annotated by Jaffé, it was shown at the National Gallery of Australia (28 March–8 June 1992), where it attracted 242 701 visitors, and the National Gallery of Victoria (20 June–30 August 1992). Jaffé became the curator of paintings at the J. Paul Getty Museum in Malibu and is now chief curator of Italian paintings at the National Gallery of Art in London.

In 1997 Brian Kennedy, the Assistant Director of the National Gallery of Ireland, succeeded Betty Churcher as the Director of the National Gallery of Australia. He had inherited masterpieces which significant galleries were anxious to borrow and to

exhibit. Between 1 November 1998 and 2 February 1999 the Museum of Modern Art (MoMA) in New York organised a retrospective exhibition of the works of Jackson Pollock. The total attendance was 329 330. The Chief Curator described *Blue Poles* as one of the linchpins of the exhibition. He said that, if the National Gallery were disposed to sell it, he would bid not less than US$25 million for it. My Government had bought it for US$1.35 million, a world record price for a modern American painting until that time.

Eighty of the 104 paintings in the Pollock retrospective at MoMA, including *Blue Poles*, were exhibited at the Tate Gallery, London, between 11 March and 6 June 1999. The exhibition attracted 196 321 visitors. When *Blue Poles* was welcomed back to Canberra on 21 July, Australian sceptics had been converted to true believers. Pollock's *Summertime* (1948) is one of the treasures of Tate Modern, Bankside, opened in May 2000. The gallery's handbook pays this tribute:

Jackson Pollock is widely seen as the key figure in western art in the mid-twentieth century, exercising an influence on the second half of the century comparable to that of Picasso on the first half . . . The celebrated Blue Poles *of 1952 was a final heroic manifestation of the high point of the Pollock of 1948–50.*

The other masterpieces from the National Gallery exhibited overseas were the 200 poles in *The Aboriginal Memorial*. The

exhibition attracted 40 000 visitors at the Olympic Museum in Lausanne between 1 July and 31 October 1999 and 26 000 at the Sprengel Museum at Hannover between 16 November 1999 and 21 January 2000. Between 2 February and 9 April 2000 *The Aboriginal Memorial* and the works of six other Aboriginal artists were exhibited at the State Hermitage Museum in St Petersburg. About half a million people attended.

Canberra's cultural institutions have come to terms with their classical backgrounds to varying degrees. In the early 1960s the architects Bunning and Madden planned a National Library building with six columns at each end and thirteen on each side. The building was opened in August 1968 with eight columns at each end but a mere sixteen on each side instead of the seventeen required by the Parthenon canon. The Chairman of the Library Council, Sir Grenfell Price, offered to pay for a coat of arms and asked the Council to help him with a suitable motto. The Council had been impressed with the skill of the National Librarian, Sir Harold White, in securing a larger building but was not impressed with Price's proposal for a motto. The National Capital Development Commission was represented on the Council by Professor Dale Trendall, a world authority on classical languages and inscriptions. He killed the proposal by suggesting the motto *Alba sine Pretio* (A Priceless White House).

In 1973 the National Gallery was offered a bronze athlete of the school of Lysippus which Italian fishermen had recovered

from the seabed off Fano, beyond territorial waters, in 1963. It may have been looted from Asia Minor by Sulla. As the National Archaeological Museum in Athens, the Louvre and the Museo Nazionale in Reggio di Calabria attest, such bronzes can now come to light only from shipwrecks. On New Year's Day 1974 I was shown round Olympia by the great Director of Antiquities in Greece, Nikos Yalouris. He had been Greece's first archaeologist diver, having explored the seabed off Katakolo in 1957–60. I sought his advice on the Lysippus. He later let me know that its provenance was impeccable. Thereupon I arranged to pay $3 714 020 in two instalments, the first immediately the 1975 Budget was passed and the second after the 1976 Budget. One of Malcolm Fraser's first acts was to cancel the order. The Getty Museum in Malibu, which I had visited in September 1974 on my way home from the UN General Assembly, was happy to pay half as much again as we would have paid. In July 1979, on my next visit to Malibu, I found that our Lysippus was the centrepiece of the Getty's expanding sculpture collection. Menzies had bought a copy of a reissue of Magna Carta by King John's grandson, Edward I, for the National Library of Australia. In the National Gallery of Australia the Lysippus would have been a more authentic part of the Australian heritage. Fraser compounded his injury by an unsurpassed display of philistinism. He cancelled the order on the grounds that the statue was an 'ancient bronze of unknown authorship'.

I unveiled plaques to make the start of construction of the National Gallery building on 7 November 1973 and of the High Court building on 29 September 1975. Queen Elizabeth II opened the latter building on 26 May 1980 and the former building on 12 October 1982. Each building was designed by Edwards, Madigan, Torzillo and Briggs. Jack Torzillo (1922–98) later designed the Sydney Entertainment Centre. His father and grandfather were distinguished violinists. His great-grandfather Pasquale, a musician, was born in Viggiano and arrived in Australia in 1832.

The New Parliament House was opened by the Queen on 27 May 1988. The principal designer was Romaldo Giurgola, who was born in Rome in 1920. He left for the United States in 1950 and became an American citizen. On Australia Day 2000 he became an Australian citizen.

On 10 July 1992, at the National Gallery, Gordon Darling, who preceded me as Chairman of the Council of the Gallery, and his wife Marilyn invited me to launch 'Uncommon Australians', a collection of paintings which they proposed as the basis of a national portrait gallery. Their ideas came to fruition in the National Portrait Gallery installed in the Old Parliament House. At the opening on 9 March 1999 Clif Pugh's two portraits of me were on display. The 1973 portrait had been lent by the New Parliament House and the 1989 portrait by St Paul's College. After Pugh won the Archibald Prize with the 1973

portrait I sent him a telegram: 'Your place in the history of politics, like mine in the history of art, is now assured.' He was so exhilarated by this tribute that I had to admonish him: 'You may be the Michelangelo of our time, but don't forget that for the present I am Julius II.' The message would have been lost on the Art Gallery of New South Wales; on its facade Michelangelo is spelt as two words.

In July 2000 the vision of the Darlings in establishing the National Portrait Gallery was dazzlingly endorsed when the Gallery acquired the 1782 portrait of Captain James Cook FRS by John Webber RA (London 1751–93 London), the official painter on Cook's third and last voyage (1776–80). The painting was purchased with $2.8 million from the Australian Government and two $1.25 million donations by Rosemount Estates Pty Ltd, Australia's largest family-owned winery, and John Schaeffer, Australia's leading collector of 19th-century European paintings.

In his masterpiece, *Life with Gough*, Barry Cohen devotes a chapter of more than twenty pages to speeches I made at the National Gallery of Australia after he approached me to chair its Council. I return the compliment by incorporating his article on an earlier opportunity to acquire the Webber portrait:

It was 4 p.m. on Thursday 10 March 1983, and I had just been elected to the first Hawke ministry. At 4.30 the great man called

me to his office and asked: 'How would you like to be Minister for Home Affairs and the Environment?' I replied, promptly: 'I would have taken Garbage Collection if you had offered it.'

At 5 p.m., ensconced in my new office and feeling suitably smug and ministerial, I was suddenly confronted by a dear friend and colleague, Manfred Cross, the MP for Brisbane. 'And what can I do for you, Manfred?' I inquired solicitously of one who had unfairly missed out on higher office. 'Barry,' he said, 'I understand you are responsible for the National Library.' 'I am?' I glanced nervously through the list of two dozen-odd boards, commissions and statutory authorities that made up the Department of Home Affairs and Environment. 'You're right, I am,' I replied as I spotted it on the list.

'Well,' said Manfred, 'I speak on behalf of the board of the National Library, of which I am a member. We would like you to ask Cabinet for $400 000 so that tomorrow we can bid at auction for the Webber painting of Captain Cook.' I had heard of Cook but I had to confess Webber was not an artist whose name came readily to mind.

'Manfred,' I said. 'Forgive me for asking what may be a ridiculous question but why is the National Library interested in acquiring a painting? I thought they were into books. Doesn't the National Gallery buy our paintings?' 'Yes, of course,' said Manfred, 'but they're not interested, because artistically it's not very good.'

As I had been minister responsible for the arts for less than an hour, I thought I'd let that one go through to the keeper. I tried another tack.

'When was it painted?' I inquired. 'Three years after Cook died,' said Manfred, 'so it's not very good from a historical point of view either.' 'Let me get this straight. You would like me to go to my first Cabinet meeting, before we have even been sworn in, and ask my 26 fellow ministers to ensure that the first act of the first Labor Government since Gough will be to spend $400 000 on a painting of Captain James Cook that is of little historical and even less artistic value?' 'Yes,' he replied. 'I think not, comrade. I can think of better ways of committing political suicide.' 'Well,' sniffed Manfred, 'the board will be very unhappy and disappointed.'

I was between a rock and an art place. 'I shall just have to live with the knowledge that the National Library board believes they have a philistine as their new minister.'

Shortly afterwards, I informed the Prime Minister of my first ministerial decision. He looked up from writing and with a wry smile nodded his approval. 'Wise decision, minister, wise decision.'

Between Hawke and Howard, the portrait of Captain Cook was appropriated and misappropriated by Alan Bond, who paid $506 000 for it. In September 2000 the Art Gallery of South Australia acquired another Bond treasure, the portrait of Matthew Flinders painted by Toussaint Antoine de Chazal in Mauritius in 1807. Half the $780 000 price was paid by the South Australian Government and the other half by David Roche, an Adelaide art collector. Bond had paid $450 000 for it in 1987.

ARCHITECTS IN AUSTRALIA

Like the painter von Guérard, the architects Henry Richard Caselli (Falmouth 1816–85 Ballarat) and Andrea Giovanni Stombuco (Florence 1820–1907 Perth) joined the goldrush to Victoria in 1852.

Caselli was the great architect in Ballarat's golden age. According to his death certificate, he was the son of Rennie Caselli, blockmaker. According to Ballarat tradition, his father had come from Naples and had worked in English naval dockyards. This would be consistent with his father being named Renato and having fled to England after the Bourbons replaced the relatively enlightened Napoleonic regime in Naples in 1815.

Stombuco designed and built three Catholic churches in Victoria and commenced the Catholic cathedral at Ballarat in the 1860s as well as the Catholic cathedral and St Patrick's College at Goulburn in New South Wales in the early 1870s. In 1875 Bishop James O'Quinn (formerly Quinn) encouraged him to practise as an architect in Brisbane. He designed an Anglican church in South Brisbane and Catholic churches in Goodna, Fortitude Valley, Kangaroo Point, Wooloowin, Ipswich, Sandgate and Nudgee, Christian Brothers colleges at Gregory Terrace and Nudgee and All Hallows' School in Brisbane. He built thirteen elegant villas, including Palma Rosa, and many

commercial buildings. He was naturalised in 1882 and moved to Perth in 1891.

Today Australians have come to realise that architects increasingly belong to an international profession. Joern Utzon was born in Copenhagen in 1918. Harry Seidler was born in Vienna in 1923 and settled in Sydney in 1948. Frank Owen Gehry was born in Toronto in 1929 and moved with his family to Los Angeles in 1947. Richard George Rogers was born in Florence in 1933; he was created a life peer in 1996. Richard Alan Meier was born in Newark, NJ, in 1934 and Renzo Piano in Genoa in 1937. Such names are associated with new cultural centres and the relocation and renovation of existing cultural centres in the main cities of the United States, Europe and Australia. In Paris, Rogers and Piano designed the Centre Pompidou and Seidler designed the Australian Embassy.

In New York, the Solomon R. Guggenheim Foundation has enlarged the Guggenheim Museum, designed by Frank Lloyd Wright (1867–1959) and opened in 1959 just after his death. In Venice the Foundation has enlarged the Guggenheim Collection housed and collected by Peggy Guggenheim (1898–1979). It realised that the Guggenheim Museum, opened in Bilbao on 18 October 1997 by Juan Carlos, King of Spain, could not have as many outstanding works of art as the Museum in New York and the Collection in Venice. The Foundation therefore commissioned Gehry to create an outstanding work of architecture.

In Berlin the Foundation mounts regular exhibitions of major German artists in the Deutsche Bank premises in Unter den Linden.

J(ean) Paul Getty (Minnesota 1892–1976 Surrey) left huge endowments and excellent collections and institutes in Los Angeles. His Trust realised that the city could never have as comprehensive art collections as the capital cities on each side of the North Atlantic, so Richard Meier was commissioned to create an outstanding work of architecture on a superb site at Brentwood above Los Angeles. The Getty Center was opened in December 1997.

In 1999 Harry Seidler completed the Wohnpark Neue Donau in Vienna; all balconies have views of the river that flows through the city where he was born. In 2000 Renzo Piano completed an office tower and apartment block with views of the Sydney Botanic Gardens, Opera House and harbour. In Italian mansions the reception rooms are called the *piano nobile*. Each of the 60 apartments in Renzo Piano's Sydney masterpiece has a *piano nobile*.

Gehry and Meier had in mind the site and scale of the Sydney Opera House designed by Utzon. Prime Minister Fraser opened the fifth session of the World Heritage Committee in the Opera House in October 1981. The first three Australian properties were inscribed on the World Heritage List, Kakadu National Park, the Great Barrier Reef and Willandra Lakes Region. The meeting was informed, however, that the Australian Government

had withdrawn the nomination of the 'Opera House in its setting' but hoped to submit a revised nomination in due course. After the inscription of Brasilia's contemporary buildings in 1987, there was a revival of bipartisan zeal in both Sydney and Canberra to prepare a nomination of the Opera House. This interest was reinforced in September 1993 when the International Olympic Committee awarded the Games of 2000 to Sydney. In March 1997, however, the Howard Government decided not to proceed with the nomination. If the Opera House was to be inscribed before the Olympics, the State and Federal Governments had to collaborate in having a valid nomination in the hands of the World Heritage Bureau well before the end of June 1998.

There is no doubt that the Sydney Opera House in its harbour setting qualifies as a property of outstanding universal value. No more significant piece of architecture was erected in the world during the second half of the 20th century. Juan Antonio Samaranch Torello, Marqués de Samaranch (1993), President of the International Olympic Committee since 1980, proclaimed that Sydney had presented to the world the best Olympic Games ever. More people focused attention on Australia before and during the Olympics than during the whole previous history of Australia. The Sydney Opera House and the Sydney Harbour Bridge were the symbols of the Games. The Howard Government refused to nominate them. John Howard is a smaller person than Malcolm Fraser.

LITERATURE

GEOFFREY CHAUCER, THE FIRST of poets in modern English, was born about 1342. His father and grandfather dealt with Italian merchants in London. In 1372–73 he himself accompanied two such merchants, Giovanni di Mari and Sir Jacopo di Provano, to Genoa to secure port facilities and mercenaries and to Florence to secure loans for Edward III. Chaucer became familiar with the works of Boccaccio, who died in Florence in 1375, the canonist Giovanni da Legnano, and Guido Delle Colonne, the historian of Troy. (At university I bought J. M. Rigg's 1903 translation of Boccaccio's *Decameron* in the Everyman edition. The tenth novella of the Third Day, however, was still printed in Italian. It describes how a young hermit teaches a pious virgin to *rimettere il diavolo in inferno*.) Chaucer's 'Knight's Tale', the first of *The Canterbury Tales*, was an abridgement and adaptation of *Teseida*, which Boccaccio had written when Gualtieri di Brienne, titular Duke of Athens, was briefly emerging

as Signore of Florence. In it, as in Shakespeare's *A Midsummer Night's Dream* and John Fletcher's *The Two Noble Kinsmen*, Theseus, the prehistoric king of Athens, was transformed into a mediaeval Duke of Athens. On Chaucer's return from Florence Edward III sent him to release a Genoese ship detained at Dartmouth.[1] In 1376 Pope Gregory XI issued a bull excommunicating Florentines and declaring their property forfeit everywhere. When this bull was published in London, the populace pillaged the houses of the Florentines and Edward III had to take them under his protection. In 1378 Richard II (the new king and Edward's grandson) sent Chaucer to Milan to negotiate with Bernabò Visconti and his son-in-law, the English *condottiere* Sir John Hawkwood, presumably on military matters. Chaucer survived the usurpation by Henry IV in 1399 and died in 1400.

In the 1450s Robert Flemmyng, John Free (Phreas in Greek) and John Gunthorpe studied Latin and Greek under Guarino da Verona in Ferrara. Before 1472 William Sellyng learned Greek at Bologna. Free died in Rome in 1465 just after Pius II had designated him as Bishop of Bath and Wells. The others became respectively dean of Lincoln, dean of Wells and prior of Christ Church, Canterbury. The humanists Stefano Surigone and Lorenzo of Savona taught Latin rhetoric respectively at Oxford from 1465 and Cambridge from 1478. Andronikos Kallistos (Thessaloniki 1400–86 London), who had taken refuge in Italy

with Cardinal Bessarion after the fall of Constantinople, settled in London in 1476. By this time there were many Englishmen who were fluent in formal speeches and letters in Latin and could read Greek.

In 1476 William Caxton (1422–91) established the first printing press in England. He gave wide circulation to the works of Chaucer and his successors and translated 24 books from French. In 1489 he published the histories of heroic women written by Cristina da Pizzano, who was born in Venice in 1365 and came to France when her father was appointed astrologer to Charles V in 1370.

THE TUDORS

Thomas Linacre, William Grocyn and John Colet, three scholars from Oxford, established Italian humanism in England. Linacre travelled between 1485 and 1497 to Bologna, Florence, Rome, Venice, Padua (M.D., 1496) and Vicenza. His translations of the works of the Greek physician Galen into Latin concentrated his interests on medicine and in 1518 he founded the Royal College of Physicians of London. After visiting Italy in 1488–90 William Grocyn taught Greek at Oxford until he became the rector of a London parish in 1495. His work was reinforced by the arrival of Cornelio Vitelli of Corneto (now Tarquinia) in 1490

to give lectures in Greek at Oxford. John Colet returned to Oxford after his Italian visit (1493–96) and in 1504 he was appointed dean of St Paul's Cathedral in London and in 1509 founded St Paul's School.

The three Englishmen set the classical framework which endured in English tertiary and secondary education till the mid-20th century. They were all associated with the young Thomas More, who achieved and retains the reputation of a great humanist without having visited Italy. They and More were all associated with Erasmus, who was in England in 1499–1500 (on the invitation of Colet), in 1505–06 (staying with More), in 1509–14 and briefly in 1515, 1516 and 1517. Erasmus left England for Italy in 1517 to be tutor to the sons of the court physician Giovanni Battista Boerio and stayed there as tutor to Alexander Stuart, the bastard son of James IV of Scotland.

In Britain the first complete translation from the classics was the Scots version (1513) in rhyming pentameter couplets by Gavin Douglas (1474–1522) of the twelve books of Vergil's *Aeneid*, with which he included the supplementary thirteenth book (1427) by Maffeo Vegio (Lodi 1407–58 Rome). The couplets were first used by Chaucer in the 'Knight's Tale'. They came to be known as the 'heroic couplet' when adopted by George Chapman to translate the *Odyssey* in 1614 and over the next two centuries by George Sandys, John Dryden, Nahum

Tate, Thomas Creech, Nicholas Rowe, Alexander Pope, Samuel Johnson, Francis Fawkes and William Gifford for their translations of Greek and Latin hexameters.[2] Douglas secured episcopal status and political influence when his nephew married Margaret Tudor, sister of Henry VIII (1509–47) and widow of James IV of Scotland (1488–1513). In 1521, proscribed as a traitor in Scotland, he took refuge in England as a friend of Polidoro Vergilio (Urbino 1470–1555 Urbino), whom Henry VII had asked to write an *Anglica Historia*.

In September 1522 Martin Luther published his translation of the New Testament from Greek into German. It was a landmark in the development of the German language. William Tyndale was encouraged to translate the New Testament into English but had to have it printed in Cologne and Worms. Modestly priced pocket editions were smuggled into England from 1526. Tyndale himself was condemned as a heretic, strangled and burned outside Brussels in 1536. His translation was a landmark in the development of the English language. It was the first of the eleven new English translations of the Bible which ended with the King James version in 1611. Half a million English Bibles were bought in Elizabeth I's reign in a population of six million. In 2000 the new British Library, opened by Elizabeth II in 1998, published the first complete edition of Tyndale's New Testament since 1526.

The Bible was translated into Italian in 1607 and revised in

1641 by Giovanni Diodati (Lucca 1576–1649 Geneva), whose nephew Carlo (1609–38) was Milton's one close friend at St Paul's School in London. Later, like his father Teodoro (Geneva 1573–1651 London), Carlo practised as a physician in London. He died while Milton was in Italy. Milton addressed two elegies in Latin and a sonnet in Italian to him and wrote the pastoral *Epitaphium Damonis* on his death. Giovanni Diodati's translation is used by the Gideons.

Sir Thomas Wyatt the Elder (c.1503–42), who undertook diplomatic missions to several Italian courts in 1527, became one of the greatest innovators in English poetry. *Terza rima* had been pioneered by Dante and adopted by Boccaccio and Petrarch. Chaucer used it in *A Complaint to his Lady*. Wyatt revived it. *Ottava rima*, pioneered by Boccaccio, and the sonnet, identified with Petrarch above all others, were transplanted by Wyatt. His 'Paraphrase of the Penitential Psalms' (1549) from Aretino alternates between *ottava* and *terza rima*. There were three satires in *terza rima*, 25 epigrams in *ottava rima* and 30 sonnets among his 96 poems first published in Tottel's *Miscellany* (1557). Sonnets were also among the 40 poems of his disciple Henry Howard (1517–47 on the block on Tower Hill), Earl of Surrey, which were the main other and the most popular components of the *Miscellany*. In his translations from Vergil, Surrey pioneered blank verse (the Italian *versi sciolti*). Wyatt's and Surrey's seminal work was to beget many of the

gems of English literature later in the century and in later centuries.

Elizabeth I and James I and his wife spoke Italian. They were taught by Protestant refugees from Italy. Queen Elizabeth was taught by Giovanni Battista Castiglione from Mantua. He served as a soldier under Henry VIII, was naturalised under Edward VI and died in 1597. Michelangelo Florio was employed in 1552 to teach Italian to Lady Jane Grey, Henry VII's great-granddaughter. He came from a Florentine family of Jews who became Catholics. Joining the Franciscans and then the reformers, he was arrested by the Inquisition. In 1550 he escaped to Venice and, with the help of the English ambassador, to London, where he was given a stipend to be pastor of the new-born Italian Protestant Church. He dedicated his *Regole de la lingua toscana* to Jane, who usurped the throne for nine days in 1554 between Edward VI and Mary I. Florio fled to Strasbourg, where he wrote a biography of Lady Jane in Italian with translations of her letters and speeches. In Basel in 1563 he translated a Latin book by Georgius Agricola, 'the father of mineralogy', into Italian and dedicated it to Queen Elizabeth. (The book was translated into English in 1912 by Herbert Hoover, President of the United States (1929–33), and his wife.) He died three years later. Florio's son John (London 1553–1625 London) is remembered for his florid translation of the Essays of Montaigne. He wrote two Italian–English textbooks and the first Italian–English dictionary,

A World of Words (1598); he married the sister of the poet Samuel Daniel. Giacomo Castelvetro (Modena 1546–1616 Greenwich), a wandering heretic and scholar in all the countries between Venice and Stockholm, was engaged in 1592 to teach Italian to James VI of Scotland and his wife, Anne of Denmark. In 1614 he wrote a book in Italian on the vegetables, herbs and fruits of Italy. It was published in translation in 1989.

Elizabeth's England set much store by Italian style and manners. The polished and sophisticated *Cortegiano* (1528) by Baldassare Castiglione (Casatico 1478–1529 Toledo) was translated as *The Courtyer* in 1561 by Sir Thomas Hoby, who had been in Italy from 1547 to 1555, and went through further editions in 1577, 1588 and 1603. *Galateo ovvero de' costumi* (1558) by Archbishop (1544) Giovanni Della Casa (Mugello 1503–56 Rome) was translated as *Galateo, of manners and behaviour* by Robert Peterson in 1576. A translation of the first three books of *La civil conversatione* (1574) by Stefano Guazzo (Casale Monferrato 1530–93 Pavia) was made by George Pettie in 1581 and of the fourth book by Bartholomew Young in 1586. A translation of *Tre dialoghi della vita civile* (1565) by the tragedian Giambattista Giraldi (Ferrara 1504–73 Ferrara), known as 'Cinzio', was published in 1606 by Lodovico Bruschetto (1546–1612) under his naturalised name Lodowick Bryskett.

Sir (1583) Philip Sidney (Penshurst 1554–86 of war wounds at Arnhem), godson of Mary's King Consort Philip and cupbearer

(1577) of Queen Elizabeth, was immediately recognised and long remembered as the English embodiment of the gallant and cultured gentleman. In the course of a Grand Tour he reached Venice in October 1573, where he sat for Veronese, and, after visiting Genoa and Padua, left Italy in July 1574. He did not live to realise his political and military promise but he was the finest of the Elizabethan writers in prose and, next to Edmund Spenser, in poetry. His *Arcadia*, widely circulated in his lifetime but not published until 1590, created the English vogue for pastorals. Based on the Neapolitan Jacopo Sannazaro's *Arcadia* (1504), a similar mixture of prose and verse, Sidney's *Arcadia* was followed by Robert Greene's *Menaphon* (1589), reprinted as *Greene's Arcadia* (1590), and Thomas Lodge's *Rosalynde* (1590), the origin of Shakespeare's *As You Like It*. Sidney's younger sister Mary (1561–1621), Countess of Pembroke, translated Petrarch's *Trionfo della Morte* in *terza rima*.

Pastoral poems or eclogues were initiated by Spenser's *Shepheardes Calender* (1579), dedicated to Sidney. In 1567 George Turbervile had turned into fourteeners nine of the ten famous Latin pastorals of the Blessed Battista Spagnoli (1448–1516), the 'good old Mantuan' invoked and misquoted in Shakespeare's *Love's Labour's Lost*, IV ii. Spenser emulated Mantuan and copied his seventh and ninth eclogues. Spenser's pastorals were followed by Drayton's *The Shepheards Garland* (1593), Richard Barnfield's *The Affectionate Shepheard* (1594), William Browne's *Britannia's*

Pastorals (1613–16) and Phineas Fletcher's *Piscatory Eclogues* (1633). The last line in Milton's *Lycidas* (1637) comes from the last line of Mantuan's ninth eclogue. The Latin poems of Mantuan and Marcantonio Flaminio (Serravalle, now Vittorio Veneto 1498–1550 Rome) long survived as textbooks in English schools.

Italian pastoral plays were soon copied in England. Torquato Tasso's *Aminta* (1573) inspired John Lyly's *Galathea* and George Peele's *Arraignment of Paris* in 1584. It was translated into Latin hexameters by Thomas Watson in 1585 and published in Italian by Giacomo Castelvetro in 1591. Abraham Fraunce paraphrased Watson's Latin in 1587 and Tasso's Italian in 1591. Battista Guarini's *Il pastor fido* (1590) was also published in Italian by Castelvetro in 1591 and in an anonymous translation in 1602; it inspired John Fletcher's *Faithful Shepherdess* in 1610 and the title and libretto of Handel's second opera in England in 1712. Milton's *Comus* was performed in 1634. Sir Richard Fanshawe translated Guarini in rhyming couplets in 1647. Guidubaldo Bonarelli's *Filli di Sciro* (1607) was translated by Jonathan Sidnam in 1655.

Sidney's sonnets, also widely circulated in his lifetime, were published as *Astrophel and Stella* in 1591. He kept more closely than Wyatt and Surrey to Petrarch's rhyme schemes but in four out of five cases used, like them, a concluding couplet. His work was followed by an astonishing outpouring of sonnets by Daniel and Henry Constable in 1592, Lodge, Watson, Giles Fletcher and Barnabe Barnes in 1593, William Percy and Michael Drayton

in 1594, Spenser and Barnfield in 1595, Bartholomew Griffin, Richard Linche and William Smith in 1596 and Robert Tofte in 1597. The anonymous *Zepheria* appeared in 1594. William Shakespeare's sonnets were published in 1609. The years in which English poets wrote the great sonnets coincided with the years in which the English composers Thomas Morley, Thomas Weelkes, John Ward and John Wilbye wrote the great madrigals. The first English woman to write a sonnet sequence was Sidney's niece, Lady Mary Wroth (c.1586–c.1652); her *Pamphilia to Amphilkanthus* was published in 1621.

The great poems of the *Rinascimento* were written in *ottava rima*.[3] In 1586 John Stewart of Baldynneis wrote a version of Ludovico Ariosto's *Orlando furioso* in Scots (*Roland Furious*) but not in *ottava rima*. Sidney twice used *ottava rima* in *Arcadia*. In 1591 it was used by Spenser in 'Virgils Gnat' and 'Muiopotmos' and by Sir John Harington, godson of Queen Elizabeth I and ancestor of Queen Elizabeth II's first son-in-law, for his translation of Ariosto. Daniel then turned to it from his earlier rhyme royal for his historic epic *The civile wars between the two houses of Lancaster and Yorke* (1595–1609). It was used by Richard Carew in 1594 to translate the first five books of Torquato Tasso's *Gerusalemme liberata,* by Edward Fairfax in 1600 to translate the whole *Gerusalemme* and by Drayton to re-write his *Mortimeriados* (1596), which was in rhyme royal, as *The Barons Warres* (1603).[4] Daniel continued to use *ottava rima* in 'To Sir Thomas

Egerton' (1603) and in the chorus at the conclusion of Act II of *Philotas* (1605). Harington again used it in 1604 to translate the sixth book of Vergil's *Aeneid*. Drayton went on to use it in *The Legend of Great Cromwell* (1607), *The Battaile of Agincourt* (1627) and *The Miseries of Queene Margarite* (1627) and Richard Crashaw (1646) and Fanshawe (1655) used it in their translations of the epics of Giambattista Marino (1569–1625) and Luis de Camões (1524–80).

Spenser, like most English poets of the period, never visited Italy but was immersed in the contemporary Italian poets. He expressly took Ariosto and Tasso as his examples for *The Faerie Queene* (1589). In Book II he modelled the enchantress Acrasia on Alcina in Ariosto (Cantos 5, 6 and 10) and Armida in Tasso (Cantos 15 and 16) but he took her name from her counterpart Acratia in Trissino's epic *Italia liberata dai Goti*. The *Faerie Queene* was never finished or imitated.

Dramatists even more than poets have been the enduring glory of the reigns of Elizabeth I and James I. They used Surrey's blank verse. All of them, not least Shakespeare, drew on the collections of short stories printed in Italy. A wide public came to know the plots from William Painter's *Palace of Pleasure* (1566–67), which comprised 94 stories translated from classical and *Rinascimento* sources, including Boccaccio's *Decameron*, Giraldi's *Gli Ecatommiti* (Greek for *The Hundred Tales*) (1565) and Bandello's *Novelle* (1554). Extracts from Bandello had been

translated into French since 1559 by Pierre Boaistuau and François de Belleforest as *Histoires Tragiques*, of which Sir (1589) Geoffrey Fenton produced an English version in 1567. Venice and Milan above all, but also all significant cities in Italy, became familiar names to London audiences. Escalus in Shakespeare's *Romeo and Juliet* and *Measure for Measure* and Benvolio, Romeo's cousin and friend, recall the ruling Della Scala and Bentivoglio families in Verona and Bologna. Gonzago, the duke in the play within *Hamlet*, recalls the Gonzaga Dukes of Mantua.

The *commedia dell'arte* had only a spasmodic impact in England. The first troupe came with Drusiano Martinelli to London in 1577–78. In 1602 a troupe, which included Flaminio Curtesse, performed at Elizabeth's court. Although their improvised dialogue was rarely understood, the Italians had an influence as acrobats and musicians. Will Kempe, the clown and dancer who acted in Shakespeare's early comedies, visited Venice in 1601. He appears in a Venetian scene in John Day's *The Travails of the Three English Brothers Sir Thomas, Sir Anthony, Mr Robert Shirley* (1607).

THE STUARTS

The Italians provided English dramatists with more than themes, locations and stereotypes. The dramatic theories and practices

of the ducal courts in Italy gave rise to the brief and brilliant period of masques in royal and aristocratic circles in the last years of Elizabeth and into the reign of James's son Charles I (Dunfermline 1600–49 on the block in Whitehall). Elizabeth's entertainment for Paolo Giordano Orsini, Duke of Bracciano, during his visit in 1600 and 1601 is recalled by the name of the duke in Shakespeare's *Twelfth Night*. Masques reached their most lavish form through the conjunction of the stage settings and costumes of the great court architect Inigo Jones (1573–1652), who twice visited Italy (1598–1603 and 1613–14), the 25 libretti of the poet-dramatist Ben Jonson (1572–1637) and the music of the younger Alfonso Ferrabosco (1575–1628). The musician Angelo Notari (Padua 1566–1663 London) came to England in 1610 to serve King James's eldest son Henry and, after his death, served Prince Charles.

In 1642, when Charles I withdrew from London to Oxford and civil war broke out, Parliament closed the theatres and patronage of the arts and architecture lapsed. Among the royalists who spent time in Italy during Cromwell's Commonwealth was Thomas Killigrew (1612–83), a page to Charles I. In July 1660 Charles II granted him letters patent to establish theatre companies and erect theatres. In May 1661 the king renewed a similar patent which Charles I had granted in 1639 to Sir (1643) William Davenant (1606–68), Shakespeare's godson or, as he would have had it believed, Shakespeare's son. Davenant

launched the Duke of York's Servants at the Duke's Playhouse in Lincoln's Inn Fields in June 1661 and Killigrew the King's Servants at the Theatre Royal, Drury Lane, in May 1663. The Duke's Playhouse was ultimately transferred to Covent Garden. Typical of Restoration drama were two plays by Aphra Behn (1640–89), *The Rover* and *The Second Part of the Rover* (1677 and 1681), about royalist exiles in Italy.

THE EIGHTEENTH CENTURY

In 1614 Count Alessandro Tassoni (1565–1635) wrote the greatest mock-epic in Italian, *La secchia rapita*, about the ridiculous raid by Bologna on his home town Modena in the 14th century to recover the bucket stolen from Bologna's town well. A century later a prolific translator, John Ozell, produced a version in English, *The Rape of the Bucket*. He was upstaged when Alexander Pope, who had never left England but could read and quote Italian, wrote the greatest mock-epic in English, *The Rape of the Lock*. Pope ridiculed Ozell in his satirical poem *The Dunciad*. The bucket is still displayed in the campanile of Modena's cathedral, the Torre Ghirlandina.

Italy's scenic and social attractions were brought home to British readers by the elegant correspondence of Lady Mary Wortley Montagu (1689–1762), daughter of the 5th Earl (1690)

and 1st Duke (1715) of Kingston, and Sappho in *The Dunciad*. Lady Mary fell in love with the connoisseur and mathematician Francesco Algarotti (Venice 1712–64 Pisa), who explained Newtonianism 'for ladies in six dialogues on light and colours'.[5] She pursued him to Italy; he, however, went to live with Frederick the Great. Thereafter her life and times are recorded in her letters from Venice, Florence, Rome, Naples and Geneva and, after 1742, from Avignon. Between 1746 and 1756 she lived with the young Count Ugolino Palazzi at Gottolengo (between Brescia and Cremona), and, in summer, at Lovere, on the northern tip of Lago Iseo. She then settled in Venice. She was on good terms with two Jacobites, William Graeme, the commander-in-chief of the Venetian land forces, and Sir James Steuart, who dedicated his *Political Oeconomy* to her, but not with the British Consul Joseph Smith, or the British Resident, John Murray. Her husband, Edward Wortley Montagu, with whom she had eloped in 1712 and who was ambassador to Turkey for seventeen months in 1717–18, remained in England and died in 1761. The following year Lady Mary returned to die in England. Many of her letters were published in 1763 and more and more have been published to the present day.

Some authors were inspired by their visits to Rome. 'It was at Rome, on the fifteenth of October, 1764,' wrote Edward Gibbon in the final version of his *Memoirs*, 'as I sat musing amidst the ruins of the Capitol, while the barefoot fryars were

singing Vespers in the temple of Jupiter, that the idea of writing the decline and fall of the City first started to my mind.' On Ash Wednesday in the following year James Boswell decided to keep explicit accounts, social and financial, of his stay in Rome. 'I thought,' he wrote, 'that one might well allow one's self a little indulgence in a city where there were prostitutes licensed by the cardinal-vicar.' Everybody to his own taste.

Gibbon (1737–94) and Boswell (1740–95) were near contemporaries. The six volumes of Gibbon's *Decline and Fall of the Roman Empire,* the most famous history in the English language, appeared in three instalments between 1776 and 1788. With *An Account of Corsica; The Journal of a Tour to That Island; and Memoirs of Pascal Paoli* Boswell became an instant international celebrity in 1768. In 1773 he took Dr Johnson (1709–84), who never left Britain, on a tour of the Hebrides. His *Life of Samuel Johnson* (1791) is the most famous biography in the English language.

THE NINETEENTH CENTURY

The first two cantos of *Childe Harold's Pilgrimage* by Lord Byron (1788–1824) were published in March 1812. He wrote, 'I woke one morning and found myself famous'. The third canto was published in 1816 after Waterloo and the fourth, after and about

a fascinating tour of Italy, in 1818. The poem was written in Spenserian stanzas.

There was a remarkable revival of *ottava rima* in English poetry after Byron left England for the last time on 25 April 1816. The following year he was attracted by the *Prospectus and Specimen of an Intended National Work by William and Robert Whistlecraft... relating to King Arthur and his Round Table* by John Hookham Frere (London 1769–1846 Valetta), a member of the Society of Dilettanti.[6] In the proem William and Robert Whistlecraft proposed to write a book 'such as all English people might peruse'.

> *And we'd take verses out to Demerara,*
> *To New South Wales, and up to Niagara.*

Frere wrote in the stanza and style of the mock-epic *Morgante maggiore* (1483) by Luigi Pulci (Florence 1432–84 Padua). In February 1818 Byron published *Beppo* 'in or after the excellent manner of Mr Whistlecraft'.

In July 1819 Byron used *ottava rima* in the first canto of his masterpiece *Don Juan*. (He had completed only sixteen cantos when he died in 1834.) He used the stanza in his 1820 translation of the first canto of *Morgante maggiore*, as did Shelley in *The Witch of Atlas* and Keats in *Isabella; or The Pot of Basil* (from the fifth novella of the Fourth Day of the *Decameron*). In 1821 the stanza was used by Charles Lloyd (1775–1839) in *Titus and*

Gisippus (from the eighth novella of the Tenth Day of the *Decameron*). Byron used it again in *The Vision of Judgement* (1822), his superb satire on Southey's *A Vision of Judgement* (1821), in which the poet laureate envisioned the entry of George III into Heaven.[7] Encouraged by Sir Walter Scott, William Stewart Rose (1775–1843) used *ottava rima* in his painstaking translation of Ariosto's *Orlando furioso* between 1823 and 1831.

The poorest pentametres of any *ottava rima* in English were those composed by the Surveyor-General of NSW, Sir (1838) Thomas Mitchell (1792–1855). During a voyage to Britain in 1853, he embarked on a translation of the ten cantos of *Os Lusíadas* (1572), the Portuguese imperial epic on the voyage to India by Vasco da Gama. It was published in London in 1854 as *The Lusiad of Luis de Camões, closely translated*.

In 1819 and 1820 there was a brief revival of *terza rima* when Byron used it in *The Prophecy of Dante* and Shelley in 'Ode to the West Wind'. The splendid Petrarchan sonnets in Wordsworth's *Poems* published in 1807 led to similar sonnets by Byron, Shelley and Keats.

Famous Italian rebels found their way to England, among them the poets Ugo Foscolo (Zante 1778–1827 London) and Gabriele Pasquale Giuseppe Rossetti (Vasto 1783–1854 London). Foscolo fled from Milan after the Austrians occupied Napoleon's Kingdom of Italy in 1814. He settled in London in 1816. Rossetti was sentenced to death for his part in the Neapolitan revolt in

1820. He escaped in an English ship to Malta and arrived in England in 1824. He taught Italian at King's College in London. His bilingual children Dante Gabriel (1828–82), William Michael (1829–1919) and Christina Georgina (1830–94) contributed greatly to English literature. The two sons were also significant in the Pre-Raphaelite Brotherhood of artists and writers.

In the days of the Roman republic the poet Arthur Hugh Clough was ambivalent towards Garibaldi in his narrative *Amours de Voyage* and Elizabeth Barrett Browning (Durham 1806–61 Florence) was effusive. Robert Browning (London 1812–89 Venice) made trips to Italy in 1838 and 1844 before he secretly married Elizabeth Barrett and eloped with her to Italy in September 1846. Their only child, the sculptor Robert Wiedemann Barrett Browning (1849–1912), known as 'Pen', purchased the Palazzo Rezzonico in 1887, and his father died there. Garibaldi's efforts to annex the Papal States inspired Algernon Charles Swinburne (1837–1909) to write 'The Halt before Rome, September 1867' and 'Mentana, First Anniversary' in *Songs before Sunrise* (published in 1871 with a dedication to Mazzini), two sonnets entitled 'Mentana, Second Anniversary' and two others entitled 'Mentana, Third Anniversary' in *Songs of Two Nations* (1875).

It is appropriate to recall that English library systems were virtually created by Italian immigrants, especially as, until 40 years ago, all collecting institutions in Australia—libraries, galleries and museums—seemed overwhelmingly English in their

provenance. Sir (1869) Anthony Panizzi (Brescello 1797–1879 London), fleeing from Modena to England in 1822 because of his anti-Austrian activities, became principal librarian of the British Museum in 1856. He designed and supervised the construction of the Reading Room, which opened in 1857 and which was copied by Melbourne. Andrea Crestadoro, migrating from Turin in 1849, was appointed chief librarian of the Manchester Free Libraries in 1864.

THE TWENTIETH CENTURY

The *Divine Comedy*, the greatest work of Dante, the greatest of Italy's poets, was translated by Sir Samuel Griffith in the hendeca-syllabic measure of the original but not in *terza rima*. Griffith, who was born in Wales in 1845 and died in Brisbane in 1920, was awarded the Mort Travelling Fellowship by the University of Sydney in April 1865. He began to study the Italian language on a voyage around Cape Horn to London in the following December and January in preparation for the grand tour of the Italian peninsula and Sicily in March and April. After being Premier and Chief Justice of Queensland and one of the founding fathers of the Australian Constitution, he was appointed the first Chief Justice of Australia in October 1903. Angus and Robertson published Griffith's *Inferno* in 1908 and Oxford University Press

published his complete *Divine Comedy* in 1911. There is a note to the 1908 edition: 'I desire to express my grateful acknowledgments to Mr C. J. Brennan, M.A., for his valuable criticisms and suggestions, without which any merit which this translation may possess would have been greatly diminished.'

Christopher Brennan (Sydney 1870–1932 Sydney) took the James King of Irrawang Travelling Scholarship to the University of Berlin when he was awarded his M.A. by the University of Sydney in 1892. He was the first poet associated with the University. His erratic and erotic verses and lifestyle made him more popular with the students than with the Senate. After many years of teaching, he was at last made an associate professor in 1921. His mistress was killed by a tram in March 1925. Three months later the Senate, by sixteen votes to four, sacked him for having committed adultery with her. He was granted a Commonwealth Literary Fund pension of £1 a week in the year before he died.

Australians entered the 20th century as one nation and one of the world's most literate countries. They were familiar with English novelists who had visited Italy or had written about Italy, such as Laurence Sterne, Tobias Smollett, Benjamin Disraeli, Charles Lever, Charles Dickens, William Makepeace Thackeray, Anthony Trollope's mother and brother, George Eliot, Henry Kingsley and 'Ouida'. Many Australian novelists had also lived in Italy in the 20th century. (George) Randolph Bedford (Sydney 1868–1941

Brisbane), Queensland Labor MLC (1917–22) and MLA (1923–41), took his family to England and Italy in 1901–04 and his Italian travel notes were published as *Explorations in Civilization* (1914). Louise Mack (Hobart 1874–1935 Sydney) lived for six years in Florence, editing the *Italian Gazette* from 1904 to 1907. Sydneysider Dorothy Manners-Sutton (1895–1972) married Salvatore Gentile, a Sicilian engineer, in Benghazi in 1936 but regained her British nationality and left Italy in 1946.

Martin Boyd (Lucerne 1893–1972 Rome), who had lived most of his life in Britain, finally settled in Rome in 1957. His straitened circumstances were brought to my attention in 1971 by Edmund Campion, whom the Keating Government later appointed as chair of the Australia Council's Literature Fund, and Richard Hall, whom my Government appointed as administrator of the Public Lending Right. I brought their concerns to the attention of Brendon Kelson, the secretary of the Literary Fund, of which, as Leader of the Opposition, I was a member. On 14 January 1972 Hall and my wife and I met Martin Boyd in Rome. Soon afterwards he was officially informed that the Fund had granted him $1000 and a weekly pension for life. A few days before he died on 3 June he was received into the Catholic Church. His nephews, the artist Arthur Boyd, sculptor Guy Boyd and potter and painter David Boyd, attended his burial in Rome's Protestant English cemetery after a service conducted by his Catholic priest and the Anglican vicar.

Morris West (Melbourne 1916–99 Sydney) lived in Rome from the late 1950s to 1971. He made a fortune from his knowledge of Italian and Vatican history and politics. Although he was rarely praised by literary critics, no Australian author has enjoyed so many readers around the world. His 30 novels have been translated into 27 languages. More than 60 million copies have been sold. A notably generous author, he was appointed chairman of the National Library Council (1985–88) by the Hawke Government. His last novel, *The Last Confession*, was unfinished when he died. It was published in June 2000 to mark the quatercentenary of the martyrdom of Giordano Bruno (1748–1600). Bruno had been the hero of one of West's three plays, *The Heretic*, written in blank verse in 1970. A Dominican (1565–76) and Calvinist (1578–80), he spent three years (1583–85) in England, where he wrote three Copernican dialogues and three moral dialogues in Italian. He associated with Robert Dudley (1632–88), Earl of Leicester (1564), a Puritan in politics but not in matrimony, and his nephew Sir Philip Sidney.[8] Bruno is commemorated in Rome by a statue erected in 1889 in the Campo de' Fiori, where, naked and gagged, he was burned alive. The Sydney radio station 2GB, established by the Theosophists in 1926, was not named after Great Britain but after Giordano Bruno. It was later taken over by the Wesley Central Mission. The Mission has recently entered into a partnership with the Philistines.

MONARCHS

THIS CHAPTER DEALS WITH the relations between hereditary heads of state who spoke Italian or English. Some readers might consider that I, a republican since 1975, give undue prominence to dynastic contacts and connections. I point out that relations between nations and their colonies continued to be the province of monarchs in most of Europe and Asia until World War I and in the Balkans until World War II.

SAXONS AND NORMANS

There was a Saxon school in Rome from the 8th century to the 12th. Alcuin of York, the greatest scholar of the age, was on his way back from Rome in 781 with the pallium for the archbishop of York when he met Charlemagne at Parma and was persuaded to become head of the new Palatine school at Aachen. Alfred

the Great was sent by his father to Rome in 853 at four years of age and taken there by his father two years later.

The Anglo-Saxon kings were notably devout. Oswald, the King of Northumbria who fell in battle with the pagan King Penda in 641, came to be venerated throughout northern Italy. Caedwalla, King of the West Saxons, turned Christian and left for Rome in 688. He was baptised by Saint Sergius I on Holy Saturday the following year and, dying ten days later, was buried in the crypt of St Peters. Early in 709 Cenred, King of Mercia, and Offa, King of the East Saxons, left to be monks in Rome. Ine, Caedwalla's successor, abdicated and retired to a Roman monastery in 726. Burgred, King of Mercia (852–74), fled from the Danish invaders to Rome, where he soon died. Two kings of England were saints, Edward the Martyr (c.963–78), who reigned from 975, and Edward the Confessor (c.1003–66), who reigned from 1042. Canute the Great, King of Denmark (1019–35), after making himself king of the English, made the pilgrimage to Rome in 1027, as did Harold II, the last Saxon king of England, in 1058. Macbeth, King of Scots (1040–57), and Thorfinn, Earl of Orkney, also made the pilgrimage in 1050.

In 1066 Pope Alexander II (September 1061–April 1073), from Milan, sent the banner of St Peter to William the Bastard, Duke of Normandy (1035–87), to bless his invasion of England. He became king of England after Harold II was killed in the

battle of Hastings on 14 October 1066. Thereafter he was known as William the Conqueror.

The Crusades gave large and diverse bodies of Englishmen an opportunity to visit Italy. Many English and Scottish knights and soldiers joined the battalion which Robert II, Duke of Normandy (1087–1106), William the Conqueror's eldest son, took to the First Crusade. Robert crossed the Alps in November 1096 and wintered in Calabria. The Conqueror's uterine brother, Bishop Odo of Bayeux, accompanied Robert from Normandy to Calabria but died in February 1097 in Palermo, the other Norman capital, and was buried in the Cathedral. Robert sailed from Brindisi in April 1097. On his way home through Apulia he married Sibylla, the daughter of Geoffrey, Count of Conversano, a nephew of the Norman adventurer Robert Guiscard.[1] Robert II's wounds were treated at Salerno, where a guide to health was written for him in Latin verse, the *Regimen Sanitatis Salernitanum*.

In the course of the Third Crusade Richard I, Coeur de Lion, King of England (1189–99), the son of Henry II, King of England (1154–89), spent seven turbulent months in Messina, where his 200 ships assembled. Having ridden to the Strait with a single companion through Genoa, Pisa, Ostia, Salerno and Mileto, he landed in Messina on 3 September 1190 and was joined by his sister Joan. Her husband, King William II of Sicily, had died in 1189 and had been succeeded by his illegitimate cousin Tancred.

Within a month Richard had quarrelled with Tancred over Joan's dower and a subsidy for the Crusade and had sacked Messina, whose citizens offended him. He then made favourable dynastic and financial arrangements with Tancred.

In 1149 Richard's mother, Eleanor of Aquitaine, had visited Roger II, Grand Count of Sicily (1105–30) and King of Sicily (1130–54) and the grandfather of William II and Tancred, on her return from the Second Crusade. She then joined her first husband, Louis VII of France, in Calabria and proceeded home with him through Rome. In 1191 she returned to Italy to bring Richard a bride, Berengaria, the daughter of King Sancho VI (1150–94) of Navarre, a region which adjoined Richard's Gascony. On 30 March he joined his mother and betrothed in Brindisi and brought them to Messina. Eleanor left three days later. As it was Lent, Berengaria and Richard had to travel in separate ships to be married in Cyprus before they reached the Holy Land. Berengaria's ship was wrecked on the island and she and her ladies were treated with disrespect by the troops of the rebel emperor of Cyprus, Issac Komnenos. Richard conquered the island. In May he and Berengaria were married and she was crowned at Limassol. (The conquest and the marriage are cele-brated in Handel's opera *Riccardo Primo* [1727].) The marriage was never consummated. In 1230 Berengaria was buried in a Cistercian monastery she founded in France at L'Épau. She was survived by her brother, Sancho VII (1194–1234).

In 1192 Richard set out on a solitary passage home through the Adriatic. He called at Corfù and Ragusa and was shipwrecked near Venice. Leopold V, Duke of Austria, whom he had insulted in the Holy Land, caught him in disguise in Vienna and imprisoned him for several months before handing him over to the Holy Roman Emperor Henry VI, husband of Roger II's posthumous daughter Costanza d'Altavilla (Constance d'Hauteville) (Palermo 1154–98 Palermo), Queen of Sicily (1194). Richard was released in 1194 after paying a colossal ransom, which Henry used to finance the expedition that deposed Tancred's son William III. He was crowned again in April 1194 and spent the second half of his reign fighting the King of France. He died in his Duchy of Aquitaine at the age of 41 and is buried with his parents at Fontevraud. Richard was succeeded by his brother John (1199–1216), who was succeeded by his son, Henry III (1216–72).

In 1235 the widowed Holy Roman Emperor (1220–50) Frederick II (Jesi, Ancona 1194–1250 Fiorentino, Apulia), the son of Constanza and King of Sicily (1197–1250) and Jerusalem (1229–43), sent his most trusted adviser, Pietro Della Vigna, to London to seek the hand of Isabella, Henry III's sister. The couple married in Worms but left Germany for Italy in 1237. In 1238 Henry sent a force to assist Frederick in his war against the Lombard League. The English captured several cities, notably Piacenza, and returned home in 1239.

In July 1241, returning from the Holy Land, Henry III's brother Richard (1209–72), Earl of Cornwall and King of the Romans (1257–72), landed in Sicily, where his brother-in-law, as King Federico I, brilliantly received him. In November he left Sicily to make a progress through the cities of Italy on his way home. In December his sister Isabella died at Foggia.

There was a vacancy in the Papacy between the death of Celestine IV, a Milanese, in November 1241 and the election of Innocent IV, a Genoese, in June 1243. Out of loyalty to Federico, Richard rejected Innocent's offers of the Imperial crown and, later, the Sicilian crown. In 1254, however, Henry III undertook to subsidise Innocent's war against Federico's son, Corrado IV (Andria 1228–54 Lavello), King of the Romans, Sicily and Jerusalem, if his own younger son Edmund (1245–96) was given the crown of Sicily. In the following year the next pope, Alexander IV (1254–61), a Roman, enfeoffed Edmund as King of Sicily. As the English barons refused to help Henry meet his obligations, the Pope cancelled the arrangement in 1258. In 1263 a third Pope, Urban IV (1261–64), a Frenchman, enfeoffed Carlo I as the first Angevin King of Sicily for barely one-third as many marks as Henry III had promised Alexander IV.

In October 1270 Lord Edward, heir of Henry III, arrived in Sicily with his brother Edmund, Earl of Lancaster (1267), his cousin Henry of Cornwall, his confidant Tebaldo Visconti of Piacenza, who had been with the papal legate in England

between 1265 and 1268, and a force of 1000 soldiers. Henry joined Carlo I and his nephew Phillip III, the new King of France, and went to Viterbo, where Pope Clement IV, a Frenchman, had died on 29 November 1268 and the cardinals had not yet elected his successor.[2] On Good Friday, 13 March 1271, Henry was murdered at the altar of S. Silvestro and his body was dragged into the piazza outside by Guy de Montfort, Carlo I's vicar in Tuscany.[3] (Guy, Edward, Edmund and Henry were grandsons of King John of England.) Later in March Edward attended Henry's funeral at S. Francesco in Orvieto.[4] His expedition sailed from Trapani for the Holy Land in May.

The cardinals elected Visconti as Pope in his absence. He returned from Acre in the Holy Land to Viterbo on 10 February 1272, then went to Rome and, after being ordained a priest, was consecrated in St Peters on 27 March as Gregory X. Edward arrived back in Trapani in October. After Henry III's death on 16 November he was immediately acclaimed as Edward I. Edmund arrived back in England in December. The new king set out for home through Italy. He was received by the new Pope. On 14 February 1273, at a ceremony in S. Francesco in Orvieto, he persuaded Carlo I and Gregory X to excommunicate and outlaw Guy de Montfort.

Edward I continued his journey through Bologna, where he engaged the jurist Francesco Accorso junior (1225–93) as his secretary and counsellor, Parma, Milan and the Mt Cenis pass.

He paid homage for his French lands to his cousin Philip III in Paris on 26 July 1273 and spent several months in Gascony. He was crowned at Westminster on 19 August 1274. Gregory X died in 1276. The next visit to Italy by a reigning English monarch was to be by Queen Victoria, who came by train to Lago Maggiore in 1879.

ORDER OF THE GARTER

The Most Noble Order of the Garter, the oldest and most distinguished order of chivalry, was founded by King Edward III in 1348. The first Italian monarch to receive the Garter was Alfonso I, King of Naples (1442–58). He had been Alfonso V, King of Aragón, since 1416 and had ousted Renato I (Shakespeare's Regnier), the last reigning Angevin King of Naples (1438–42) and the father of Margaret of Anjou (1430–82), who married Henry VI (1421–71), King of England (1422–61 and 1470–71), in 1445. In 1450 Henry VI, however, saw diplomatic and dynastic advantages in making Alfonso the 166th knight in the Order.

Alfonso had his illegitimate son Ferdinando (Valencia 1423–94 Naples) legitimated and recognised as his heir. Ferdinando reigned as Ferdinando I of Naples from 1458. In 1463 Edward IV (1442–83), King of England (1461–70, 1471–83), sent him the 192nd Garter. In the same year he sent Francesco

Sforza, Duke of Milan, the 195th Garter. In 1480 he sent Ercole I d'Este, Duke of Ferrara and Modena, the 219th Garter. In 1493, Henry VII, King of England (1485–1509), sent the Garter of the 242nd Knight to Ferdinando I's eldest son Alfonso, who reigned as Alfonso II of Naples in 1494 and 1495.

Henry VII had sent the 212th Garter to Federico II da Montefeltro (1422-82) in 1474, when he became the first Duke of Urbino. In 1506 Baldassare Castiglione, the paragon of courtiers, visited England to take delivery of the Garter for the 259th Knight, Guidubaldo I, the son of Federico. Before the duke died in 1508 he decorated the palace at Gubbio with the insignia of the Garter, as his father had done in the ducal palace at Urbino.[5]

THE HOUSE OF SAVOY

English royal families had contacts with the House of Savoy between the 12th and 20th centuries. The first link was established when Henry II sought territories for his youngest son, John 'Lackland', by arranging a marriage between him and Alice, the daughter of Count Umberto III of Savoy. He received four castles as an advance on the dowry. Alice died soon afterwards.

Savoy established more enduring and profitable associations with England through the children of the next count, Tommaso I. In 1236 his elder daughter's daughter, Eleanor of Provence,

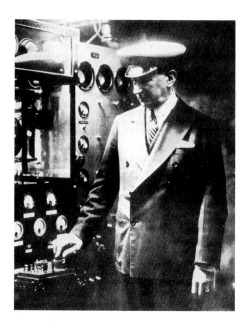

Guglielmo Marconi aboard his yatch Elettra, moored in Genoa harbour, transmits the radio signal that lights up Sydney Town Hall.

Sydney Town Hall illuminated by Marconi. (COURTESY STATE LIBRARY OF NEW SOUTH WALES)

The future kings George VI (left) and Umberto II (right) at play.

Prince Umberto on parade.

EGW on Sydney Harbour with the President of Italy, Giuseppe Saragat (second from right), during his 1967 State visit. (STATE LIBRARY OF NEW SOUTH WALES)

After EGW's 1967 private audience Margaret, Nicholas and John Menadue were presented to Pope Paul VI by God's banker and the Pope's assistant, Monsignor Paul Marcinkus, with the words sono anglicani. (COURTESY JOHN MENADUE)

Margaret and EGW being led by the Vatican Guard to their 1973 audience with Pope Paul VI.

Mick Young (right), national secretary of the ALP, and Eric Walsh, EGW's public relations officer, were given bronze medals by Paul VI with the words sono polizia. They had taken the place of our security officers Bob Brown and Bob Massey. (COURTESY CAV. TONY FACCIOLO)

Catherine, Margaret and EGW with the beneficiaries of the Treaty of Rome, Queen Fabiola and King Baudouin.

At the opening of the Sydney Opera House with two first ladies, Margaret and Imelda Marcos (third from left). (COURTESY STATE LIBRARY OF NSW)

EGW considering an ancient Roman warrior during a visit to the Colosseum in 1975. (COURTESY *THE AGE*)

At an ecumenical service to inaugurate the restoration of the organ in the church of S. Martino in Castello, Venice. From right to left: the Most Reverend Felix Arnott (the Vicar of Venice), EGW, the Vicar-General, Valerie Howse and Amina Belgiorno-Nettis. Douglas Scott, the Australian ambassador to Italy, is at the microphone. (COURTESY VALERIE HOWSE)

Margaret and EGW approaching the Cá Venier dai Leoni and Palazzo da Mula with fellow travellers John Wellings and Anne Krone. (COURTESY REG TAYLOR)

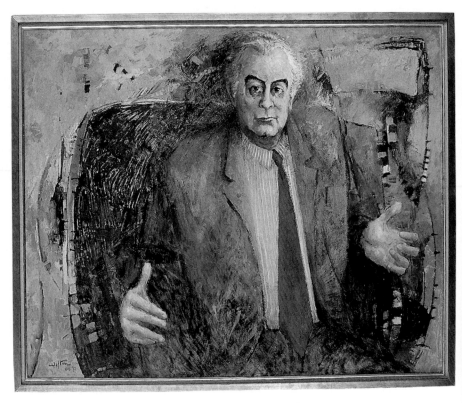

Clifton Pugh's original portrait of EGW.

married Henry III. His fifth son, Guglielmo, accompanied his niece to England. His sixth son, Peter of Savoy (Susa c.1203–68 Pierre Châtel), 'the little Charlemagne', came to England at the king's invitation in 1241 and was made Earl of Richmond. He became one of the king's most intimate and constant advisers, serving him as soldier and negotiator in England, France, Scotland and Italy, even after himself becoming Count of Savoy as Pietro II (1263), and gave the Castle of Chillon its importance and present appearance. In 1246 the king gave Pietro the site in the Strand in London on which he erected the Palace of Savoy, burnt down in 1381. The name has been used for the hospital, which Henry VII built in 1505 in accordance with medical ideas current in Florence, for the chapel which was part of it and for the military prison, hotel and theatre which have successively occupied the site.[6]

The count's gilt figure stands over the entrance of the Savoy Hotel and a plaque in the courtyard proclaims that he lodged in his palace 'the many "beautiful foreign ladies" whom he brought in 1247 from the courts of Europe before marrying them to his wards, a large number of rich young English nobles'. The count's seventh son, Boniface (1207–70), was nominated by the king as Archbishop of Canterbury in 1241. He was unpopular to the point of violence in England and finally left on the crusade with Lord Edward in 1269, dying in Savoy on 14 April 1270. He was beatified in Savoy in 1838; his feast day is 14 July.

Amedeo VIII (1383–1451), Count of Savoy (1391–1416), was promoted to Duke after acquiring Piedmont. In 1434 he installed his son Ludovico as regent and devoted himself to creating the religious Order of S. Maurizio, the patron of Piedmont, Savoy and Sardinia. In 1440 Amedeo abdicated as Duke and was crowned as Pope Felix V. Under pressure from England, France and Sicily, he abdicated as Pope in 1449 in favour of Nicholas V, who appointed him cardinal bishop of Sta Sabina in Rome.

Warwick the Kingmaker wanted Edward IV (1442–83), King of England (1461), to marry Bona, daughter of Ludovico, the second Duke (1440–65). Shortly before Henry VII (1457–1509), King of England (1485), died he was negotiating to marry Margaret (1480–1530), the widow of Filiberto II, the eighth Duke (1497–1504).

In 1555 Mary I, Queen of England (1553–58), made the tenth Duke, Emanuele Filiberto Testa di Ferro (1553–80), the 333rd Knight of the Garter. In 1611 his son, Carlo Emanuele I, the 11th Duke (1580–1630), proposed to James I of England that their eldest sons should marry their eldest daughters. The following year, however, Henry, Prince of Wales, died and Princess Elizabeth (1596–1662) married the Protestant Friedrich V (1596–1632), Count Palatine of the Rhine.[7]

Carlo Emanuele II (1634–75), the 14th Duke (1638), was involved in the massacre of the Valdesi (Waldenses) which outraged Oliver Cromwell, Protector of England. He was still

under the tutelage of his mother, Maria Cristina, daughter of Henri IV of France, when on 24 April 1655 his representative Andrea Gastaldo perpetrated the massacre, the *Pasque Piemontesi* (Easter in Piedmont). Cromwell ordered Admiral Blake to prepare a blockade of Nice and Villefranche, the ports of the dukedom, despatched Latin letters drafted by Milton to the Protestant powers in May and sent Samuel Morland (1625–95) to Turin to remonstrate with the Duke. In order to secure a treaty with England, France compelled the Duke to extend toleration to the Valdesi by the Treaty of Pinerolo on 18 August 1655. Milton wrote the sonnet 'On the Late Massacre in Piedmont' and Morland, who became a baronet (1660) and a prolific inventor, published *The History of the Evangelical Churches of the Valleys of Piemont*, an inflammatory martyrology, in 1658.

The Savoy Declaration was a statement of Congregational principles drawn up at a conference in the chapel of the Savoy Palace in London in 1658. The Savoy Conference between Anglicans and Presbyterians at the palace in 1661 met to revise the Prayer Book and resulted in the separation of the churches.

Vittorio Amedeo II (1666–1732), the 15th Duke (1675–1730) and the first Savoy king (Sicily 1713–20, Sardinia 1720–30), married Anne-Marie d'Orleans (1669–1728), who in dynastic terms had the strongest claim to succeed Anne (1665–1714) as the second Queen of Great Britain; they were granddaughters of Charles I of England and Scotland.

Prince Eugene of Savoy (Paris 1663–1736 Vienna), the imperial general and the Duke of Marlborough's companion-in-arms in the coalition against Louis XIV, was the grandson of the Prince of Carignano, a younger son of Carlo Emanuele I. (His mother was Cardinal Mazarin's niece Olimpia Mancini, the sister of Charles II's mistress, the Duchess of Mazarin, and the cousin of James II's mother-in-law, the Duchess of Modena.) After Marlborough was replaced as English commander by the Duke of Ormonde in December 1711, Eugene was sent by the emperor on a fruitless mission to persuade the British Government to continue the war against Louis XIV. During his stay in London (January–March 1712), his nephew and namesake, aged nineteen, died of smallpox and was buried in the Ormonde vault in Westminster Abbey.

Ferdinando (1822–55), first Duke of Genoa, was entertained by Queen Victoria in 1852. His brother, Vittorio Emanuele II (1820–78), King of Sardinia (1849) and first King of Italy (1861), was entertained by the queen in 1855 after he became her ally in the Crimean War. (She invested him as a Knight of the Garter, the 714th, 300 years after his ancestor Emanuele Filiberto.) Lake Amadeus in the Northern Territory of South Australia was named after Amedeo Ferdinando Maria (1845–90), Vittorio Emanuele II's younger son and first Duke of Aosta, and King Amadeo I of Spain (1870–73). The lake had been explored in 1872 and revisited in 1874 by (William) Ernest (Powell) Giles

(Bristol 1835–97 Coolgardie), who was made a Knight of the Order of Merit of the Crown of Italy and an honorary member of the Royal Italian Geographic Society.

In 1878, on his accession as the second king of Italy, Umberto I was made the 768th Knight of the Garter and in 1891 his heir, later Vittorio Emanuele III, the 794th Knight. In 1902 Edward VII gave the Garter of the 820th Knight to Emanuele Filiberto, who had succeeded Amedeo as Duke of Aosta. Edward visited the Savoy kings on his many visits to Italy as Prince of Wales and his two visits as king. George V made a State visit to Rome in 1923. Vittorio Emanuele III, a minute monarch, and his tall Montenegrin queen were known as Curtatone and Montanara after the sites of two battles west of Mantua on 29 May 1848. They made State visits to London in 1903 and 1924 and had a handsome family.

THE HOUSE OF MEDICI

There were contacts between the Medici and the second Tudor Queen of England and the first and second Stuart Kings of England.

Caterina de' Medici (Florence 1519–89 Blois), daughter of Lorenzo il Magnifico's grandson Lorenzo II, Duke of Urbino, married Henri II, King of France. Her three eldest sons became kings of

France. Her fourth and youngest son, Hercule-François (1554–84), duc d'Anjou (1576) and formerly duc d'Alençon (1566–76), was engaged to Elizabeth I in 1579. After two wooing visits to London (1579 and 1581–82) the marriage did not take place.

Cosimo II de' Medici, Grand Duke of Tuscany, unsuccessfully sought marriages between his family and the children of James I. In 1612 he proposed a marriage between his second sister Caterina and Henry, Prince of Wales. After the death of the prince he unsuccessfully proposed marriages between his third sister Maria Maddalena and the new British heir, Charles, and between his younger brother Francesco and Elizabeth, the eldest daughter of James I.

Maria (Florence 1575–1642 Cologne), the sixth and youngest daughter of Francesco I de' Medici, Grand Duke of Tuscany (1574–87), was the second wife of Henri IV, the first Bourbon King of France. Their daughter Henriette-Marie married Charles I after he succeeded James I. Maria, the mother of Louis XIII, took refuge with her daughter in England between October 1638 and July 1641.

THE HOUSE OF STUART

The earliest memorial of the House of Stuart in Italy is to be found in the Castello Principesco (Landesführstliche Burg) at

Merano.[8] The top floor was added to the castle after the marriage in 1449 of Eleonore (1433–80 Innsbruck), sixth of eight children of James I of Scotland, and Archduke Sigismund (Innsbruck 1427–96 Innsbruck), Duke of Tirol (1446–90). The Stuart and Habsburg coats of arms are sculpted in the bedroom and study respectively over the connecting doorway. Although the Archduke is credited with three or four score children from his conscientious exercise of the *ius primae noctis*, he had none by Eleonore or her successor and, to keep the Tirol in his family, was persuaded to abdicate in favour of Maximilian, the heir to the Holy Roman Empire.

James Stuart (1476–1504), Duke of Ross, second son of James III, went to Rome in 1498 to be confirmed as Archbishop of St Andrew's. He made such a favourable impression there that Ariosto made him, under the name of Zerbino, one of the heroes of the *Orlando Furioso* and, in canto X, 84,[9] paid the tribute *Natura il fece, e poi ruppe la stampa* (Nature fashioned him, then broke the mould).

The popes greatly favoured the Stuarts. Innocent VIII sent a Golden Rose to James III in 1486 and to James IV in 1491.[10] Alexander VI sent James IV the sceptre and Julius II sent him the sword which still form part of the Scottish royal regalia in Edinburgh Castle. James V accepted a sword from Paul III in 1537 for use against Henry VIII of England, who had received one from Leo X in 1513. Mary (Linlithgow 1542–87 Fotheringay

on the block), Queen of Scots (1542–67), was sent a Golden Rose by Pius IV in 1560 when she was Queen of France. In 1625 Henriette-Marie received a Golden Rose from Urban VIII as she was leaving France to marry Charles I and in 1636 he sent her Gian Lorenzo Bernini's bust of the king modelled on Van Dyck's triple portrait.

In 1673 Charles II's brother James (London 1633–1701 Saint-Germain-en-Laye), Duke of York, married Maria Beatrice (Modena 1658–1718 Saint-Germain-en-Laye), the daughter of Alfonso IV d'Este, Duke of Modena (1658–62). Maria's mother, Laura Martinozzi, a daughter of one of Cardinal Giulio (Jules) Mazarin's sisters, brought her to England for the marriage and she made another visit in 1680.[11] The poets, like the public, gave Maria a mixed reception. To Rochester 'Signior Dildo' was 'one of Her Highness's train And helped to conduct her over the main'. John Dryden, the first person entitled poet laureate (1668), dedicated his opera *The State of Innocence* to her and in 1682 wrote his 'Prologue to The Dutchess On Her Return from Scotland'. In February 1685 the Duke succeeded to the thrones of Scotland and England as James VII and II.

Ortensia (Hortense) Mancini (Rome 1646–1699 Chelsea), daughter of another of Mazarin's sisters, went to France at the age of nine. In 1661 she married and her husband was created Duc de Mazarin. She left him in 1668 and lived in Italy and Savoy before settling in London in 1675. Edmund Waller had

her wanderings and the cardinal's ambitions in mind when he
greeted her arrival:

When through the world fair Mazarin had run
Bright as her fellow-traveller, the sun,
Hither at length the Roman eagle flies,
As the last triumph of her conqu'ring eyes.
As heir to Julius, she may pretend
A second time to make this Island bend.

She had been sought as his wife by Charles II when he was
in exile in France; she now became briefly his mistress. Her
Mémoires were published in an English translation in 1676. She
received pensions from Charles II and James II and, on a reduced
scale, from William III.

James Frances Edward (London 1688–1766 Rome), the sixth
child of Mary of Modena and James II, and the first to survive,
was born in June 1688, the occasion of Dryden's *Britannia Redi-*
viva. Six months after his birth the Queen fled with him to
France to escape the indignation in England over her husband's
support of Catholicism. James II followed.

Their son, 'James VIII of Scotland and III of England', or
the Old Pretender, was compelled to move from France to
Lorraine after the Treaty of Utrecht 1712 and to the papal city
of Avignon after the failure of his 1715–16 expedition to reclaim
the Scottish throne. He took refuge across the Alps after the Triple

Alliance in 1717 and was accommodated by Pope Clement XI in the ducal palace at Urbino, where his suite was called the *Sala del Re d'Inghilterra*. In 1719, in the Cathedral of Montefiascone, he married Maria Clementina (1703–35), the granddaughter of John III Sobieski, King of Poland. The Pope granted them the Palazzo Muti (now Palazzo Balestra, 56 via Veneto, the international department of the Banca Nazionale del Lavoro) in Rome and the Palazzo Savelli in Albano. They were buried in St Peter's, Benedict XIV raising a monument by Filippo Barigioni to her. There is also a monument to her by Filippo Valle in the church of the Santi XII Apostoli.

Charles Edward Louis Philip John Casimir Silvester Severino Maria (Rome 1720–88 Rome), 'Charles III', or the Young Pretender, was the elder son of the Old Pretender. He distinguished himself at the siege of Gaeta in 1734. In August 1745 he landed in the Hebrides, raising his father's standard, and invaded England as far as Derby by November. He withdrew to Scotland in December and, after losing the battle of Culloden Moor in April 1746, had to remain in hiding until he crossed to France disguised as a maid in September. He made a secret visit to London in 1750 and settled in Rome in 1766. The Popes had recognised his father as king but did not recognise him.

Charles was married to Louise Maximilienne Caroline Emmanuel de Stolberg-Gedern (Mons 1752–1824 Florence) on Good Friday 1772 by the Bishop of Macerata. They lived, as

the Count and Countess of Albany, in Rome until 1774, when they moved to Florence. In 1777 they bought the Palazzo Guadagni, now Palazzo San Clemente. They separated in 1780. Charlotte (Liège 1753–1789 Bologna), his daughter by Clementina Walkinshaw (c.1720–1802 Freiburg), was legitimised and created Duchess of Albany by him in 1784 and went to live with him in Florence and in 1785 in Rome. Robert Burns sang of her as the 'Bonnie Lass of Albany'. Bonnie Prince Charlie died on 31 January 1788 and was buried at Frascati in his brother's cathedral, where there is an inscription to his memory. On 7 February Governor Arthur Phillip was proclaimed Governor of New South Wales. He had to swear on the Bible that he acknowledged George III as the only lawful sovereign and that he abjured allegiance to the descendants of the Old Pretender.

The Old Pretender's younger son, Henry Benedict Thomas Edward Clement Francis Xavier (Rome 1725–1807 Frascati), 'Henry IX' of England, Cardinal (1747), Duke of York and Bishop of Frascati (1761), was granted a yearly secret service pension by George III in 1800. He was buried in the crypt of St Peter's, Rome, and his brother's body was transferred there. The Prince Regent, later King George IV, commissioned Canova to erect the monument to them and their father (1819). Queen Elizabeth, widow of George VI, paid for its restoration in 1959. Vestments embroidered with the old British royal arms are kept in the cathedral in Frascati. When the cardinal restored a chapel

in Santa Maria in Trastevere, a shield with the arms, surmounted by a royal crown and a cardinal's hat, was placed above the door.

The Countess of Albany met the dramatist and poet Vittorio Alfieri (Asti 1749–1803 Florence). After leaving the Young Pretender, she lived with Alfieri in Rome and Paris. In 1791 they visited London where, as Princess of Stolberg, she was received by George III and Queen Charlotte and by their sons but not their daughters. She and Alfieri then settled in Florence in the palace now occupied by the British consulate. After Alfieri died there he was succeeded by the painter and art dealer Baron (1828) François Xavier Fabre (1766–1837), who inherited the Albany and Alfieri libraries from her and in 1825 donated them and his own art collection to found the Musée Fabre in Montpellier. The tombs of Alfieri and the countess are in Santa Croce in Florence; she paid for his tomb and Fabre paid for hers. On the death of Cardinal York, George III granted her an annuity.

BALKAN DYNASTIES

The British Empire was involved in the dynastic politics and religions of the Balkans in World Wars I and II. Australia has been affected by the religions and politics of the region for many years, but first through the connections of the British royal family. Queen Victoria, her consort Prince Albert of Saxe-Coburg and

Gotha and Prince Augustus of Saxe-Coburg and Gotha were first cousins. Their descendants occupied the thrones of Greece, Romania, Bulgaria, Serbia and Yugoslavia. The Savoy and Bourbon-Parma families were linked with Montenegro, Bulgaria, Croatia and Romania.

Queen Victoria and Prince Albert had nine children. Their eldest child, Victoria Adelaide Mary Louise (1840–1901), married the future German Emperor Frederick III in 1858. Her eldest child was the third German Emperor, Wilhelm II. Victoria and Frederick had three other sons and four daughters. The third daughter, Sophie Dorothea (1870–1932), married the future Constantine I in 1889. Their three sons became kings.

Queen Victoria's and Prince Albert's second son, Alfred Ernest Albert (1844–1900), was offered the Greek throne after the overthrow of the first King of Hellas, Othon, a Bavarian prince and a Catholic, in October 1862. In a plebiscite in December Alfred received 230 016 votes out of 241 202. The National Assembly ratified the election in February 1863. The British Government, however, had entered into an arrangement with Russia and France that no prince of any of those countries could ascend the throne of Greece.

In March 1863 Britain, France and Russia nominated, and the Greek National Assembly accepted, Prince William George of Denmark (1845–1913) as the King of the Hellenes. He took the title of George I. (In the same month his sister, Princess

Alexandra, married Queen Victoria's and Prince Albert's eldest son, Edward Prince of Wales, the future King Edward VII.) George married Olga (1851–1926), daughter of the Grand Duke Constantine, second son of the Russian Emperor Nicholas I. Their eldest son, Constantine (1868–1923), was to become King Constantine I of the Hellenes (1913–17 and 1920–23).[12] Their third son, Nicholas (1872–1938), married a granddaughter of the Russian Emperor Alexander II and was the father of Princess Marina, Duchess of Kent (1934). Their fourth son, Andrew (1882–1944), married Princess Alice of Battenberg (1885–1969), a granddaughter of Queen Victoria, and was the father of Prince Philip, Duke of Edinburgh (1947).

Prince Alfred, who was created Duke of Edinburgh in May 1866, succeeded to the Duchy of Saxe-Coburg and Gotha in August 1893. In 1867 and 1868, as captain of HMS *Galatea*, he had visited South Australia, Victoria, New South Wales and Queensland.[13] During his visit to Melbourne Prince Alfred was impressed by the talented Carandini family. Girolamo Carandini (Modena 1803–70 Modena), 10th marchese di Sarzano, was exiled from Italy by the Austrians in 1835. In Hobart in 1843 he married a promising singer Maria Burgess (London 1826–94 Bath), whose family had arrived as assisted immigrants ten years earlier. They had seven daughters and three sons.[14] When Prince Alfred returned home he made representations to Vittorio Emanuele II. The marchese was pardoned and in 1869

returned to reclaim his confiscated estates. His grandson, the 12th marchese, was the first Italian ambassador to Britain after World War II.

In St Petersburg in 1874 Prince Alfred married Marie Alexandrovna, only daughter of the Emperor Alexander II. Their eldest daughter, Marie Alexandra Victoria (Eastwell Park, Kent 1875–1938 Pelisor Castle, Romania), was married on 10 January 1893 at Schloss Sigmaringen in Baden-Württemberg to Crown Prince Ferdinand of Romania in three ceremonies: a civil ceremony as required by German law, a Catholic service in accordance with his faith and an Anglican service in accordance with her faith. They lived in the Cotroceni Palace in Bucharest. Their six children were baptised in the Orthodox faith. The eldest, Carol (1893–1953), married Princess Helen of Greece. The second, Princess Elisabeth, married George II (1890–1947), King of the Hellenes (1922–24 and 1935–47) and first cousin of Prince Philip. The third, Princess Marie, married Alexander I (1888–1934), the second King of the Serbs, Croats and Slovenes (1921) and the first King of Yugoslavia (1929).

The anglophile Queen Marie of Romania corresponded with Queen Mary of Britain about their scapegrace sons, Carol II and Edward VIII. Carol II abdicated on 6 September 1940. (His son, Michael I, dismissed the dictator Ion Antonescu [1882–1946] on 23 August 1944 as suddenly as Vittorio Emanuele III had dismissed Benito Mussolini [1883–1945] on 25 July 1943.) He

signed his abdication on King Arthur's Round Table in the Cotroceni Palace on 30 December 1947. In 1948 he married Princess Anne of Bourbon-Parma.

The Cotroceni Palace is three centuries old. In 1888 it was given to the Crown Prince by his uncle Karl Eitel Friedrich (Sigmaringen 1839–1914 Sinaia), Prince of Hohenzollern-Sigmaringen and nephew of Napoleon III, who was elected Prince Carol I of Romania in 1866 and crowned King in 1881. Queen Marie of Romania greatly expanded the palace. President (1967–89) Nicolae Ceausescu lavishly restored it between 1977 and 1987 for an anticipated visit by Queen Elizabeth II. Born in 1918, and coming to power in 1967, Ceausescu was for many years more highly regarded in Western countries than any other Communist leader. He established diplomatic relations with the Federal Republic of Germany in 1966, maintained them with Israel in 1967 and denounced the Soviet occupation of Prague in August 1968. President Johnson landed in Bucharest on his way back to the United States after attending the memorial service for Prime Minister Holt in December 1967. Presidents Nixon and Giscard d'Estaing and Prime Minister Wilson were among the foreign leaders who visited him. He and his wife Elena made a State visit to London in May 1978. The Queen created him a Knight Grand Cross of the Order of the Bath and he invested her with the Order of the Star of the Socialist Republic of Romania 1st Class.

The State visit of the President of Romania to London co-incided with my last visit there as a member of the Australian Parliament. The Callaghan Government was rebuffed when it sought the Royal Box at the Theatre Royal, Drury Lane, for a performance on 16 May. The proprietor, Robert Holmes à Court (Johannesburg 1937–90 Perth), was then told that it was required for the two State visitors. He replied that he owned the theatre and that he and his wife Janet required the box for themselves and the Whitlams. When Margaret and I arrived, there was a band outside the theatre. I expostulated, 'Robert, you should not have gone to this trouble'. He coolly responded that the band was for the Ceausescus. They were duly installed in a Prince's Box next to ours. Janet recalls the displeasure with which the presidential couple would glance at the republicans who had upstaged them. The performance was *The Pirates of Penzance*.

Ceausescu was awarded the Olympic Gold Medal in 1985. Premier Burke of Western Australia extended an invitation to Ceausescu and his wife to Australia's Bicentennial in 1988. Prime Minister Hawke had to confirm the invitation. Governor-General Sir Ninian Stephen and Lady Stephen retain vivid memories of their sojourn at Yarralumla.

On 22 December 1989 the Ceausescus fled by helicopter from demonstrations in Bucharest and, in London, the Queen, on Prime Minister Thatcher's advice, revoked his knighthood and returned his Star. At Tirgoviste, the old capital of Wallachia,

the Ceausescus were condemned by a kangaroo court and shot by a firing squad on Christmas Day.

The Bulgarian monarchs were descended from Prince Augustus of Saxe-Coburg-Gotha, the first cousin of Victoria and Albert. They married Italians. They were at war with Britain and Australia in World Wars I and II. Ferdinand (Vienna 1861–1948 Coburg), the youngest of the three sons of Prince Augustus, a Catholic, was elected Prince of Bulgaria in 1887. In 1893 he married Princess Maria Luisa (1870–99), eldest of the 23 children of Roberto (1848–1907), the last Duke of Parma and Piacenza (1854–59). He assumed the title Tsar in 1908. His sons, Boris (Sofia 1894–1943 Sofia) and Cyril (Sofia 1895–1945 Sofia), were brought up in the Orthodox faith. Pope Benedict XV lifted the ban of excommunication on Ferdinand when Boris turned 21. Ferdinand joined the Central Powers on 6 September 1915 and abdicated on 4 October 1918.

Boris took the throne as Tsar Boris III. In October 1930 he married Princess Giovanna (1907–2000), the third of the four daughters of Vittorio Emanuele III (Naples 1869–1947 Alexandria, Egypt), King of Italy (1900–46), at a Catholic service at Assisi and an Orthodox service in Sofia. The Tsar spent a weekend with George VI at Balmoral in August 1938. On 1 March 1941 his government signed the Tripartite Pact with Germany, Italy and Japan and declared war on Britain and the United States on 14 December 1941. Boris allowed Bulgarian

troops to invade Yugoslavia and Greece but he did not allow them to be involved in the war against Russia or Jews to be deported from Bulgaria. He died on 28 August 1943 shortly after a plane brought him home from a stormy interview with Hitler. He was succeeded by his son, Simeon II, born in 1937.

The Communist-dominated Fatherland Front formed a government on 9 September 1944. Prince Cyril and the other regents were executed in February 1945 as collaborators with Germany. A plebiscite abolished the monarchy on 8 September 1946. On 25 July 2001 Simeon Borisov Saxe-Coburg-Gotha took the oath of allegiance as Prime Minister of Bulgaria.

Marie, Queen of the Serbs, Croats and Slovenes, gave birth to Peter in September 1923. Peter was named after Peter I, the last King of Serbia and the first King of the Serbs, Croats and Slovenes. Peter II's short reign is described in Appendix 4.

On 20 March 1944, at the Yugoslav Embassy in London, Peter married Princess Alexandra (1921–70), the posthumous child of Alexander (1893–1920), King of the Hellenes (1917–20) and first cousin of Prince Philip. George VI was King Peter's best man. The wedding was attended by King George II of Greece, another first cousin of Prince Philip. Their first child, Crown Prince Alexander, was born on 17 July 1945 in Claridge's Hotel in a room briefly declared Yugoslav territory. The future Queen Elizabeth II was his godmother. My wife and I were presented to ex-King Peter at functions organised in his honour

by his compatriots and former subjects in my electorate in September 1960. He urged them to be good citizens of Australia and loyal subjects of our Queen. He also visited Perth, Melbourne and Brisbane in his six-week tour. Ex-King Peter died in Los Angeles in November 1970.

Crown Prince Alexander was married in 1972 near Seville with Princess Anne as his principal witness. He visited Belgrade for the first time in October 1991 and has made further visits in 1992, 1995 and 2000. The well-known Princess Elizabeth of Yugoslavia is a daughter of Prince Regent Paul of Yugoslavia and Princess Olga, the elder sister of Princess Marina, Duchess of Kent.

In 1883 Zorka (1864–90), the eldest child of Nicholas (1841–1921), Prince (1860–1910) and King (1910–18) of Montenegro, married the future Peter I (Belgrade 1844–1921 Belgrade), the last King of Serbia (1903) and the first King of the Serbs, Croats and Slovenes (1918). Elena (Cetinje 1873–1952 Montpellier), the fifth child and fourth daughter of Prince Nicholas, was converted to the Catholic faith at Bari in October 1896 and married to the future King Vittorio Emanuele III in Rome three days later. They had five children, Umberto II, who succeeded to the throne on his father's abdication in May 1946, and four daughters.

In 1941 Aimone, Duke of Spoleto, was created King of Croatia, Hitler's puppet state. He was the grandson of Vittorio

Emanuele II's younger son, Amadeo I, King of Spain. In 1939 he married a great-granddaughter of Queen Victoria. He never visited his kingdom and he died in 1948.

King Juan Carlos I and Queen Sofia of Spain are both descended from Queen Victoria and Prince Albert. The king's father was Juan, the youngest child of King Alfonso XIII of Spain and Queen Victoria Eugénie Julia Ena (1887–1969), the daughter of Queen Victoria's youngest daughter, Beatrice Mary Victoria Feodore (1857–1944), and Prince Henry Maurice of Battenberg (1858–96). Queen Sofia is the daughter of Paul (1901–64), King of the Hellenes (1947–64) and first cousin of Prince Philip, and Queen Frederika (1917–81), the only daughter of Wilhelm II's only daughter, Viktoria Luisa Adelheid Mathilde Charlotte, Duchess of Brunswick and Hanover. King Paul and Queen Frederika were first cousins. Their son, Constantine II, who reigned from 1964 to 1974, married Princess Anne-Marie of Denmark. Her mother was Princess Ingrid of Sweden (Stockholm 1910–2000 Fredensborg), who was descended from both Victoria, Queen of the United Kingdom and Empress of India, and Josephine, first Empress of the French and first Queen of Italy. The last King and Queen of the Hellenes and their sons still visit Australia.

ITALIAN HERITAGE SITES

In Chapter 3 I noted that, as a member of the World Heritage Committee from 1983 to 1989, I visited all the World Heritage sites in Italy and I acknowledged the leadership of the Holy See's observers at Unesco in coordinating some inscriptions on the World Heritage List. Margaret Whitlam's *My Other World* demonstrates the popular appeal of World Heritage sites in many parts of Europe, Asia and the Americas. She and I noted the importance attached to such sites in Africa in 1993 when we were mustering support for the Olympic Games of Sydney.

It might be of interest to readers to know the titles and dates of the properties that have been inscribed in Italy and in the countries formerly ruled by Venice, Genoa and United Italy and to have a short description of the grounds on which the Committee considered these properties to have outstanding universal value.

ITALY

1979 Rock Drawings in Valcamonica

Valcamonica, in the Lombardy plain, has one of the greatest collections of prehistoric petroglyphs to be found—more than 140 000 signs and figures carved in rock over a period of 8000 years, depicting themes of agriculture, navigation, war and magic.

1980 The Church and Dominican Convent of Santa Maria delle Grazie with The Last Supper by Leonardo da Vinci

An integral part of the architectural complex built in Milan beginning in 1463 and reworked at the end of the 15th century by Bramante, the rectory of the convent of Saint Mary of the Graces still has on its northern wall a masterpiece without equal—*The Last Supper* painted between 1495 and 1497 by Leonardo da Vinci, whose work heralded a new era in the history of art.

1982 Historic Centre of Florence

Built on the site of an Etruscan settlement, Florence, the symbol of the Renaissance, assumed its economic and cultural predominance under the Medici in the 15th and 16th centuries. Its 600 years of extraordinary artistic creativity can be seen above all in its 13th-century cathedral, the Santa Maria del Fiore, the Santa Croce Church, the Uffizi Palace and the Pitti Palace

comprising the work of artists such as Giotto, Brunelleschi, Botticelli and Michelangelo.[1]

1987 Venice and its Lagoon
Founded in the 5th century and spread over 118 small islands, Venice became a major maritime power in the 10th century. It is, as a whole, an extraordinary architectural masterpiece in which even the smallest of its buildings contains the works of some of the world's greatest artists such as Giorgione, Titian, Tintoretto, Veronese and others.

1987 Piazza del Duomo, Pisa
On a vast lawn, the Piazza del Duomo houses a group of monuments known the world over. The Piazza contains four of the masterpieces of medieval architecture that considerably influenced monumental art in Italy from the 11th to the 14th centuries—the cathedral, the baptistry, the campanile (the 'Leaning Tower') and the cemetery.

1990 Historic Centre of San Gimignano
'San Gimignano delle belle Torri' is situated in Tuscany, 56 km south of Florence. It served as an important relay point for pilgrims on the Via Francigena to and from Rome. The patrician families, who controlled the city, built some 72 tower-houses (up to 50 m high) as symbols of their wealth and power. Only 14 have survived but San Gimignano has retained its feudal

atmosphere and appearance. The city also contains masterpieces of 14th- and 15th-century Italian art.

1993 I Sassi di Matera
This is the most outstanding and intact example of a troglodyte settlement in the Mediterranean region, perfectly adapted to its terrain and ecosystem. The first inhabited zone dates from the Palaeolithic period, while later settlements illustrate a number of significant stages in human history.

1994 The City of Vicenza and the Palladian Villas of the Veneto
Founded in the 2nd century BC in northern Italy, the city prospered under Venetian rule, from the early 15th to the end of the 18th century. The work of Andrea Palladio (1508–80), based on the intimate study of classical Roman architecture, gave the city its unique appearance. His work inspired a distinct architectural style (Palladian style) which spread to England, other European countries and to North America.

1995 Historic Centre of Siena
Siena is the embodiment of a medieval city. Its inhabitants, transposing their rivalry with Florence to the area of urban planning, pursued a Gothic dream down the centuries, preserving the appearance their city had acquired between the 12th and 15th centuries. During this period Duccio, the Lorenzetti brothers

and Simone Martini were shaping the paths of Italian and, more broadly, European art. The entire city, converging on the masterpiece of urban planning that is the Piazza del Campo, was devised as a work of art incorporated into the surrounding landscape.

1995 Historic Centre of Naples

From the Neapolis founded by Greek settlers in 470 BC to the city of today, Naples has received and retains the stamp of the cultures that emerged one after the other in the Mediterranean Basin and in Europe. These layers of influence and its continuing role in history have made the site unique, containing such remarkable monuments as the Santa Chiara Church and the Castel Nuovo, to name but two.

1995 Crespi d'Adda

Crespi d'Adda is an outstanding example of the 19th- and early 20th-century 'company towns'. These were villages in Europe and North America built by enlightened industrialists to meet a worker's every need. The site is still remarkably intact and partly in industrial use, although changing economic and social conditions pose a threat to its continued survival.

1995 Ferrara, City of the Renaissance, and its Po Delta

Ferrara, which grew up around a ford over the River Po, became an intellectual and artistic centre that attracted the greatest

minds of the Italian Renaissance in the 15th and 16th centuries. Piero della Francesca, Jacopo Bellini and Mantegna decorated the palaces of the House of Este. The humanist concept of the ideal city came to life here in the quarters built after 1492 by Biagio Rossetti according to the new principles of perspective. The completion of this project marked the birth of modern town planning and its subsequent development.

1996 Castel del Monte

The location, the mathematical and astronomical precision of its layout and its perfect shape reflect the symbolic ambition which inspired Emperor Frederick II when he built this southern Italian castle in the 13th century. A unique piece of medieval military architecture, Castel del Monte is a completely successful blending of classical antiquity, the Islamic Orient and northern European Cistercian Gothic.

1996 The Trulli of Alberobello

The *trulli*, limestone dwelling houses in the southern Italian region of Puglia, are remarkable examples of drywall (mortarless) construction, a prehistoric building technique still in use in this region. These structures, dating from as early as the mid-14th century, were constructed using roughly worked limestone boulders collected from neighbouring fields. Characteristically, they feature pyramidal, domed or conical roofs built up of corbelled limestone slabs. Although rural *trulli* can be found

throughout the Itria Valley, their highest concentration is in the town of Alberobello, where there are over 1500 structures in the quarters of Monti and Aja Piccola.

1996 Early Christian Monuments of Ravenna
Ravenna was the seat of the Roman Empire in the 5th century and then of Byzantine Italy until the 8th century. It has a unique collection of mosaics and early Christian monuments. All eight buildings—the Mausoleum of Galla Placidia, the Neonian Baptistery, the Basilica of Sant'Apollinare Nuovo, the Arian Baptistery, the Archiepiscopal Chapel, the Mausoleum of Theodoric, the Church of San Vitale, the Basilica of Sant'Apollinare in Classe—were constructed in the 5th and 6th centuries. All show great artistic skill, including a wonderful blend of Greco–Roman tradition, Christian iconography and oriental and western styles.

1996 Historic Centre of the City of Pienza
It was in this Tuscan town that Renaissance urban ideas were first put into practice after Pope Pius II decided in 1459 to renovate his birthplace. The architect chosen, Bernardo Rossellino, applied the principles of his mentor Leone Alberti and built the extraordinary Pius II Square, around which are built the Piccolomini Palace, the Borgia Palace and the cathedral with its purely Renaissance exterior and an interior in the late Gothic style of south German churches.

1997 18th Century Royal Palace at Caserta with the Park, the Aqueduct of Vanvitelli, and the San Leucio Complex
The monumental complex at Caserta, created by Carlo VII, the Bourbon King of Naples and Sicily (1734–59), to rival Versailles and Madrid, is exceptional for the way in which it brings together a sumptuous palace and its park and gardens, as well as natural woodland, hunting lodges, and an industrial establishment for the production of silk.[2] It is an eloquent expression of the Enlightenment in material form, integrated into, rather than imposed upon, its natural landscape.

1997 Residences of the Royal House of Savoy
When Emanuele Filiberto, Duke of Savoy, moved his capital to Turin in 1562, he began a series of building projects, carried on by his successors, to demonstrate the power of the ruling house. This complex of buildings of high quality, designed and decorated by the leading architects and artists of the time, radiates out into the surrounding countryside from the Royal Palace in the 'Command Area' of Turin to include many country residences and hunting lodges.

1997 Botanical Garden (Orto Botanico), Padua
The first botanical garden in the world was created in Padua in 1545. It still preserves its original layout—a circular central plot, symbolic of the world, surrounded by a ring of water. Subsequently additional elements have been included, both architectural

(ornamental entrances and balustrades) and practical (pumping installations and greenhouses). It continues to serve its original purpose as a source of scientific research.[3]

1997 Portovenere, Cinque Terre, and the Islands (Palmaria, Tino and Tinetto)
The Ligurian coastal region between Cinque Terre and Portovenere is a cultural landscape of high scenic and cultural value. The form and disposition of the small towns and the shaping of the landscape surrounding them, overcoming the disadvantages of a steep and broken terrain, graphically encapsulate the continuous history of human settlement in this region over the past millennium.

1997 Cathedral, Torre Civica and Piazza Grande, Modena
The magnificent 12th-century cathedral at Modena is a supreme example of Romanesque art, the work of two great artists (Lanfranco and Wiligelmo). With its associated piazza and the soaring tower, it testifies to the strength of the faith of its builders and to the power of the Canossa dynasty who commissioned it.

1997 Archaeological Areas of Pompeii, Herculaneum, and Torre Annunziata
When Vesuvius erupted on 24 August 79 AD it engulfed the two flourishing Roman towns of Pompeii and Herculaneum, as well as the many rich villas in the area. Since the mid-18th

century these have been progressively uncovered and made accessible to the public. The vast expanse of the commercial town of Pompeii contrasts with the restricted but better preserved remains of the holiday resort of Herculaneum, while the superb wall paintings of the Villa Oplontis at Torre Annunziata give a vivid impression of the opulent lifestyle of the wealthier citizens of the early Roman Empire.

1997 *Costiera Amalfitana*

The Amalfi coastal strip is one of great physical beauty and natural diversity. It has been intensively settled by human communities since the early Middle Ages. It contains a number of towns such as Amalfi and Ravello which contain architectural and artistic works of great significance, and its rural areas demonstrate the versatility of its occupants in adapting their utilisation of the terrain to suit its diversity, from terraced vineyards and orchards on the lower slopes to wide upland pastures.

1997 *The Archaeological Area of Agrigento*

Founded as a Greek colony in the 6th century BC, Agrigento became one of the leading cities of the Mediterranean world. Its supremacy and pride are demonstrated by the remains of the magnificent Doric temples that dominate the ancient town, much of which remains intact under latter-day fields and orchards. Selected excavated areas throw light on the later Hellenic and

Roman town and on the burial practices of its palaeochristian inhabitants.

1997 *Villa Romana del Casale*

Roman exploitation of the countryside is symbolised by the villa, the centre of the large estate upon which the rural economy of the Western Empire was based. In its 4th-century AD form the Villa Romana del Casale, probably conceived by Diocletian's co-emperor Maximian, is one of the most luxurious examples of this type of monument. It is especially noteworthy for the wealth and quality of the mosaics which decorate almost every room, and which are the finest still *in situ* anywhere in the Roman world.

1997 *Su Nuraxi di Barumini*

During the late 2nd millennium BC, in the Bronze Age, a special type of defensive structure, known as *nuraghi*, for which no parallel exists anywhere else, developed on the island of Sardinia. The complex consists of circular defensive towers in the form of truncated cones built of dressed stone, with corbel-vaulted internal chambers. The complex at Barumini, which was extended and strengthened in the first half of the 1st millennium under Carthaginian pressure, is the finest and most complete example of this remarkable form of prehistoric architecture.

1998 Archaeological Area and the Patriarchal Basilica of Aquileia

Aquileia, one of the largest and wealthiest cities of the Early Roman Empire, was destroyed by Attila in the mid-5th century. Most of it still remains unexcavated beneath fields, and as such it constitutes the greatest archaeological reserve of its kind. Its Patriarchal Basilica, an outstanding building with an exceptional mosaic pavement, also played a key role in the evangelisation of a large region of Central Europe.

1998 Cilento and Vallo di Diano National Park with the Archaeological Sites of Paestum and Velia, and the Certosa di Padula

The Cilento area is a cultural landscape of exceptional quality. Dramatic chains of sanctuaries and settlements along its three east–west mountain ridges vividly portray the historical evolution of the area as a major route for trade and for cultural and political interaction during the prehistoric and medieval periods. It was also the boundary between the Greek colonies of Magna Grecia and the indigenous Etruscan and Lucanian peoples and so preserves the remains of two very important classical cities, Paestum and Velia.

1998 Historic Centre of Urbino

Urbino is a small hill town that experienced an astonishing cultural flowering in the 15th century, attracting artists and scholars from all over Italy and beyond, and influencing cultural

developments elsewhere in Europe. Owing to its economic and cultural stagnation from the 16th century onwards, its Renaissance appearance has been remarkably well preserved.

1999 Villa Adriana (Tivoli)
Villa Adriana, an exceptional complex of classical buildings created in the 2nd century AD by the Roman Emperor Hadrian, reproduces the best elements of the material cultures of Egypt, Greece, and Rome in the form of an 'ideal city'.

2000 Isole Eolie (Aeolian Islands)
The Aeolian Islands provide an outstanding record of volcanic island-building and destruction and ongoing volcanic phenomena. Studied since at least the 18th century, the islands have illustrated two of the types of eruption (Vulcanian and Strombolian) to vulcanology and so have featured prominently in the education of all geoscientists for over 200 years. The site still continues to enrich the field of vulcanological studies.

2000 Assisi, the Basilica of San Francesco and Other Franciscan Sites
Assisi, an ancient sanctuary and a medieval hill town, is the birthplace of Saint Francis and fundamentally associated with work of the Franciscan Order. The masterpieces of medieval art, such as the Basilica of San Francesco and the paintings by Cimabue, Simone Martini, Pietro Lorenzetti, and Giotto, have

made Assisi a fundamental reference point for the development of Italian and European art and architecture.

2000 *City of Verona*

The historic city of Verona was founded in the 1st century AD. It flourished particularly under the rule of the Scaliger family in the 13th and 14th centuries and as part of the Republic of Venice from the 15th to 18th centuries. Verona, a city of culture and art, has preserved a remarkable amount of monuments from antiquity and the medieval and Renaissance periods and represents an outstanding example of a military stronghold.

ITALY AND THE HOLY SEE

1980 *Historic Centre of Rome, the Properties of the Holy See in that City Enjoying Extraterritorial Rights and San Paolo Fuori le Mura*

Founded, according to legend, by Romulus and Remus in 753 BC, Rome was first the centre of the Roman Republic, then of the Roman Empire, and it became the capital of the Christian World in the 4th century. The World Heritage Site, extended in 1990 to the walls of Urban VIII, includes some of the major monuments of Antiquity such as the Augustus Mausoleum, the Hadrian Mausoleum, the Pantheon, the Marcus

Aurelius Column, as well as the religious and public buildings of Papal Rome.

THE HOLY SEE

1984 Vatican City
One of the most sacred places in Christendom, the Vatican City attests to a great history and a formidable spiritual venture. A unique collection of masterpieces of art and architecture can be found within the boundaries of this small state. At its centre is St Peter's Basilica, with the double colonnade and circular piazza in front and bordered by palaces and gardens. The Basilica, erected over the tomb of St Peter the Apostle, is the largest religious building in the world and the fruit of the combined genius of Bramante, Raphael, Michelangelo, Bernini and Maderno.

FRANCE

1983 Cape Girolata, Cape Porto, Scandola Nature Reserve, and the Piano Calanches in Corsica
The nature reserve, part of the Regional Natural Park of Corsica, occupies the Scandola peninsula, an impressive, porphyritic rock mass. Its vegetation is an example of scrubland. Seagulls,

cormorants and sea eagles can be found there. The clear waters, with the islets and inaccessible caves, host a rich marine life.

MALTA

1980 Hal Saflieni Hypogeum

An enormous subterranean structure excavated with cyclopean rigging to lift huge blocks of coralline limestone around the year 2500 BC, the Hypogeum, possibly conceived as a sanctuary, has been a necropolis since prehistoric times.

1980 City of Valetta

The capital of the Republic of Malta is irrevocably linked to the history of the military and charitable order of St John of Jerusalem. Ruled successively by the Phoenicians, Greeks, Carthaginians, Romans, Byzantines, Arabs and the Order of the Knights of St John, its 320 monuments, confined within an area of 55 hectares, make it one of the most concentrated historic areas in the world.

1980 Megalithic Temples

Seven megalithic temples are to be found on the islands of Malta and Gozo, each a result of an individual development. The Ggantija complex on the island of Gozo is remarkable for its superhuman achievements dating from the Bronze Age. On

the island of Malta, the temples of Hagar Qin, Mnajdra and Tarxien are unique architectural masterpieces, given the very limited resources of their builders. The Ta'Hagrat and Skorba complexes bear witness to the development of the temple tradition in Malta.

LIBYAN ARAB JAMAHIRIYA

1982 Archaeological Site of Leptis Magna

Leptis Magna was enlarged and embellished by Septimius Severus, who was born there and later became emperor. It was one of the most beautiful cities of the Roman Empire, with its imposing public monuments, man-made harbour, market place, storehouses, shops and residential districts.

1982 Archaeological Site of Sabratha

A Phoenician trading-post that served as an outlet for the products of the African hinterland, Sabratha was part of the short-lived Numidian kingdom of Massinissa before being Romanised and rebuilt in the 2nd and 3rd centuries AD

1982 Archaeological Site of Cyrene

A colony of the Greeks of Thera, Cyrene was one of the principal cities in the Hellenic world. It was Romanised and remained

a great capital until the earthquake of 365. A thousand years of history is written in its ruins, famous since the 18th century.

YUGOSLAVIA

1979 Natural and Culturo-Historical Region of Kotor
This natural harbour on the Adriatic coast in Montenegro was an important artistic and commercial centre with famous masonry and iconography schools in the Middle Ages. A large number of its monuments, among which four Romanesque churches and the town walls, were heavily damaged by an earthquake in 1979 but the town has been restored, mostly with Unesco's help.

CROATIA

1979 Old City of Dubrovnik
The 'Pearl of the Adriatic', the only port in Dalmatia which was not part of the Venetian empire, became an important Mediterranean sea power from the 13th century onwards. Although severely damaged by an earthquake in 1667, Dubrovnik managed to preserve its beautiful Gothic, Renaissance and Baroque churches, monasteries, palaces and fountains. Damaged again

in the 1990s by armed conflict, it is being repaired as part of a major restoration program coordinated by Unesco.

1979 Historical Complex of Split with the Palace of Diocletian
The ruins of Diocletian's Palace, built between the late 3rd century and the early 4th century AD can be found throughout the city. The cathedral was constructed in the Middle Ages out of the ancient mausoleum.[4] Romanesque churches from the 12th and 13th centuries, medieval fortifications, Gothic palaces of the 15th century, and other palaces in Renaissance and Baroque style make up the rest of the protected area.

1997 Episcopal Complex of the Euphrasian Basilica in the Historic Centre of Poreč
The group of religious monuments in Poreč, where Christianity was established as early as the 4th century, constitutes the most complete surviving complex of this type. The basilica, atrium, baptistery and episcopal palace are outstanding examples of religious architecture, while the basilica itself combines classical and Byzantine elements in an exceptional manner.

1997 Historic City of Trogir
Trogir is a remarkable example of urban continuity. The orthogonal street pattern of this island settlement dates back to the Hellenistic period, and it has been embellished by successive rulers with many fine public and domestic buildings and

fortifications. Its fine Romanesque churches are complemented by the outstanding Renaissance and Baroque buildings from the Venetian period.

GREECE

1988 Medieval City of Rhodes

The Knightly Order of St John of Jerusalem occupied the city from 1309 to 1523 and set about transforming the city into a stronghold. It was subsequently under Turkish and Italian rule. Its Upper Town is one of the most beautiful urban ensembles of the Gothic period, with its Palace of the Grand Masters, the Great Hospital and the Street of the Knights. In the Lower Town the Gothic architecture co-exists with mosques, public baths and other buildings built during the Ottoman period.

1989 Mystras

Mystras, the 'wonder of the Morea', was built as an amphitheatre around the raised fortress in 1249 by the prince of Achaia, William of Villehardouin. Reconquered by the Byzantines, then occupied by the Turks and the Venetians, the city was abandoned in 1832, leaving only the medieval ruins, breathtaking against a very beautiful landscape.

1999 Historic Centre (Chorá) with the Monastery of Saint John the Theologian and the Cave of the Apocalypse on the Island of Pátmos

The small island of Pátmos in the Dodecanese is reputed to be where St John the Theologian wrote both his Gospel and the Apocalypse. A monastery dedicated to the 'Beloved Disciple' was founded there in the late 10th century and it has been a place of pilgrimage and of Greek Orthodox learning continuously since that time. The fine monastic complex dominates the island, and the old settlement of Chorá associated with it, which contains many religious and secular buildings.

—ⱺⱳ—

In Italy and former Italian territories there are innumerable natural and cultural heritage sites which are not inscribed on the World Heritage List but which are of great interest to visitors from around the world. I presume to describe some of the sites which may interest visitors from varied backgrounds, but specifically from Australia.

GARDENS

The Villa d'Este is probably the most glamorous hotel in the world.[5] Extensive gardens surrounded the unsurpassed property

which Caroline of Brunswick (Brunswick 1768–1821 London), the wife of the Price Regent, bought at Cernobbio on Lake Como in 1815 and renamed Villa d'Este. There are still beautiful waterfalls and avenues of trees on the rising ground behind it.

Another garden open to visitors is the Giardino Botanico Hanbury, founded in 1867 at La Mortola near Ventimiglia in Liguria by Sir Thomas Hanbury (1832–1907) and his brother Daniel (1825–75). It was acquired by the Italian state in 1960 and has been restored by the University of Genoa since 1983 as a wild garden for exotic plants from all over the world.

An Italianate garden, La Pietra, was constructed in 1904 outside Florence on the road to Bologna by Arthur Acton, a descendant of the Scottish baronet John Francis Edward Acton (Besançon, France 1736–1811 Palermo), who had commanded the navy of Pietro Leopoldo, Grand Duke of Tuscany, before entering the service of Ferdinando IV of Naples and III of Sicily. The garden was maintained by his son, Sir (1974) Harold Mario Mitchell Acton (1904–94), the distinguished art connoisseur and historian.

The gardens at the Castello di Montegufoni near Florence were developed between 1925 and 1940 by George Reresby Sitwell, 4th Baronet of Renishaw, Derbyshire, and father of Dame Edith, Sir Osbert and Sir Sacheverell Sitwell.

Neil Boyd Watson McEachern (London 1884–1964 Pallanza) constructed the botanic gardens of the Villa Taranto at Pallanza

on Lago Maggiore. His father was Sir (1900) Malcolm Donald McEachern (London 1852–1910 Cannes), co-founder of the shipping company McIlwraith McEachern, Lord Mayor of Melbourne (1897–1900) and MHR for Melbourne (1901–04). His mother was the daughter of John Boyd Watson (Paisley, Scotland 1828–89 Sydney). Neil McEachern bought the estate in 1931 and named the villa after the Jacobite Maréchal (1809) Macdonald, whom Napoleon created Duke of Taranto. McEachern gave the gardens and villa to the Italian state in 1938. He was obliged to leave for England at the outbreak of war in 1940 but returned to Pallanza in 1946.

MANTUA

There were artistic links between England and Mantua for two centuries. In 1432 Gianfrancesco Gonzaga (1395–1444), the 5th Captain of Mantua, was created the 1st Marquis by the Emperor Sigismund. In 1436 he was authorised by Henry VI of England to use the Lancastrian S device and swan in his huge palace. Il Pisanello (Antonio Pisano [1395–1455]) painted Arthurian legends on the walls. (In 1163–66 a local craftsman Pantaleone had included King Arthur in the mosaic pavement of the Cathedral in Otranto in Puglia.)

In 1526 Giulio di Pietro de Gianuzzi (Rome 1492–1546 Mantua), known as Giulio Romano, the only Italian master mentioned by Shakespeare (*The Winter's Tale*, v, ii), was appointed by Federico II Gonzaga, the 5th Marquis, to superintend the construction and decoration of the buildings, such as the Palazzo del Te, for which Mantua is renowned.[6] The Emperor Charles V made Federico II the first Duke of Mantua. During his brief reign (October 1626–December 1627) the 7th Duke, Vincenzo II, sold the family treasures to Charles I of England.

Even though Verdi's opera *Rigoletto* (1851) is set in Mantua, it is futile to search Mantua for places associated with the Duke. Piave's libretto was based on Victor Hugo's verse play *Le Roi s'amuse* (1832) about François I of France.

VENICE

In SS Giovanni e Paolo (S. Zanipolo), the church of the Doges, I was struck by a monument to two Venetian officers in the Austrian navy, Attilio (born 1810) and Emilio (born 1819) Bandiera. They had deserted to Corfù, then a British possession, and with another officer, Domenico Moro, landed in Calabria. Their correspondence with Mazzini in London had been intercepted by the British Home Secretary, Sir James

Graham, and passed to the government in Naples. The three were captured and shot at Cosenza on 25 July 1844 under the brutal regime of Ferdinando II (Palermo 1810–59 Caserta), King of the Two Sicilies (1830). A petition by Mazzini to the House of Commons disclosed the British complicity. The remains of the three heroes were returned to Venice in 1867, when the city was incorporated in United Italy.

Australians have made notable contributions to the restoration and enhancement of cultural sites in Venice. Following the terrible *acqua alta* of November 1966, René Maheu, the Director-General of Unesco, launched a campaign to assist the Italian Government in the safeguarding of Venice from further flooding. The Australian Committee for Venice was set up under Valerie Howse, the dynamic and distinguished wife of John Howse, a former Liberal MHR for Calare (1946–60), and the daughter-in-law of Sir Neville Howse, VC, a former Nationalist MHR for Calare (1922–29) and Minister for Health.

In 1971 the Committee commenced restoration of the parish church of S. Martino in Castello near the Arsenal. The church was founded in the 10th century and rebuilt by Jacopo Sansovino in the 16th century. The Committee's contribution concluded in 1984 with the restoration of an organ built and installed by Pietro Nacchini in 1737. The organ was inaugurated on 21 June 1984 in an ecumenical service. Margaret and I attended with the Most Reverend Felix Arnott, the Anglican chaplain in Venice,

among others.[7] We all remember that after the recital and the service the Catholic nuns lined up to kiss the Anglican chaplain's episcopal ring. Valerie Howse has been recognised in both the Order of Australia and as a Cavaliere (1975) nell' Ordine al Merito della Republica Italiana.

My appointment to Unesco had been announced on 4 May 1983. The next day Timothy Pascoe, chairman of the Australia Council, asked me to assist Franco Belgiorno-Nettis, the Founding Governor of the Biennale of Sydney, in his plans for an Australian pavilion in the Napoleonic gardens where the Biennale of Venice is held.[8] In Venice the authorities allocated Australia a site just past the bridge over the *rio* on the eastern side of the exhibition grounds. Belgiorno-Nettis, whom I have described as an Australian Leonardo da Vinci, chose a Sydney architect, Philip Cox, to design our pavilion. It consists of a steel frame, metal roof, plasterboard walls and timber flooring prefabricated in Australia. The design is appropriate for the setting of a river frontage with substantial trees. Opened in 1988, the structure and its contemporary Australian art exhibitions attract constant international attention. Betty Churcher and I visited it on 22 May 1990 in the course of our negotiations in Italy for our National Gallery's 'Rubens and the Italian Renaissance' exhibition. We also visited the church of S. Vidal which the Sydney art magnate, Ray Hughes, had taken over for an exhibition by twenty Australian and New Zealand artists.

CORSICA

Corsica may be of particular interest to visitors from New South Wales. One of the great Sydney families had Corsican connections, while a suburb of Sydney bears the name of a Corsican viceroy.

During Corsica's war of independence against Genoa (1729–69) a British agent, Baron Theodore Stephen von Neuhoff (Cologne 1694–1756 Soho), landed in Corsica on 12 March 1736 with weapons purchased in Tunis. On 15 August he was crowned King Theodore I but on 11 November he was driven from the island. The Marcus Clark families of Sydney and Adelaide are descended from him.

Pasquale Paoli (Morosaglia 1725–1807 London) was the son of one of King Theodore's ministers. On 29 April 1755 he returned to Corsica and on 13 July was proclaimed General of the Nation. Corsica adopted the most democratic constitution in Europe. Genoa, however, still held some of the coastal forts and on 15 May 1768 ceded its rights in the island to Louis XV. The conquest of Corsica consoled France for the loss of Québec. Paoli's troops were finally defeated in May 1769. His secretary was Carlo Maria Buonaparte (Ajaccio 1746–85 Montpellier). Paoli left the island on 13 June and found his way through Italy, Austria, Germany and the Netherlands to London on 19 September. He was given a pension by George III.

Under an amnesty passed by the French Constituent Assembly in 1889, Paoli, Fellow of the Royal Society (1774), was triumphantly received in Paris and on 17 July 1790 he returned to Corsica. He was elected president of the new département and commandant of its national guard. When he failed in an expedition to liberate Sardinia in January and February 1793 he was outlawed by the new French republic. On 27 April he was proclaimed generalissimo in Corsica. He appealed to Britain. In January 1794 Gilbert Elliott (1751–1814), 4th Baronet (1777), arrived in Corsica and Nelson captured Bastia and Calvi, where he lost the sight of his right eye. On 19 July a Constitution of the Kingdom of Corsica, in Italian, was unanimously adopted and signed by a General Assembly of the Corsican People. It established a single-chamber two-year Parliament. The King was to be George III, King of Great Britain, and his successors on the Throne of Great Britain. His powers were to be exercised in Corsica by a Vice Roy. The Crown was accepted on behalf of the King by Elliott, his Commissioner Plenipotentiary. The oath of allegiance was signed by Paoli as President of the Assembly. Lord Frederick North, son of Lord North who lost Britain's North American colonies, was appointed Elliott's English secretary of state.

Paoli caused trouble when Elliot was appointed Vice Roy and he was not. In October 1795 Paoli was recalled to England, where his pension was doubled. In October 1796 Nelson

evacuated Elliott and the British forces from Bastia to Elba while the French reoccupied Corsica along the east coast. In October 1797 Elliott was raised to the peerage by the title of Baron Minto and the Moor's head from the Corsican flag was incorporated in his coat of arms. After serving as Governor-General of Bengal and of India (1807–13) he was elevated to Earl of Minto. Because the colony of New South Wales was under his supervision, a suburb of Sydney still bears his name. Some of the members of an Anglo–Corsican battalion formed in 1795 settled in New South Wales. There is a bust of Paoli by Flaxman in Westminster Abbey. His remains were buried in his birthplace at Morosaglia in 1889.

Britain was more successful in acquiring and retaining other Mediterranean islands where Italian was the official language.

THE MALTESE AND IONIAN ISLANDS

Italian was the language of church and state in Malta until 1934. In 1948 Australia signed an assisted passage agreement with Malta after its heroic resistance during World War II. Fifty years later there were 50 000 Australians who had been born in Malta.

The Knights of St John, the Hospitallers, took over Rhodes from the Genoese in 1309. Süleyman the Magnificent (1495–1566), who succeeded his father Selim I as Sultan of the Ottoman

Empire in 1520, expelled them in 1523. Their Grand Master visited Henry VIII of England and other kings to seek their support to recapture the island. In 1530 the Emperor Charles V (King Carlos I of Spain) gave Malta to the Knights as a replacement for Rhodes.

On 9 June 1798 the Knights refused permission for Carlo Buonaparte's son Napoleon (Ajaccio 1769–1821 St Helena) to water his ships which were taking 54 000 French troops to conquer Egypt. On 12 June the Knights surrendered to the French and fled to Rome. The Maltese rose against the French after hearing of Nelson's destruction of the French fleet in the Battle of the Nile on 1–2 August. The French, however, did not surrender Valetta to the British until 5 September 1800. Under the Treaty of Amiens on 27 March 1802 the British were to return Malta to the Knights. The British, however, remained in Malta and between 1809 and 1814 occupied the seven Ionian Islands which Napoleon incorporated in the French Empire in 1807.

In 1813 Lieutenant-General Thomas Maitland was appointed Governor of Malta. The Treaty of Paris confirmed Malta as a British possession in 1814 and in 1815 the reconvened Congress of Vienna established the United States of the Ionian Islands, the King of Great Britain and Ireland being the Protecting Sovereign. Sir Thomas Maitland was appointed Lord High Commissioner in and for them in 1816, introducing a constitutional

charter the following year.[9] In 1818 the Prince Regent created the Order of St Michael and St George, the patron saints of Malta and Greece, to confer honours in the islands where honours had previously been conferred by the Knights of Malta and the Doges of Venice. Maitland was created GCMG and died in Malta in 1824. Maitland in New South Wales was named after him.

Two members of the British colonial service, trained in the Ionian Islands, left their marks on executive and legislative developments in Australia in the 19th century. George Ferguson Bowen (Donegal, Ireland 1821–99 Brighton, England), KCMG (1856), GCMG (1860), went to Corfù in 1847. In 1856 he married Diamantina Roma, a member of a Venetian noble family long established in the Ionian Islands. A protégé of Gladstone, he was appointed the first Governor of Queensland in 1859. He was later appointed Governor of New Zealand (1868), Victoria (1873), Mauritius (1879) and Hong Kong (1882–86). His last colonial service was as chairman of a royal commission to determine the boundaries of the electorates of the elected members of the Legislative Council of Malta in 1887. Many places in Queensland were named by, or after, him and his wife. (Recently retired Victorian Governor Sir James Gobbo and Lady Gobbo were the next vice-regal couple to speak Italian in Government House, Melbourne.)

John Young (Bombay 1807–76 Baillieborough), 2nd Baronet

(1848), GCMG (1855), was the eighth Lord High Commissioner in and for the Ionian Islands (1855–59), Governor-General of New South Wales (1861–67) and Governor-General of Canada and Governor of Prince Edward Island (1869–72). He was created Baron Lisgar in 1870. Prince Edward Island, named after Queen Victoria's father, was annexed to Canada in 1873. A street in Sydney and a town in New South Wales are named after Sir John Young.

Two inadequate Governors of New South Wales in World War I were born in Malta. Gerald Strickland (1861–1940), 6th Count della Catena (1875), KCMG (1897), GCMG (1913), was the son of a Royal Navy captain and a Maltese noblewoman. He was appointed Governor of the Leeward Islands (1902), Tasmania (1904), Western Australia (1909) and New South Wales (1913). He quarelled with three successive Governors-General, although Lord Denman and Sir Ronald Munro-Ferguson and he himself had been appointed by George V on the advice of Liberal Prime Ministers of Britain. Relations between the Governor-General and State Governor became critical after Labor Prime Minister Hughes and New South Wales Premier Holman formed National Governments in November 1916 and Liberal Prime Minister Lloyd George formed a National Government in December. Hughes sponsored unsuccessful plebiscites for conscription for overseas service on 28 October 1916 and on 20 December 1917. Strickland was

replaced by Walter Davidson (1859–1923), KCMG (1914), who had been Governor of the Seychelles (1904–12) and Newfoundland (1913–16).

During the campaign for the 1999 referendum on an Australian republic some monarchist judges and professors in the States claimed that under the model on offer the President could be peremptorily dismissed by the Prime Minister. They had not read the Australian vice-regal commissions which demonstrate how governments have always been able to advise our Queens and Kings not just to dismiss but to supersede their vice-regal representatives. The 1917–18 New South Wales chronology is instructive. A file in the Premier's office notes that 'Sir Gerald Strickland has been granted leave of absence from 13 April'. The *Government Gazette* of 26 April contained two notices by the Acting Premier. One invited the Chief Justice, members of the State Parliament and others to assemble at Circular Quay, Sydney, on Saturday 28 April when 'His Excellency the Governor' was intending to leave the State by steamer at noon. The other invited them to attend Government House at noon on Monday 30 April when the Chief Justice would take the Oath of Office on his assuming the Government consequent on the departure from the State of 'His Excellency Sir Gerald Strickland'.

On 1 October 1917 in London George V issued a commission,

countersigned by the Colonial Secretary in Lloyd George's Government:

To Our Trusty and Well-beloved Sir Walter Edward Davidson, Knight Commander of Our Most Distinguished Order of Saint Michael and Saint George: Greeting!

WE do, by this Our Commission, under Our Sign Manual and Signet, appoint you, the said Sir Walter Edward Davidson, to be, during Our pleasure, Our Governor in and over Our State of New South Wales and its Dependencies, in the Commonwealth of Australia, with all the powers, rights, privileges, and advantages to the said office belonging or appertaining.

And We do hereby appoint that so soon as you shall have taken the prescribed oaths, and have entered upon the duties of your office, this Our present Commission shall supersede Our Commission under Our Sign Manual and Signet bearing date the twenty-fifth day of November, 1912, appointing our Trusty and Well-beloved Sir Gerald Strickland, Count della Catena, Knight Commander (now Knight Grand Cross) of Our Most Distinguished Order of Saint Michael and Saint George, to be Governor on and over Our State of New South Wales and its Dependencies.

In the *Government Gazette* of 18 February 1918 Premier Holman published the text of Davidson's commission for general information and Davidson proclaimed that on the same day he

had taken the prescribed Oaths before the Chief Justice and had assumed the office of Governor.

Davidson proved as pompous as Strickland. In a private letter sent to Freda Dudley Ward from Sydney in 1921 and published in London in *Letters from a Prince*, Edward Prince of Wales summed up Sir Walter and Lady Davidson: '... no wonder the dominions get fed up with the Old Country and want to abolish all Imperial Governors if the Colonial Office will insist on sending out such hopeless boobs.' He wrote that on his return home he intended to tell the British Prime Minister: '... what a lot of harm is done throughout the Empire by the rotten governors they appoint who are nearly always pompous duds whom they don't want in London.'

Davidson died and was buried in Sydney. Strickland lasted longer. In 1921 he helped draft a constitution which gave Malta self-government with a Senate of seventeen members and a Legislative Assembly of 32 elected members. The Prince of Wales opened the first session on 1 November. Strickland was elected to the Assembly in 1921 and was Prime Minister from 1927 to 1932. He was concurrently a member of the British House of Commons from 1924 and of the House of Lords from 1928 as the first andlast Baron Strickland of Sizerd Castle. He died and was buried in Rabat. The Sovereign Military Hospitaller Order of St John of Jerusalem, of Rhodes and of Malta retains its headquarters in Rome. In December 1998 the Republic of Malta gave

the Knights a 99-year lease of Fort St Angelo where they success-fully resisted a siege by Süleyman the Magnificent in 1565. The Knights exercise sovereign rights in this autonomous territory.

Since the 1926 Imperial Conference the Prime Ministers of Australia have possessed and exercised the right to tender advice to the Kings or Queen of the United Kingdom on the appoint-ment of Governors-General of Australia. Since the *Australia Acts 1986* the Premier of each State has possessed and exercised the right to tender advice to Queen Elizabeth II on the appoint-ment of the Governor of the State. There is no doubt that most of the men whom Kings George V and VI and Queen Eliza-beth II have appointed Governors-General on the advice of Australian Prime Ministers have acted with more propriety than most of the Governors-General whom Queen Victoria and Kings Edward VII and George V appointed on the advice of British Prime Ministers. There is no doubt that since the *Australia Acts 1986* all the men and women whom the Queen has appointed Governors on the advice of Labor Premiers and all the men whom she has appointed as Governors on the advice of Liberal Premiers have acted with more propriety than most of the Gover-nors who were appointed on the advice of British Prime Ministers. The Queen remains Australia's Head of State. All the current vice-regal commissions were granted by her in London. That will continue to be the procedure until the electors of Australia approve a law proposed by the Australian Parliament

to make an Australian the Head of State of Australia. Vice-regal commissions are valid during the Queen's Pleasure; they do not mention the dates or periods of the appointment.

1859 BATTLEFIELDS

In 1998 our son Stephen drove me to the battlefields I used to invoke at the early naturalisation ceremonies at the Club Marconi. The troops of Napoleon III and Vittorio Emanuele II defeated the Austrians at Montebello on 25 May 1859, at Magenta on 4 June and at San Martino and Solferino on 24 June.

There are several towns called Montebello in Italy. Montebello Vicentino, between Vicenza and Verona, is Belmont, the seat of Portia in Shakespeare's *The Merchant of Venice*. At Montebello, between Alessandria and Piacenza, there are monuments to the victories over the Austrians in both 1800 and 1859. The earlier battle was won by French troops under General Jean Lannes (1769–1809). It contributed five days later to the victory by the First Consul, Napoleon Bonaparte, at Marengo. The Montebello (erroneously Monte Bello) Islands off the northwest coast of Australia, where the British exploded atomic bombs on 3 October 1952 and 16 May and 19 June 1956, were mapped

by the Baudin scientific expedition in 1801. The islands were called after the battle and not the general; he was created a Marshal of the Empire in 1804 and Duke of Montebello in 1808. Montebello in Québec was named after a diplomatic visit in 1854 to the French Canadian leader Louis-Joseph Papineau by Napoléon-Auguste Lannes (1801–74), second Duke of Montebello, an ambassador of Napoleon III. After the 1859 victory the town was called Montebello della Battaglia.

Near the railway station of Magenta, between Milan and Novara, there is an ossuary for the remains of the soldiers killed in the battle and a monument to the French commander-in-chief Marshal MacMahon (1808–93), whom Napoleon III created Duke of Magenta. His final victory was over the Paris Commune in 1871. He was the second President (1873–79) of the Third French Republic. In Australia the victory at Magenta is commemorated by a lake between Katanning and Norseman in Western Australia and a cattle station between Hillston and Wentworth in New South Wales.

The Italians engaged the Austrians at San Martino before the French engaged the Austrians on the same day. The town has been renamed San Martino della Battaglia to distinguish it from the very great number of other Italian towns called San Martino. Italian governments have embellished the town

and have installed elaborate sculptures and paintings of the campaign in a 74-m tower.

The victories of San Martino and Solferino, south of Lake Garda, were won at a heavy cost. The French lost two generals, seven colonels, 200 other officers and 6500 soldiers, and the Italians lost one general, three colonels, 76 other officers and 2200 soldiers. In the Parco della Rocca above Solferino a tower erected by the Scaligeri houses the Risorgimento museum. It records the inauguration of the ossuaries by Napoleon III and Vittorio Emanuele II on the eleventh anniversary of the battles. War broke out between France and Prussia 25 days later. In Australia the victory of Solferino is commemorated by a cattle station north of Clermont in Queensland.

The Swiss humanitarian (Jean-) Henri Dunant (1828–1910) organised emergency aid services for the tens of thousands of men wounded in the battles of San Martino and Solferino. In *Un Souvenir de Solferino* (1862) he urged the formation of voluntary societies in all countries to relieve suffering in war and peace. In 1864 he founded the Red Cross and the first national societies and organised the first Geneva Convention. There is a Red Cross Museum in the Piazza Castello of Solferino at the foot of the Rocca. In 1992 Leon Stubbings, who had been Secretary-General of the Australian Red Cross Society from 1955 to 1988, wrote its history under the title *Look What You Started Henry!*. In my foreword I stated: 'In civil wars, such as broke

out after Portugal's withdrawal from East Timor, successive Australian Governments have sought the services of the Red Cross as the most compassionate and dispassionate of international non-governmental organizations.'

Appendices

Appendix 1

MOROSINI'S LEGACY

Francesco Morosini (1618–94), the greatest Venetian general, was the first person to remove sculptures from the Parthenon, which Pericles built on the Acropolis of Athens between 447 and 438 BC.

After the Polish King John III Sobieski raised the second Turkish siege of Vienna in 1683, the Catholic powers attempted to drive the Turks out of Europe. Morosini overran the Peloponnesos with an army of German mercenaries and besieged the Acropolis of Athens. His field commander, Count Königsmark, placed his artillery on the Hill of the Muses. There was a powder magazine in the Parthenon, which was still in almost pristine condition. On 26 September 1687 a mortar bomb landed in the Parthenon, which exploded. I quote William St Clair's authoritative book, *Lord Elgin and the Marbles*, first published in 1967:

When the garrison surrendered and Morosini took possession of the Acropolis he decided to take home to Venice as a trophy of his conquest the large group of sculptures from the west pediment which had survived the explosion. But when his engineers were lowering the massive statues their cables broke and the whole group was shattered. A head from one of the pedimental figures, now in Paris, was taken back to Venice by Morosini's secretary. Two heads from a metope, now in Copenhagen, were

taken by another officer of his army. The following year Morosini was compelled to withdraw from Athens, leaving the Acropolis a heap of marble rubble. More damage was done to the Parthenon in one year than in all its previous history.

The Venetians gave Morosini the title Peloponnesiacò and elected him doge (1688).

British readers became familiar with the features and sculptures of the Parthenon from the descriptions and illustrations in *The Antiquities of Athens* (1762) by James Stuart (1713–88) and Nicholas Revett (1720–1804). The first ambassador to seek sculptures from the Parthenon was a French nobleman, the Comte de Choiseul-Gouffier. He had met the French antiquary Louis-François-Sébastien Fauvel on a tour of Greece in 1780. They carved their names on the Monument of Philopappos in Athens. The British ambassador protested at their activities. The Turkish authorities refused to let the French remove any sculpture from the building itself.

The next British ambassador was a Scottish nobleman, Thomas Bruce (1766–1841), seventh Earl of Elgin. He presented his credentials to Sultan Selim III in November 1799. He engaged Giovanni Battista Lusieri (Naples 1755–1821 Athens) to work for him in Athens as Fauvel had worked for Choiseul-Gouffier. Elgin's arrival was timely. Napoleon Bonaparte's Egyptian Expedition had invaded Turkey's most precious province in July 1798. Nelson had destroyed the French fleet during the Battle of the Nile on the night of 1–2 August. (The boy Casabianca stood on the burning deck of the flagship *Orient* before it exploded.) Bonaparte escaped to France between 22 August and 9 October. The French capitulated in Egypt in August 1801. The Turks turned a blind eye to Elgin's manipulation and corruption of their officials in Athens since he was the envoy of the British Empire that had saved the Ottoman Empire.

Elgin left Constantinople in January 1803. The first part of his collection arrived in England in January 1804 and the second part in

May 1812. All the artists declared that the sculptures were the finest works of art they had ever seen. Lord Byron satirised Lord Elgin in *The Curse of Minerva*, which he wrote at the Capuchin convent in Athens in March 1811; he admired the plunder but abhorred the thief. In 1812 in *Childe Harold's Pilgrimage* he cursed Elgin as the modern Pict who rived what Goth, and Turk, and Time had spared. In 1816 a Select Committee of the House of Commons judged £35 000 to be a reasonable and sufficient price for the Elgin Collection of Sculptured Marbles. Elgin died in Paris.

The first sculptures removed from a Greek temple to the British Museum did not come from the temple of Athena in Athens but from the temple of Apollo in Vassai. (The Select Committee called them the Phygalian Marbles.) In 1811 John Robert Cockerell (1788–1863), an architectural student, and Haller von Hallerstein, an agent of Ludwig, Prince Royal of Bavaria (Strasbourg 1786–1868 Nice), paid £40 to the leading men of Aigina for the marble pedimental sculptures on the temple of Aphaia. They then removed the 23 marble slabs of the cella frieze from the temple of Apollo Epikourios at Vassai. In 1812 the marbles from both Aigina and Vassai were auctioned in Zante, which had been included in the Illyrian Provinces of the Napoleonic Empire but had been occupied in 1809 by the British general Richard Church (Cork 1784–1873 Athens). The Aigina marbles were purchased for Prince Ludwig for £6000. He had them renovated by Thorvaldsen in Rome and built the Glyptothek to house them in Munich. The Prince of Wales, newly installed as Prince Regent, provided £15 000 for the British Museum to acquire the Vassai marbles.

On 17 December 1940, when Mussolini was at war with both the British Empire and Greece, Miss Thelma Cazalet, a Tory MP, asked Prime Minister Churchill 'whether he will introduce legislation to enable the Elgin Marbles to be restored to Greece at the end of hostilities as some recognition of the Greeks' magnificent stand for civilisation.' On 23 January 1941 the Labour Leader, Clement Attlee,

then Lord Privy Seal and Deputy to Churchill, rose to say: 'His Majesty's Government are not prepared to introduce legislation for this purpose.'

In 1942 Mr Ivor Thomas tabled a question asking the Prime Minister 'whether, in order to mark our gratitude for the continuing resistance of Greek guerilla forces, he would consider the transfer of the Elgin Marbles to the Greek Government for restoration to their original site after the war.'[1] On 13 October Churchill referred to the reply which had been given to Mrs Cazalet Keir. Churchill himself arrived in Athens on Christmas Eve 1944 and arranged a temporary truce in the civil war between the monarchists and the communists. He was accompanied by an Australian classicist, Sir Reginald Wildig Allen Leeper (1888–1968), known as Rex, the British ambassador to the Greek Government-in-exile from 1943 to 1946. After the war Leeper made the remarkable suggestion that Greece should join the Commonwealth. During the war in Crete, where the Greek monarchy was never popular, another Australian classicist, Thomas James Dunbabin (1911–55), DSO, is still fondly remembered as the comrade-in-arms of the British resistance leader, Patrick Leigh-Fermor DSO.

For 100 years after Byron's death Britain used to bask in the glory of his role in the liberation of Greece. One of the first actions of the first Hellenic Republic in 1924 was to issue two postage stamps inscribed 'Lord Byron' to commemorate the centenary of his death at Mesolongi. He is still the liberator most honoured at Mesolongi.

In 1962 the Menzies Coalition Government in Australia offered the Labor Party four ministerial style visits to Europe to assess the consequences of Britain joining the European Community. I was sent as the forerunner and made my first visit to the Parthenon in Athens and the Elgin Marbles in London. In December 1972 and again in May 1974 I was elected Prime Minister of Australia. In August 1974 Australia became the seventh country to ratify Unesco's 1972 World Heritage Convention. In January 1975 I was the first Head of Government to be received by Constantine Karamanlis, the first Prime Minister of the second Hellenic Republic.

I became involved with the Parthenon Marbles in two contexts. Australia and Greece are the only two countries from which athletes have gone to every Olympic Games since 1896. Australia and Greece were among the 28 founding members of Unesco. In September 1990 the International Olympic Committee awarded the 1996 Centennial Games to Atlanta ahead of Athens (the sentimental favourite), Toronto, Melbourne, Manchester and Belgrade. In September 1993 the Committee awarded the 2000 Games to Sydney; my wife's and my contacts with the francophone African members of the International Olympic Committee and Unesco had secured the 2000 Games for Sydney ahead of Beijing, Manchester, Berlin and Istanbul. Australia helped to secure the 2004 Games for Athens and the 2008 Games for Beijing.

Meanwhile, in 1981, Melina Mercouri was appointed the Greek Minister of Culture and the World Heritage Convention was ratified by Greece. In the opening speeches at the General Conference in October 1983 Melina Mercouri, was followed by Senator Susan Ryan, the Australian Minister for Education, who announced that Australia proposed to become a party to two Unesco Conventions on Cultural Property, the 1954 Convention for the Protection of Cultural Property in the Event of Armed Conflict and the 1970 Convention on the Means of Prohibiting and Preventing the Illicit Import, Export and Transfer of Ownership of Cultural Property. In pursuit of the 1970 Convention I went to Athens in April 1985 as an observer at the fourth session of Unesco's Intergovernmental Committee for Promoting the Return of Cultural Property to its Countries of Origin or its Restitution in Case of Illicit Appropriation. Melina Mercouri chaired the Committee. We met in the renovated Zåppeion. I observed the United Kingdom's reluctance to discuss the return of the Parthenon Marbles. Australia was elected to the Committee at the next Unesco General Conference in October 1985.

In February 1986 the Australian Attorney-General, Lionel Bowen,

who had come to Greece with me in January 1975, wrote to a Greek organisation in Australia:

The Government . . . has taken a sympathetic position on the question whenever the issue has been raised with the Government as, for example, in discussions in 1984 between the Minister of Arts, Heritage and Environment, Mr Cohen, and the Greek Minister for Culture, Ms Melina Mercouri.

Legal advice available to the Government is that the return of the Marbles is essentially a political matter to be resolved between the British and Greek Governments rather than a legal one and that, so far as international law is concerned, the title of the British Museum could not be successfully challenged. The Government, nevertheless, acknowledges the salience of arguments on aesthetic, technical and moral grounds.

In 1987 the British Committee for the Restitution of the Parthenon Marbles sent me the book by Christopher Hitchens, *The Elgin Marbles—Should They be Returned to Greece?* (Chatto & Windus). Under the Thirty Year Rule the author was able to obtain Foreign Office documents which showed the frantic efforts taken to frustrate Miss Cazalet's initiative in 1940. In 1988 the book was translated into Greek with a Foreword by Melina Mercouri and Prologue by archaeologist Manolis Andronikos.

As a member of the World Heritage Committee from 1983 to 1989 I supported the inscription of the first Greek sites on the World Heritage List:

- The Temple of Apollo Epikourios at Vassai in 1986;
- Delphi and the Acropolis of Athens in 1987;
- Epidavros, Mt Athos, Meteora, the Paleochristian and Byzantine Monuments of Thessaloniki and the Medieval City of Rhodes in 1988; and
- Mystras and Olympia in 1989.

Australia accepted the 1970 Convention in 1989.

In 1998 the Secretary of State for Culture, Media and Sport assured the House of Commons that 'the Parthenon sculptures were legally and properly acquired. They have been kept in very good condition.' St Clair's book showed that the first contention was highly dubious. A few days later the latter contention was demolished in the preface to the third edition of St Clair's book:

My researches have brought to light the facts of how, in 1937 and 1938, while in the stewardship of the British Museum, the Elgin Marbles were, over a period of at least eighteen months, and against the regulations then in force in the Museum, scraped with metal tools and smoothed with carborundum in an effort to make them appear more white. As a result, the historic surfaces of most of the sculptures were severely and irreparably damaged. With recourse to the official records to which access was repeatedly denied to me until 1996, I am here able to present the full account of the circumstances in which the disaster occurred, and of the extent of the damage, which the official inquiry of the time, hitherto suppressed, said 'cannot be exaggerated'. I also describe the measures subsequently taken by the British Museum authorities to cover up, quite literally, the effects of the mistreatment, and then, by unlawfully denying access to the relevant public documents, to prevent the full facts from becoming known until now.

In 1938 Lord Duveen of Millbank (Hull 1869–1939 London), the millionaire art dealer, had undertaken to pay for the construction of a new gallery in the British Museum to accommodate the marbles and ordered workers to 'spruce them up'. During World War II they were stored in a disused underground station at Aldwych. They were not installed in the Duveen Gallery until 1962, when at last the British Museum acquired proper air filters. Lords Elgin and Duveen were shown to be worse barbarians than Alaric the Goth, who spared the Parthenon in 396 AD. In the *International Journal of Cultural Property*

(1999, pages 397–521) St Clair published full documents on the acquisition and stewardship of the sculptures from Elgin to Duveen.

Four significant conferences arose from St Clair's revelations:

a) The 10th session of the Intergovernmental Committee in Paris in January 1999 adopted a recommendation for 'further initiatives to promote bilateral negotiations' between the UK and Greece.

b) A seminar on 'The Parthenon Sculptures: their History and Destiny' was held in February 1999 in Washington at the Corcoran Gallery of Art and a paper was delivered by Mr David Walden, the chairman of the Intergovernmental Committee.

c) An international conference was held at the British Museum in November 1999 concerning the present state of the surfaces, including the effects of the damage done in 1937/38, in which, among others, experts of the British Museum and the Greek Ministry of Culture participated. Despite promises to Parliament and Unesco, the Museum has not published the papers, perhaps in an attempt to avoid the further revelations in the paper by William St Clair. Incidentally, he is a Fellow of the British Academy and the Royal Society of Literature and Senior Research fellow of Trinity College, Cambridge. Until 1992 he was a senior official in Her Majesty's Treasury, professionally concerned with the matters of standards and accountability which arise in this affair.

d) The Greek Government and the Greek National Committee for Unesco organised a two-day international conference on the Parthenon Marbles in Athens in May 2000.

In October 1999 the House of Commons Culture, Media and Sport Committee announced its intention to conduct an inquiry into matters relating to cultural property, including measures to control the illicit trade in such property. The Committee held eight oral evidence sessions between late March and early June 2000. Australians for the Return of the Parthenon Marbles, whose patrons are Malcolm Fraser

and I, sent a memorandum to the Committee. The Commons Committee's report, ordered by the House to be printed in July 2000, was strictly neutral, setting out the arguments on each side.

In June 2001 a delegation from the Hellenic Council of Australia and the World Council of Hellenes Abroad gave the Australian Prime Minister a petition signed by 30 000 Australians calling for the British Government to return the Parthenon sculptures to Athens. Our Prime Minister told the delegation that he would give the petition to the British Prime Minister in the margins of the Commonwealth Heads of Government Meeting which was to meet in Brisbane in October. The Secretary of Australians for the Return of the Parthenon Marbles was a member of the delegation and sent each Prime Minister a letter with points to support the return. On 8 October, however, the following reply was received from Britain:

While the British Government have considered the issue over a number of years, they have decided that the return of the sculptures to Greece is not a feasible or sensible option. The British Museum, who hold these sculptures, is not permitted under its governing statute to dispose of any items within its collection (with minor exceptions). The institution is independent of Government, so any decision, for example on loans, would be a matter for the Museum's Trustees. The Trustees are of the view that they hold these items in a world class museum in trust for the British Nation and that 6.5 million visitors per annum from around the world see them in a multicultural context for free, and in conditions of excellent conservation and maintenance.

Although CHOGM was postponed to March 2002, on 30 November 2001 the Assistant Secretary of the Australian Department of the Prime Minister and Cabinet wrote to the Secretary of Australians for the Return of the Parthenon Marbles: 'Mr Howard considers the Parthenon Marbles an irreplaceable part of Greek heritage and national identity and has publicly expressed some sympathy for their return.'

It is gratifying that Australian Governments have moved since Mark Latham first raised the return of the Parthenon Sculptures in the Australian Parliament and Gareth Evans in 1994 and Alexander Downer in 1996 obsequiously endorsed the superficial and supercilious reply: 'My Department has not made representations to either the Greek or British Governments, nor in Commonwealth or United Nations forums on this matter.'

The British Prime Minister appoints fifteen of the British Museum's 25 Trustees; six of the fifteen have been appointed since September 1999. The Australian letter to the Prime Ministers asserted that a recent survey showed only 1.5 million persons visit the Duveen Gallery each year, a figure comparable with the number of visitors to the Acropolis each year. I find it sad that in the second half of the 20th century British Governments, Labour and Conservative, have dissipated the affection and admiration that Britain enjoyed in Greece in the century after Byron.

The first and largest restitution of movable cultural property took place very soon after the Elgin collection arrived in England. As the commanding general of the first French Republic in Egypt and Italy and then as First Consul and finally as Emperor, Napoleon assembled the greatest collection of movable cultural property in history. There will never again be as fabulous a repository as the Louvre during his reign. In August 1815 Canova, who had made many statues of Napoleon and his family, was sent by Pius VII to Paris to recover Napoleon's loot from Louis XVIII. He assisted the other occupying powers to recover their treasures.

Countries whose museums are still replete with treasures from old empires are not impressed by the British argument that, if Britain returns the Parthenon sculptures to Greece, they in turn will be pressured to return their treasures to the countries of origin. There are no signs of a domino effect. Turkey accepts that Prussia legally acquired the Hellenistic marbles from Pergamon for Berlin and that Austria legally acquired those from Ephesus for Vienna. After the Fourth

Crusade Doge Enrico Dandolo took the four Bronze Horses from the Hippodrome in Constantinople to the facade of St Mark's in Venice. Napoleon appropriated them for the Arc du Carousel in Paris. After Waterloo, the Habsburgs gained Venice and the Bronze Horses were restored to St Mark's. Turkey does not seek their return to Istanbul. Nor, I understand, does Egypt seek the return of the Rosetta Stone to Alexandria.

Suggestions that the Parthenon sculptures should be sent temporarily or in perpetuity to Athens have been met by assertions that the British Museum is prohibited from lending any of its works. I well remember, however, that while I chaired the Council of the Australian National Gallery in Canberra in 1990, the last year of the Thatcher Government, the Director of the Gallery and Sir David Wilson, the Director of the British Museum, arranged an exhibition of 100 objects, massive and minute, called 'Ancient Treasures from the British Museum'. In the preface to the catalogue Sir David wrote: 'This exhibition is without precedent in the history of the British Museum.' Germany is commemorating Greece's hosting of the Olympic Games by returning architectural sections from the Philippeion, the circular building at Olympia begun by Philip II after Chaironeia and finished by Alexander the Great. In return, the Pergamon Museum in Berlin will create a permanent exhibition space to receive regular loans of significant Greek antiquities.

The adoption of conventions on cultural property continues. The Unidroit Convention on Stolen or Illegally Exported Cultural Objects was adopted in Rome on 24 June 1995. The Second Protocol to the Hague Convention of 1954 for the Protection of Cultural Property in the Event of Armed Conflict was adopted under the auspices of Unesco at The Hague on 26 March 1999. The Unesco Convention on the Protection of the Underwater Cultural Heritage was adopted in Paris in November 2001.

On cultural property the UK, Greece and Australia have variable records in ratification and accession but in Unesco they have

opportunities to consult and cooperate. Greece was elected to the 21-member World Heritage Committee for a six-year term from 1997 and the UK for a six-year term from 1999. Greece was elected one of the 22 members of the Intergovernmental Committee for a four-year term from 1999. Greece was elected to the 58-member Executive Board for a four-year term from 1999 and the UK and Australia were elected for four-year terms from 2001.

It is reasonable to enquire why Australians should concern ourselves with the return of the Parthenon sculptures to Greece from Britain. There are more people in Australia than in Britain who can speak and read Modern Greek and, indeed, ancient or Christian Greek. There are more people in Australia than in Britain who know the politics and cultures of the Balkans, Orthodox, Catholic and Muslim. Australian schools, universities, galleries and museums developed along British lines and are still mostly influenced by British practice.

The Parthenon Marbles constitute an exceptional and special case for restitution. They are incomparably the finest examples of classical sculpture. The city of Pericles was also the city of Aeschylus, Sophocles and Euripides. Athens became the city of Thucydides, Aristophanes, Socrates, Isocrates, Plato, Xenophon, Demosthenes and Aristotle. Athens was the centre of ancient Greek culture and civilisation. Western civilisation and democracy were born in Athens. Australians and others who are among the inheritors of those assets should do what we can to have the most significant symbols returned to Athens.

On 8 December 2001, in the keynote address at a conference at University College, London, on 'Moral and Legal Imperatives for the Return of Cultural Property' I concluded:

On Easter Monday 6 April 1896 George I, King of the Hellenes and brother-in-law of our future King Edward VII, and Crown Prince Constantine, who was married to Queen Victoria's granddaughter, spoke at the opening of the first Olympic Games of the modern era in the Panathenaic Stadium in Athens. Many in this audience will be in

the Panathenaic Stadium when the President of the Hellenic Republic
opens the Games of Athens celebrating the XXVIII Olympiad in 2004.
Few will accept the view expressed by Byron in 1819:

> The isles of Greece, the isles of Greece!
> Where burning Sappho loved and sung,
> Where grew the arts of war and peace,
> Where Delos rose, and Phoebus sprung!
> Eternal summer gilds them yet,
> But all, except their sun, is set.

Most will accept the view expressed by Shelley in 1822:

> Another Athens shall arise,
> And to remoter time
> Bequeath, like sunset to the skies,
> The splendour of its prime.

Appendix 2

THE LONGEST CATHEDRALS

Brass tablets in the pavement of St Peter's in Rome with the lengths in metres

Templum Vaticanum 186.36

Londinense S Pauli Fanum 158.10

Florentina Metropolitana 149.28

Ecclesia SS Cordis Jesu Bruxelles 140.94

Sanctuarium Immaculatae Concept, Washington 139.14

Ecclesia Cathedralis Rhemensis [Reims] 138.69

Templum Cathedrale Coloniense [Köln] 134.94

Primarium Templum Mediolanense [Milan] 134

Ecclesia Cathedralis Spirensis [Speyer] 134

Basilica S Petronii Bononiae [Bologna] 132.54

Templum Metropolitanum Hispalensis Sevilla 132

Basilica Metropolitana BMV Parisien 130

Basilica S Pauli via Ostiensi [St Paul's Outside the Walls] 127.36

Ecclesia Cathedralis S Viti Pragae [Prague] 124

Primatialis Ecclesia Toletana [Toledo] 122

SS Ecclesia Lateranensis 121.84

Ecclesia Cathedralis Metropolitana Platensis [La Plata] 120

Ecclesia Cathedralis BMV Antverpiensis 118.60

Ecclesia S Justinae VM Patavin [Padua] 118.50

Basilica Cathedralis Esztergom 118

Ecclesia Cathedralis Ferrariens 118
Basilica Assisien S. Mariae Ang [Assisi] 114.76
Cath Metrop Sancti Pauli Brasilia 111.45
Ecclesia Cathedralis Westmonasteriensis [Westminster] 110
Constantinopolitana Divae Sophiae Ecclesia [Istanbul] 109.57
Basilica Gedanensis Beatistimae Virginis Mariae [Gdańsk] 103.50
Ecclesia Metropolitana S Patritii Neo Eboracen [New York] 101.19

Appendix 3

CASTRATI IN ENGLAND

England depended on Italy to supply castrati. In 1668–69 Baldassare Ferri (Perugia 1610–80 Perugia) was the first castrato to sing in concerts in England. In 1687 the soprano Giovanni Francesco Grossi (Chiesina Uzzanese 1653–97 by murder on the way to Ferrara), known as 'Siface' from his role in Cavalli's *Scipione Africano*, was sent by Francesco II, Duke of Modena, to sing for his sister in the Catholic chapel of her husband, King James II. Public performances were given by the soprano Pier Francesco Tosi (Cesena c.1653–1732 Faenza) in 1692–94. He was followed in 1707–11 by the mezzo-soprano Valentini Urbani, in 1708–12 and 1714–17 by the mezzo-soprano Nicolò Grimaldi (Naples 1673–1732 Naples), known as Nicolini, in 1714–15 by Filippo Balatri (near Pisa 1676–1756 Fürstenfeld) and in 1716–17 and 1729–30 by the mezzo-soprano Antonio Maria Bernacchi (Bologna 1685–1756 Bologna). Nicolini also performed in Dublin in 1711. Tosi returned to London as a teacher in 1724–27.

The greatest castrati were engaged by the Royal Academy of Music from 1720 to 1728 and by the Opera of The Nobility from 1732 to 1737. The Venetian soprano Matteo Berselli appeared in London in 1720–21; the mezzo-soprano Senesino-Francesco Bernardi (Siena c.1680–c.1759 Siena) appeared from 1720 to 1728 and from 1730 to 1736; the contralto Andrea Pacini (Lucca c.1690–1764 Florence) in 1724–25; Baldi, a countertenor, from 1726 to 1728; Giovanni Carestini

(Filottrano 1705–60 Filottrano), successively soprano, countertenor and contralto, in 1733–1735 and in 1739–40; the soprano Carlo Scalzi in 1733–34; the soprano 'Farinelli'—Carlo Broschi (Andria 1705–82 Bologna)—in 1734–36; the soprano 'Gizziello'—Gioacchino Conti (Arpino 1714–61 Rome)—in 1736–37; and the mezzo-soprano 'Caffarelli'— Gaetano Maiorano (Bitonto 1710–83 Naples)—in 1737–38.

For the rest of the century few London seasons lacked performances by castrati: the soprano Andreoni from 1740 to 1742; the soprano Angelo Maria Monticelli (Milan c.1710–64 Dresden) from 1741 to 1744 and in 1745–46; the contralto Gaetano Guadagni (Lodi 1725–92 Padua) in 1748–49, 1755 and 1770-71; the soprano Giusti Ferdinando Tenducci (Siena c.1735–90 Genoa) from 1758 to 1865; Filippo Elisi in 1760–62 and 1765–66; the soprano Giovanni Manzuoli ('Succianoccioli') in 1764–65; the soprano Tommaso Guarducci Toscano in 1766–69; Giuseppe Millico in 1772–74; the soprano Venanzio Rauzzini (Camerino 1746–1810 Bath) in 1774–76; the soprano Gaspare Pacchierotti (Fabriano 1740–1821 Padua) in 1778–80; Domenico Cremonini in 1784–87; the mezzo-soprano Girolamo Crescentini (Urbania 1762–1846 Naples) in 1785; the contralto Giovanni Battista Rubinelli (Brescia 1753–1829 Brescia) in 1786–87; the soprano Luigi Marchesi (Milan 1755–1829 Milan) ('Marchesini') in 1788–90; the soprano Giuseppe Benigni in 1790–91 and the soprano Agrippino Roselli in 1794–96 and 1800. It was 25 years before another, and the last, castrato appeared in London, the soprano Giovanni Battista Velluti (Montolmo, now Corridonia 1780–1861 Sambruson) in 1825–29. Alessandro Moreschi (1858–1922) did not appear in opera but made ten records in 1902–03.

Appendix 4

ITALIANS IN ALBANIA

In *Abiding Interests* (page 90) I described the precipitate and syco-phantic speed with which the Keating Government followed the Bush Administration and the Major Government in recognising the inde-pendence of former Yugoslav republics with the artificial frontiers Tito had defined for domestic purposes. In this book I should add a note about Italy's relations with Albania during World War II. Those re-lations have had repercussions among many families who have migrated to Australia from the Balkan countries.

Albania broke away from the Ottoman Empire in 1912 and was admitted to the League of Nations in 1920. Ahmed Bey Zogu (1895–1961) was elected President of Albania in February 1925 and proclaimed Zog I, King of the Albanians, in September 1928. He married an Hungarian countess in October 1939 and she gave birth to a son, Leka, on 5 April 1941. The next day the queen and prince left for Greece. On 7 April, Good Friday, Italian troops landed at four Albanian ports. The following day King Zog left for Greece. On 13 April Vittorio Emanuele III of Italy accepted the throne of Albania. One of the Italian disembarkation ports was renamed Porto Edda after Mussolini's daughter Edda, the wife of his Foreign Minister Galeazzo Ciano, Conte di Cortellazzo.

On 28 October 1940 the Greek dictator Metaxas replied 'No' to an ultimatum by Mussolini, who then ordered Italian troops based in

Albania to invade Greece. In January 1941 the Greeks drove the Italians back into Albania and in March German troops crossed Bulgaria into Greece. In Vienna on 25 March Prince Regent Paul of Yugoslavia (St Petersburg 1893–1976 Paris) signed the Tripartite Pact of Germany, Italy and Japan. Two days later, on 27 March, a coup d'état in Belgrade allowed King Peter II, aged seventeen, to be declared of age. He was Britain's and Australia's only ally in the continent of Europe. On 6 April, Palm Sunday, German bombers blitzed Belgrade, killing 17 000 civilians. On 10 April the German army entered Zagreb and the fascist Ante Pavelić (Bradina, Bosnia 1889–1959 Madrid) proclaimed the Independent State of Croatia. German troops then occupied Belgrade on 13 April and Athens on 27 April. By the end of the month, Yugoslavia had been dismembered. Germany and Italy divided Slovenia, Hungary and Bulgaria annexed adjacent Yugoslav provinces and Italy annexed Montenegro and several Dalmatian ports and islands and incorporated Kosovo in a Greater Albania. On 15 June 1941 Croatia adhered to the Tripartite Pact. In September 1943 Germany took over Greater Albania.

In 1945 a reconstituted Yugoslavia became an original member of the United Nations. In 1946 the United Kingdom and the United States broke off relations with Albania and vetoed its admission to the United Nations. Albania and Italy were admitted in December 1955, the United States abstaining from voting on Albania. In April 1961 Albanian exiles in Paris crowned Crown Prince Leka as King Leka I. He married Susan Cullen-Ward, who was born at Waverley near Sydney in January 1941, in October 1975 at Biarritz.

In 1999 NATO took military action against Yugoslavia on the basis of allegations that Serbs were indiscriminately killing Albanians in Kosovo. The British spokesman trumpeted that there were 10 000 victims. An aerial blitz against Yugoslavia was conducted between 24 March and 10 June from bases in Italy. One US army aviation regiment operated from the Albanian capital, Tirana. In August 2000 a spokesman for the International Criminal Tribunal for the Former Yugoslavia, established by the Security Council in 1993, announced,

'The final number of bodies uncovered will be less than 10 000 and probably more accurately determined as between 2000 and 3000'.

Shamefully and incredibly, John Howard and Kim Beazley in April 1999 published messages celebrating the anniversary of the Pavelić regime. In 1964 Menzies refused to defend Snedden over a similar transgression (*The Whitlam Government*, page 168). Croatia, the state which the Keating Government recognised in January 1992 and which, since the death of Franjo Tudjman, has a relatively democratic president, celebrates its Statehood Day on 30 May.

Appendix 5

ITALIAN NAMES OF FOREIGN OR HISTORIC PLACES

Agrigento	*Girgenti*	Fiume	*Rijeka*
Alto Adige	*Südtirol*	Imperia	*Porto Maurizio-*
Antivari	*Bar*		*Oneglia*
Arbe	*Rab*	Lepanto[1]	*Návpaktos*
Bolzano	*Bozen*	Lesina	*Hvar*
Brazza	*Brač*	Lissa	*Vis*
Calchi	*Khálki*	Lubiana	*Ljubljana*
Calino	*Kálimnos*	Malvasia	*Monemvasía*
Candia	*Iràklion*	Melita	*Mljet*
Canea	*Khaniá*	Milo	*Mèlos*
Capodistria	*Koper*	Morea	*Pelopónnesos*
Caso	*Kásos*	Navarino	*Pỳlos*
Castelrosso	*Kastellórizon*	Negroponte	*Evvia*
Cattaro	*Kotor*	Nicosia	*Levkosía*
Cefalonia	*Kefallinía*	Nizza	*Nice*
Cerigo	*Kíthera*	Norcia	*Nursia*
Cherso	*Cres*	Piscopi	*Tílos*
Coo	*Kos*	Pola	*Pula*
Corfù	*Kérkira*	Ragusa	*Dubrovnik*
Curzola	*Korčula*	Retimo	*Rèthymnon*
Durazzo	*Durres*	Rodi	*Rhòdos*
Etna	*Mongibello*	Santorini	*Thera*

Scarpanto	*Kárpathos*	Trau	*Trogir*	
Scio	*Khíos*	Veglia	*Krk*	
Scutari	*Shkodër*	Velia	*Elèa*	
Sebenico	*Sibernik*	Vittorio Veneto	*Serravalle-*	
Spalato	*Split*		*Ceneda*	
Stampalia	*Astipálaia*	Zante	*Zákynthos*	
Tarquinia	*Corneto*	Zara	*Zadar*	

Appendix 6

ITALIAN PLACES IN
ENGLISH PLAYS

AMALFI

John Webster, *Duchess of Malfi* (c.1613)

FLORENCE

Ben Jonson, *Everyman in His Humour* (original version, 1598, in which
 William Shakespeare acted)
Shakespeare, *All's Well That Ends Well* (1602–03)
George Chapman, *All Fools* (1605)
Thomas Dekker, *The Wonder of a Kingdom*
Thomas Heywood, *A Maidenhead Well Lost*
John Fletcher and others, *The Fair Maid of the Inn*
Thomas Middleton, *Women Beware Women* (1620)
Philip Massinger, *The Great Duke of Florence* (1627)
Sir William D'Avenant, *The Just Italian*
James Shirley, *The Traitor* (1631)
Henry Hart Milman, *Fazio* (1815)

Richard Henry Horne, *Cosmo de Medici* (1837)

Oscar Wilde, *A Florentine Tragedy* (1894—Puccini considered it for an opera)

The Duke of Florence in Webster's *The White Devil* is Francesco I de' Medici (1541–87), the father of Maria who married Henri IV of France. Giovanni, the devil, is the son of Paolo Giordano Orsini, who visited London in 1600–01.

GENOA

John Day, *Law Tricks* (1608)

John Fletcher and Thomas Middleton, *The Nice Valour*

John Ford, *The Lady's Trial* (1639)

Nicholas Rowe, *The Fair Penitent* (1703—featuring the gay Lothario)

John Stoddart and Georg Heinrich Nöhden, *Fiesco, or the Genoese Conspiracy* (1796—a translation of Schiller's 1783 tragedy)

There is a former Duke of Genoa in John Marston's *Antonio and Mellida* and his ghost in the sequel, *Antonio's Revenge*. Marston's *The Malcontent* has a sometime Duke of Genoa as well as the reigning one. The second customer observed by *Fanny Hill* (1748) was a young Genoese merchant.

MALTA

Christopher Marlowe, *The Jew of Malta* (1590)

John Fletcher, *The Knight of Malta* (1618)

MILAN

Shakespeare, *The Two Gentlemen of Verona* (1594–95)
Jonson, *The Case is Altered*
Dekker and Middleton, *The Honest Whore*, Part I (1604)
Dekker, *The Honest Whore*, Part II (1605)
Middleton, *More Dissemblers Besides Women*
Francis Beaumont and John Fletcher, *The Women-Hater* (1605)
Massinger, *The Duke of Milan* (1623)
Thomas Killigrew, *The Pilgrim*
William Dunlap, *The Italian Father* (1799)
John Howard Payne (New York 1791–1852 Tunis), *Clari: or, The Maid of Milan*
Richard Penn Smith, *The Deformed* (Philadelphia, 1830—an adaptation of the Dekker and Dunlap plays)
Charlotte Mary Sanford Barnes, *Octavia Brigaldi* (1837)
Edward Reeve, *Raymond, Lord of Milan*, (Sydney, 1851)

In Shakespeare's *The Tempest* Prospero is the rightful Duke of Milan and his brother Antonio the usurping Duke. There is a Duke of Milan in Heywood's *A Maidenhead Well Lost*, in Field's 'The Triumph of Love' (the second of the *Four Plays, or Moral Representations, in One*) and in the Beaumont and Fletcher canon. A general of Milan appears in Massinger's *The Guardian*. The last act of Webster's *The Duchess of Malfi* takes place in Milan. A son of the Duke of Milan appears in Marston's *Antonio and Mellida* and *Antonio's Revenge* and the Duke and Duchess of Milan are characters in D'Avenant's *Love and Honour*. A princess of Milan appears in Shirley's *The Grateful Servant*. Isabella, widow of Duke Gian Galeazzo Sforza, is a character in John Crowne's *The History of Charles the Eighth of France* (1672). The hero of M.G. ('Monk') Lewis's Gothic drama *Rugantino; or, The Bravo of Venice* (1805) turns out to be the Duke of Milan.

MONTEBELLO VICENTINO (BELMONT)

Shakespeare, *The Merchant of Venice* (1596–97)

NAPLES

Dekker, *If This Be Not a Good Play, the Devil Is In It*
Fletcher and Massinger, *The Double Marriage*
Webster, *The Devil's Law Case* (1620)
Fletcher, *A Wife for a Month* (1624)
Shirley, *The Young Admiral, The Royal Master*
Thomas Killigrew, *Bellamira her Dream* (1664)
John Crowne, *The History of Charles the Eighth of France* (1672), *City Politicks* (1675)
Aphra Behn, *The Rover: or, the Banisht Cavaliers*, Part I (1677) and Part II (1681)

PADUA

Shakespeare, *The Taming of the Shrew* (1593–94)
Richard Penn Smith, *The Actress of Padua* (Philadelphia, 1836)
Oscar Wilde, *The Duchess of Padua* (New York, 1891—'The play itself was a great success, but the audience was a profound failure.')

ROME

Shakespeare, *Julius Caesar* (1599–1600), *Coriolanus* (1607–08)
Barnabe Barnes, *The Devil's Charter: A Tragedy Containing the Life and Death of Pope Alexander VI* (1607)
Webster, *The White Devil* (published 1612)
Massinger, *The Roman Actor* (1626)
Dryden, *The Assignation* (1673)
Nathaniel Lee, *Caesar Borgia* (1680)
Day, *The Travailes of the three English Brothers Sir Thomas Sir Anthony Mr Robert Shirley* (1607)
Percy Bysshe Shelley, *The Cenci* (1821)
Edgar Allan Poe, *Politian: A Tragedy* (1837)
Richard Henry Horne, *Gregory VII* (1840)

SALERNO

Robert Wilmot and others, *The Tragedie of Tancred and Gismund* (1568 in quatrains and 1591 in blank verse—the first English play from an Italian source, *Decameron*, IV, i)
Frederick Howard, Earl of Carlisle, *The Father's Revenge* (1783—from *Decameron*, IV, i)

SALUZZO

Dekker, Chettle and Haughton, *Patient Grissil* (1600—from *Decameron*, X, x)

Paolo Antonio Rolli FRS (1729), *Griselda* (1721—in Italian and
 English)

SAVOY

Shirley, *The Grateful Servant*
D'Avenant, *Love and Honour*

Alonso, King of Naples in Shakespeare's *The Tempest*, becomes Alonzo,
Duke of Savoy, in D'Avenant's and Shadwell's versions. A prince and
a lord of Savoy appear in Thomas Killigrew's *Cicilia and Clorinda*.

SICILY

Shakespeare, *The Comedy of Errors* (1592–93), *The Winter's Tale*
 (1610–11)
Beaumont and Fletcher, *Philaster*
Massinger, *A Very Woman*
D'Avenant, *The Platonic Lovers*
Samuel Harding, *Sicily and Naples, or, The Fatall Union* (1640)
James Thomson, *Tancred and Sigismunda* (1745—from Lesage, *Gil
 Blas*, IV, iv)
Thomas Killigrew, *Bellamira her Dream Claricilla* (1641)
B.W. Procter, *A Sicilian Story* (1820)
Felicia Dorothea Browne Hemans, *The Vespers of Palermo* (1823)
Helen Selina Sheridan, *Finesse; or a Busy Day in Messina* (1863)
Rodgers and Hart, *The Boys from Syracuse* (1938)

There are kings of Sicily in Massinger's *The Maid of Honour*, which is partly set in Sicily, and Shirley's *The Young Admiral* and a Sicilian Duke Alphonso in D'Avenant's *The Siege of Rhodes*. In Killigrew's *The Prisoners* the hero is the King of Sicily and most of the cast are Sicilian.

SIENA

Ford, *The Fancies Chaste and Noble*
Stephen Phillips, *Pietro of Siena* (1910)

A Duchess of Siena is a character in Massinger's *The Maid of Honour*, which is partly set in Siena. The Duke of Siena is a character in John Fletcher's *Women Pleased* and the hero of D'Avenant's *The Cruel Brother*.

URBINO

Sir William Killigrew, *The Siege of Urbin* (1666)

VENICE

Shakespeare, *Merchant of Venice* (1596–97), *Othello* (1604–05)
Chapman, *May Day* (1611)
Jonson, *Volpone* (1607)
Day, *Humour out of Breath* (1608)
Beaumont and Fletcher, *The Captain* (1612)

Marston, *Antonio and Mellida* (1602), *Antonio's Revenge* (1602), *The Insatiate Countess* (1613)

Shirley, *The Gentlemen of Venice*

Otway, *Venice Preserved* (1682)

M.G. ('Monk') Lewis, *Rugantino, or, The Bravo of Venice* (1805), *Venomi, or, The Novice of St Mark's* (1808)

Byron, *Marino Faliero* (1821), *The Two Foscari* (1821)

Richard Penn Smith, *The Bravo* (1831)

Swinburne, *Marino Faliero* (1885)

Gilbert, *The Gondoliers* (1889)

Benjamin Britten, *Death in Venice* (1973)

There is a Duke of Venice in Robert Davenport's *The City Night-Cap* (1624)

VERONA

Shakespeare, *Romeo and Juliet* (1594–95)

Susannah Centlivre, *The Cruel Gift* (1716) (from *Decameron*, IV, i)

Appendix 7

ENGLISH WORDS
FROM AND IN ITALIAN

Architectural and musical terms have been omitted from this list.

alarm from *all'arme* through French
argosy from Ragusa
baldacchino from Bagdad
bankrupt from *banca rotta* (broken bank)
beret from *biretta*
bergamasque from Bergamo
boloney from Bologna, with reference to the academic jargon of its
　university
bravo (1597) from the word for a hired assassin
broccoli from the word for cabbage sprouts
cadre from *quadro*
carixea (1454) for a kersey
catso, a 17th-century term from *cazzo*, a prick
confetti from the bonbons thrown during carnival in Italy
damask from Damascus
ducat from *ducato*, meaning dukedom. A silver coin issued in 1140
　by King Roger II of Sicily as Duke of Apulia; a silver coin issued
　in 1202 by Doge Enrico Dandolo (1192–1205) of Venice, the
　conqueror of Constantinople; and the Gold Ducat, the first bimetallic

coin issued by Doge Giovanni Dandolo (1280–89) and circulated until the fall of the Venetian Republic in 1797.

excavator for the original British archaeologists in Italy

faience from Faenza

fiasco from the word for a flask or flagon

finale has three syllables.

florin from *fiorino*, the gold coin issued in Florence in 1252

forte, meaning a person's strong point, comes from French not Italian.

furore has three syllables; in the United States it is spelt furor.

gazette (1605) from *gazeta*, a cheap Venetian coin of sufficient value to buy a news-sheet

ghetto perhaps from *getto*, the Venetian foundry where the first ghetto was established in 1516, or from *borghetto*, a little town

gondola is already found in Spenser's *Faerie Queen*, II, vi, 2.

grotesque from the type of paintings found in a grotto

gusto from the Italian word for taste

harangue from *arengo*, Venetian for a general convocation

imbroglio for embroilment in the messy intrigue (*broglio*) customary among Venetian office-seekers in buying the votes of the *barnabotti*, the impoverished nobles who lived in the parish of S. Barnabà

influenza (1743) for an epidemic attributed to an astral or occult influence

italics for the printing type introduced by the Aldine press in 1500

lombard for a banker, money-changer or pawnbroker (used between 1377 and 1709) or his place of business (used between 1609 and 1799); the word lumber is derived from the latter

macaroni, an 18th-century term for a dandy

manifesto is first found in 1644.

mantua, an 18th-century term for a silk gown erroneously associated with Mantua; *cf* mantilla in Spanish

Martello tower from Cape Mortella in Corsica captured by the British in 1794

milanese for textiles from Milan

muslin from Mosul

ounce from *oncia*, a Sicilian gold coin mentioned in the folk song which concludes the fifth *novella* of the Fourth Day of the *Decameron*

paparazzo from a character of that name in Fellini's film *La Dolce Vita* (1960)

pasquinade from the satirical Latin verses attached to 'Pasquino', the 3rd-century BC statue re-erected in Rome in the 16th century

picayune from a copper coin in francophone Piedmont

polacre from the word for a three-masted sailing ship in Italian, French and Spanish; it is not related to words for Polish in those languages

pistol from Pistoia

sequin from *zecchino*, as the Gold Ducat was called under Doge Francesco Donà (1545–53) and until 1797

seraglio from *serraglio*, the Italian version of *saray*, the Persian word for palace; used by the Turks for the parts of the palace where the wives or concubines were secluded

stanforti for Stamford cloth

stradiots (or estradiots) from *stradiotti*, light cavalrymen recruited from the Venetian possessions in Greece, where *stratiotis* is the word for soldier

tarantella from Taranto

terracotta from baked earth used in pottery

tontine from the life insurance plan devised by the 16th-century Neapolitan financier Lorenzo Tonti

traject from *traghetto*, a Venetian ferry; the Burchiello motor launch now follows the route of the *traghetto* along the Brenta canal between Venice and Padua. ('Tranect' in earlier editions of Shakespeare's *Merchant of Venice* [III, iv, 53] was a misprint for traject.)

turquoise from the Turkish stone brought from Turkestan or through Turkey

vendetta, from Latin *vindicta*, is used in English in the Corsican sense

of hereditary revenge and not in the Italian sense of Judgement (Day).

zach from the coin *zecchino*

zany from Zanni, the Venetian form of Gianni, the name of the foolish servant in the *commedia dell'arte*

ENDNOTES

POLITICS

1 My first Minister for Immigration, Al Grassby, unveiled a monument to Carboni in Urbino in 1974.

2 The family of Anthony Sylvester Luchetti (1904–84), MHR for Macquarie (1951–75), came from Ancona. The grandfather of (Dominic) Eric Costa (1900–76), MHR for Banks (1949–69), was the son of Cavaliere Pasquale Costa of Naples. Another of Pasquale's sons, Sir (1869) Michael Costa (Naples 1810–84 Hove), went to London in 1829. He was the first master conductor to appear in England. He made Handel more popular. Meyerbeer called him 'the greatest *chef d'orchestre* in the world'.

3 In October 1997 the Australian Department of Education, Training and Youth Affairs, jointly with the Australian Vice-Chancellor's Committee, signed a record of understanding with Italy on arrangements for the recognition of qualifications. This provides for appropriate levels of comparison of academic titles.

4 Rodrigo de Borja y Borja was born at Játiva near Valencia in 1431. His maternal uncle, Alonso de Borja (1378–1458), was elected Pope Callistus III in 1455. He established the family fortunes in Italy and began the rehabilitation of Joan of Arc. Rodrigo was brought to Italy where, as Borgia, he was educated, promoted and

enriched. Alexander VI was no saint but one of his grandsons, Ippolito II d'Este (1508–72), the younger son of his daughter Lucrezia (Duchess of Ferrara, Modena and Reggio), was archbishop of Milan and a cardinal. Francisco de Borjia (Gandía 1510–72 Rome), the grandson of his second son Giovanni (Rome 1476–97 Rome), Duke of Gandía, was the second founder of the Jesuits (1565) and a saint (1671).

5 Bixio and Goffredo Mameli (Genoa 1827–49 Rome) were comrades in arms against the Austrians in northern Italy in 1848 and against the French in Rome in 1849. Mameli wrote the revolutionary hymn 'Fratelli d'Italia' in 1847 and Michele Novaro set it to music in 1848. In 1855 Bixio brought 84 immigrants to Sydney in the Sardinian vessel *Goffredo Mameli*. His hymn is now the national anthem of Italy.

6 The meeting between Garibaldi and Vittorio Emanuele II is commemorated in Australia by the Teano Range between the Ashburton and Gascoigne Rivers in Western Australia.

7 In Bronte, on the western foothills of Mt Etna, road signs still point the way to the Castello Nelson.

SANTAMARIA

1 In 1903 Mannix was appointed President of the Royal College of St Patrick, the Catholic seminary established by the British Government at Maynooth in Ireland in 1795. He entertained Edward VII there in 1903 and George V in 1911. In 1912 he was consecrated bishop of Pharsalus, where Caesar defeated Pompey in 48 BC, and he arrived in Melbourne in 1913 as coadjutor archbishop to Archbishop Thomas Joseph Carr (1839–1917). I refer to the influence of Mannix on Menzies and me in *The Whitlam Government* between pages 296 and 300.

2 Frederick Ramón de Bertodano y Wilson (1871–1955), 8th Marqués del Moral (1921), was a student at St Paul's College within the University of Sydney from 1888 to 1891.

3 I first met Sir (1959) Frank Packer (1906–74) when he was a lieutenant in the AIF after serving as Director of Personnel in the Allied Works Council under Ted Theodore, Treasurer of Australia in the Scullin Government and Director of Allied Works under the Chifley Government. On 2 March 1945 we sat together on a Dutch military DC 3 taking me from Brisbane to Sydney for a short leave between tours of duty in northern Australia and the Philippines. As we flew into Sydney over Palm Beach, my fellow-traveller showed me the mansions and mentioned their owners. Our second son, Nicholas, was born on St Nicholas' Day, 6 December 1945.

4 Vidkun Quisling (1887–1945) founded the Norwegian National Unity Party in imitation of the German National Socialist Party. After Germany occupied Norway in World War II he was recognised as the head of the puppet administration.

5 On 14 December 1960, the United Nations General Assembly approved a Declaration on the Granting of Independence to Colonial Countries and Peoples, although Portugal and Australia were among the nine countries which abstained on the vote. On 5 February 1963, the Menzies Government came to the conclusion that 'no practicable alternative to eventual Indonesian sovereignty over Portuguese Timor presented itself'. In the United Nations General Assembly the Menzies, Holt, Gorton and McMahon Governments never voted against Portuguese colonialism. My Government was sworn in on 5 December 1972 and voted against that country's colonialism. On 25 April 1974, with the overthrow of the Government in Lisbon by the Armed Forces Movement, the new Portuguese Government was committed to decolonisation. In August 1975 civil war broke out between the new-born parties in Dili, the capital of East Timor. During the night of 27 August, the

Portuguese Governor and his officers decamped to the offshore island of Atauro.

On 13 November 1995 Henry Kissinger was asked at a business luncheon in Sydney about his and President Ford's reaction, when, at their departure from Jakarta airport on 6 December 1975, they were told about Indonesia's imminent landings in Timor. Kissinger replied:

> We didn't know much about East Timor. All we knew was that West Timor was Indonesian and that East Timor was Portuguese and that the Portuguese had already declared that they were leaving. When President Ford and I were leaving, the Indonesians told us at the airport that they were going to invade in the next few days. To us it looked like India taking Goa and it looked like the normal evolution of the end of colonial rule. It was also the year in which Viet Nam had collapsed and the Cubans were putting arms into Angola. We were not looking for a fight with Indonesia over a country we didn't know much about.

Before dawn on 7 December Indonesian marines and paratroopers landed in Dili. The Governor and his officers sailed home in three new Portuguese frigates commissioned in February, June and October 1975. The heirs of Vasco de Gama never fired a shot.

RELIGION

1 In *Paradiso* (canto X, line 131) Dante links Bede with two other theologians, St Isidore of Seville and St Richard of Saint-Victor, who was born in Scotland. St Isidore was declared a Doctor of the Church by Innocent XIII (1721–24) in 1722 and Bede by Leo XIII in 1899. King Alfred the Great (871–900) helped to translate Bede's history into English. The Abbey of Saint-Victor in Paris

was built in 1113 by Louis VI and suppressed in 1790 under Louis XVI. St Thomas Becket and Abélard resided there.

2 Andrea Della Rena appears as Ammonio in the British *Dictionary of National Biography* published between 1885 and 1900. In Latin, the language of scholars, his name was Arena, the word for sand. Like many scholars, he adopted a name from Greek, in which *ammos* is the word for sand. Accordingly, in contemporary documents he is called Ammonius in Latin and Ammonio in Italian. At the time there was revived interest in the writings of the Aristotelian philospher Ammonios, who flourished in Alexandria in 500 AD. The *Dizionario Biografico degli Italiani*, published since 1960, is valuable for correcting the entries on Italians in the *Dictionary of National Biography*. Volume 55 (2000) of the *Dizionario Biografico degli Italiani* covers Gigli.

3 In 1981 Dr James Carroll, Titular Archbishop of Amasea (1965) and senior auxiliary bishop to the Cardinal Archbishop of Sydney, gave me, 'a benign heretic', warm letters of introduction to the rectors of the English and Scots Colleges. I was shown the treasures of the English College by John Philip Parsons, who, like me, had been a pupil at Canberra Grammar School, the diocesan school of the Anglican diocese of Canberra and Goulburn. He was ordained at the end of 1981 and is now chaplain to Canberra's Tridentines. His father was a lawyer in the Attorney-General's Department when my father was Crown Solicitor. Nicholas Wiseman, appointed Rector of the College in 1828, was appointed the first Archbishop of Westminster in 1850. In 2000, Cormac Murphy-O'Connor, appointed rector of the college in 1971, was appointed the most recent Archbishop of Westminster. The most notorious student of the Pontifical Scots College, established in 1600 by Clement VIII (1592–1605), was Frederick William Rolfe (London 1860–1913 Venice), who was expelled. He wrote the autobiographical fantasy *Hadrian the Seventh* in 1904 in Venice, where he assumed the title Baron Corvo. In the 1920s and 1930s,

his brother, Alfred James Rolfe, an Anglican priest, was the head-master of Sydney's Malvern Church of England Grammar School at Woolwich, opposite St Ignatius College, Riverview. The Pontifical Irish College opened in Rome in 1628 in the reign of Urban VIII (1623–44) and was reconstituted in 1826 in the reign of Leo XIII (1823–29).

4 In 1430, Thomas Palaiologos married the daughter of Centurione II Zaccaria, the last Genoese despot of Morea (1404–30), and received the principality as her dowry. The popes acted as the guardians of their children. Paul II (1464–71) planned to marry their daughter Zoe (Sophia Palaiologina), who had become a Catholic, to Tsar Ivan III of Russia as a step towards reconciling the Catholic and Russian Churches. The next Pope, Sixtus IV (1471–84), effected the dynastic union in 1472 but never effected the ecclesiastical union. Sophia's grandson, Ivan IV, the Terrible, established a link with the Romanovs, who inherited the double eagle of the Palaiologoi.

5 In June 1660, the month he returned to London, Charles II received ambassadors from Venice with the republic's congratulations to him and pleas for support in Crete. In December 1661 Roger Palmer (1634–1705) was created Earl of Castlemaine after his wife Barbara, née Villiers, became the King's mistress. After she gave birth to her first royal duke in June 1662, he went abroad. He sailed with a Venetian squadron to Crete in 1664 and wrote *An Account of the Present War between the Venetians and Turks; with the State of Candia: in a Letter to the King from Venice.* The letter was published in London in 1666. In 'The Last Instructions to a Painter, London, 4 September 1667' the poet Andrew Marvell (1621–78) has 'Pilgrim Palmer' travelling to Candy to measure his own cuckold's horns against the Minotaur's. In 1670 the Countess of Castlemaine was created the Duchess of Cleveland.

6 After the audience, the Pope's assistant, Monsignor Paul Marcinkus, Bishop of Orta, presented Margaret, our son Nicholas,

who was resting between Harvard and London Universities, and John Menadue, my secretary. I had met Menadue, a Treasury official, in 1960 on the recommendation of George Wheen, a Methodist minister in Canberra.

7 The saint was commemorated by mosaics in the beautiful cathedral which William II, King of Sicily (1166–89), began to build at Monreale above Palermo in 1174. He married Joan, Henry II's daughter, in 1177. All the saint's relics in England were destroyed by Henry VIII.

8 More was already a Marxist hero. On Lenin's orders his name was inscribed on an obelisk erected in Moscow.

9 Baltimore was the first Catholic diocese and archdiocese in the United States. In Britain's American colonies Catholics had been most welcome in Maryland, granted by Charles I to Cecilius Calvert, second Baron Baltimore, and named after Charles's Catholic wife, Henrietta Maria. After the War of Independence, the Holy See was free, and impelled, to establish a local hierarchy. In 1789 Pius VI (1775–99) created the diocese of Baltimore. In 1790 the patriot John Carroll (1735–1815) was consecrated in England as the first bishop. In 1808 Pius VII created four additional dioceses and made Baltimore an archdiocese. The British minister to the United States brought the pallium to Carroll in 1811. In 1886 Leo XIII appointed James Gibbons, Archbishop of Baltimore, the second US cardinal.

10 Nine years later, on 5 March 1982, the second Apostolic Pro-Nuncio to Australia, Monsignor Luigi Barbarito, Titular Archbishop of Fiorentino, helped me to meet the Apostolic Pro-Nuncio to Indonesia, Monsignor Pablo Puente, Titular Archbishop of Macri, in Jakarta. Earlier that year the Australian media featured allegations of famine in East Timor emanating from an inaccurate and mischievous letter to Australian Catholic Relief by Monsignor Martinho da Costa Lopez, who had been the apostolic administrator in Dili since 1977. In 1975 I had been closely associated with Leon Stubbings, secretary-general of the Australian Red Cross

Society, and the regional delegate of the International Committee of the Red Cross for South East Asia in providing a RAAF plane, radio equipment and funds for ICRC programs in East Timor and later for 40 000 refugees from Fretilin in West Timor. In February 1982 Stubbings invited me to go to Bali to be briefed by three ICRC officials, who had completed an inspection in Timor, and to accompany the ICRC delegate in Indonesia around East Timor in jeeps and helicopters. In Jakarta Puente gave the ambassador and me a candid and confidential briefing. The following year the apostolic administrator was replaced in Dili by a Salesian, Carlos Filipe Ximenes Belo, Titular Bishop of Lorium and Apostolic Administrator *sede vacante et ad nutum Sanctae Sedis*. Puente is now the Nuncio to Britain. The Nuncio to Australia, Monsignor Francesco Canalini, Titular Archbishop of Valeria, was Pro-Nuncio to Indonesia from 1986 to 1991. Lopez died in 1991.

11 In a review of John Cornwell's biography of Pius XII in *The Times of London* on 4 October 1999, the media celebrity Lord (1988) Rees-Mogg, describing himself as a Vatican II rather than a Vatican I Roman Catholic, wrote:

> Between 1941 and 1945, according to the latest research, 487 000 Orthodox Serbs, 27 000 gypsies and some 30 000 Jews were massacred in the Independent State of Croatia, mainly by the Ustashe. The Croatian leader was Ante Pavelić. Croatia was a Catholic state, and the papacy had access and influence. Cornwell comments, and he documents his comment, that Pius XII was anything but benevolent to the leaders and representatives of the Pavelić regime. He seems to have regarded Pavelić as an anti-Bolshevik crusader.

> It is also claimed that some 70 000 Jews were exterminated between March 1939 and March 1945 while Josef Tiso, a Catholic priest, was president of Hitler's puppet state of Slovakia.

OPERA

1 After Queensland signed the hospital agreement under the Medibank legislation on 1 September 1975, the Golden Casket lottery revenues, which had helped to maintain public hospitals in Queensland, were diverted to the construction of the Cultural Centre on the South Bank of the Brisbane River. The State lotteries in New South Wales and Queensland were the inspiration for the British *National Lotteries Act 1993*, under which the Heritage Lottery Fund has financed the restoration of Covent Garden, the relocation of the National Library and the conversion of the Tate Gallery of Modern Art.

2 Alcorso's first anglophone cultural contacts were not with royalty but with viceroyalty. He would recall that he had travelled to Australia in the same ship as Patrick Hore-Ruthven, the son of Lord Gowrie, the Governor-General of Australia and former Governor of South Australia and New South Wales. He was warned, 'Claudio, my ancestors knifed people like you'.

In March 1566, Patrick Ruthven, the third Lord Ruthven, was one of the conspirators who seized the Piedmontese David Riccio, the adviser and French secretary of Mary, Queen of Scots, from her supper room in Holyroodhouse, Edinburgh, and stabbed him to death. Ruthven died in Newcastle upon Tyne three months later.

Patrick Hore-Ruthven was killed by Italians in Libya in 1942. His son, who succeeded his grandfather as the second Earl of Gowrie, was Minister for the Arts (1983–85) in the Thatcher Government and then Chairman of Sotheby's.

3 George Henry Hubert Lascelles, the seventh Earl of Harewood, is the son of the sixth earl and Princess Mary (1897–1965), the Princess Royal, the only daughter of King George V. He is married to the distinguished Sydney violinist, Patricia Tuckwell, the daughter of an eminent organist, Charles Tuckwell.

4 Vauxhall comes from Falkes' Hall. Falkes de Bréauté was an ungodly Norman adventurer who was able to appeal successfully to Pope Honorius III (1216–27) against his banishment by King Henry III in 1225. He died in France on the way back to England, but he is enshrined in English social history and Russian everyday life. Vauxhall Gardens flourished in London from 1661 to 1859. In emulation, the concert hall for Catherine the Great's palaces south of St Petersburg was named Vauxhall. It was in constant use throughout the 19th century; Johann Strauss II directed summer concerts there between 1855 and 1865. In 1837 Nicholas I built the first railway in Russia to Tsarskoye Selo from St Petersburg, where the departure platform was labelled Vokzal, which became the Russian word for railway station.

5 Lucrezia Borgia (Rome 1480–1519 Ferrara) was the second wife of Alfonso I (Ferrara 1476–1534 Ferrara), the third Duke of Ferrara (1505), to whom she bore seven children. Their floor tombs are in the church of Corpus Domini and hers is especially venerated.

ARTS AND ARCHITECTURE

1 In England four copies were made of the Villa Rotonda constructed in 1550–51 by Andrea Palladio (Padua 1508–1580 Vicenza), the greatest north Italian architect of the 16th century. Mereworth Castle in Kent was designed by Colen Campbell (1676–1729) and built between 1722 and 1725. Chiswick House in Middlesex was designed by Burlington and built between 1723 and 1729. Nuthall Temple in Nottinghamshire was designed by Thomas Wright (1711–86), built between 1754 and 1757 and demolished in 1929. Foots Cray Place in Kent was probably designed by Isaac Ware (c.1717–66) in 1754; it was demolished after a fire in 1949.

2 Dr John Power (1881–1943), a graduate of the University of Sydney, served as an army medical officer in France during World War I and then gave up medicine for art. Terry Smith, who has been the Power Professor of Contemporary Art in the University of Sydney since 1995 and Director of the Power Institute Centre for Art and Visual Culture since 1994, has described Power as the first Australian to take a serious practical interest in cubist painting and a close associate of the Abstraction-Creation group of artists in Paris during the 1930s.

 Sir (1979) Frederick Deer was coopted as a Fellow of the Senate of the University of Sydney at four-yearly intervals from 1959 to 1983 and was Chairman of the Finance Committee from 1960 to 1983. He was the General Manager of the MLC from 1955 to 1974 and a director from 1956 to 1983. The Power Bequest consisted of shares in the MLC, which was falling behind its life assurance competitors. Deer had a duty to look after the interests of the MLC and the University. He preferred the former and delayed selling the Power shares for decades. The bequest lost over half its value.

3 London had no dedicated museum of modern art. We met the director of the Tate Gallery, Nicholas Serota. He has transferred its modern collection to a converted powerhouse designed by Giles Gilbert Scott in the 1940s and built in the 1950s. Tate Modern is the world's largest museum of modern art. It is even bigger than Sydney's Powerhouse Museum.

LITERATURE

1 The title Duke of Clarence was brought to the English royal family by Edward III's wife, Philippa of Hainault, from the port of the Crusader Principality of Morea; the port is named Klarenza in the

seventh story of the Second Day of Boccaccio's *Decameron* (Greek for ten days).

2 In 1686 Nahum Tate, the playwright and third Poet Laureate (1692) remembered for the Christmas hymn 'While shepherds watched their flocks by night' (1700), translated the Latin poem *Syphilis sive Morbus Gallicus* (1530) by Girolamo Fracastoro (Verona 1478–1553 Verona), medical adviser to the Council of Trent (1545–63).

3 The conquest of Chile was the subject of the Spanish imperial epic, *La Araucana*, written by Alonso de Ercilla y Zuñiga (Madrid 1533–94 Madrid) in 37 cantos and published in instalments in 1569, 1578 and 1589. When Philip II of Spain went to England in 1554 to marry Mary I of England, Ercilla accompanied him. From 1555 to 1563 he served in the Spanish forces in the Americas. Only small portions of his poem have been translated into English.

4 Two centuries later the people of Palermo compared the relations between Lady Hamilton and Lord Nelson with the relations between Armida and Rinaldo in Tasso's epic.

5 Algarotti was made a Fellow of the Royal Society, which was given a charter by Charles II in 1662, as were many other Italians: the physiologist Marcello Malpighi (Bologna 1628–94 Rome); the oceanographer Count Luigi Ferdinando Marsigli (Bologna 1658–1730 Bologna); the mathematician Guido Grandi (1671–1742); Abate Antonio Conti (Pavia 1677–1749 Padua), who went to London to observe the total eclipse in 1715; the anatomist Antonio Cocchi (Benevento 1695–1758 Florence); the scholar and dramatist Marchese Scipione Maffei (Verona 1675–1755 Verona); the astronomer and mathematician Father Ruggero Giuseppe Boscovich S.J. (Ragusa 1711–87 Milan); the natural philosopher Tiberio Cavallo (Naples 1749–1809 London); the physicist Count Alessandro Giuseppe Antonio Anastasio Volta (Como 1745–1827 Como); and the mathematician (Antonio) Luigi (Gaudenzio Giuseppe) Cremona (Pavia 1830–1903 Rome). James Cook, who

charted the east coast of Australia, and William Bligh, Governor of NSW, were Fellows of the Royal Society.

6 The Society of Dilettanti was founded in 1733 by men who had visited Italy and delighted in its fine arts. Among its members have been two British Prime Ministers—Sir Robert Peel and Archibald Philip Primrose, the 5th Earl of Rosebery—and the cousin of another. The amateur architect Thomas Pitt was a member; he died in Florence in 1793 and called his home at Twickenham the 'Palazzo Pitti'. Another member was Sir George Macleay (London 1809–91 Menton), a benefactor of the University of Sydney and Australian Museum, NSW MLC (1851–56) and MLA (1856–59) and, from 1865, owner of Elizabeth Bay House in Sydney; he joined the Dilettanti in 1869.

7 A comparison can be made between Sir John Kerr's *Matters for Judgment* (1978) and my response, *The Truth of the Matter* (1979).

8 Dudley features in Scott's *Kenilworth* and Donizetti's *Elisabetta al castello di Kenilworth*. His illegitimate son Robert Dudley (Richmond 1574–1649 Florence) was knighted by Elizabeth I in 1596 for his services in the Carribbean. Denied his ancestral titles by the Star Chamber, he eloped in 1605 with his cousin to France. Becoming Catholics, they were given a papal dispensation to marry in Lyon. In 1606 Ferdinando I (1549–1609), a cardinal from 1563 to 1589 and Grand Duke of Tuscany from 1587, engaged Dudley to build the Tuscan navy and the port of Livorno, which had been commenced by his father Cosimo I (1519–74), the first Grand Duke. Dudley completed the massive breakwater between 1611 and 1621 under Cosimo II (1590–1621), the next Grand Duke. In 1620 Ferdinand II (1578–1637), Holy Roman Emperor from 1619, created Dudley Duke of Northumberland. In 1630 Maffeo Barberini (Florence 1568–1644 Rome), Pope Urban VIII from 1623, made him a patrician of Rome. In 1646 his *Arcano del mare*, an encyclopedia of shipbuilding and navigation, was published in Florence.

MONARCHS

1 In August 1059 at Melfi in Apulia the Pope invested Robert Guiscard (Normandy c.1015–85 Cephalonia), fourth of twelve sons of Tancred d'Hauteville, with the duchies of Apulia and Calabria and the lordship of Sicily. His brother Roger Guiscard (Normandy 1031–1101 Mileto) was made Count Roger I of Sicily in 1072.

2 Philip III (1270–85) was taking home the body of his father, St (1297) Louis IX (1226–70), who had died in Tunis.

3 Henry's heart, enclosed in a golden urn, was deposited in Westminster Abbey. Guy is to be found in Dante's *Inferno*, canto XII, lines 118–20. S. Silvestro in Viterbo was renamed Gesù in the 16th century.

4 The name Viterbo comes from the Latin *vetus urbs*, 'old city', and Orvieto from *urbs vetus*.

5 Prince Henry the Navigator (1394–1460), the first cousin of Henry V (1387–1422), King of England (1413–22), is buried in the Monastery of Batalha, which was inscribed on the World Heritage List in 1983. His tomb bears the insignia of the Garter.

6 In 1994 the Savoy Hotel in London was acquired by Charles Forte, who was born in Frosinone in 1908 and was created a life peer in 1982.

7 I describe her destiny in *Abiding Interests* at pages 132, 140 and 309.

8 The only son of Prince Alfred, Duke of Edinburgh, committed suicide in Merano in 1899.

9 Stanza 70 in Harington's translation.

10 A golden rose was an ornament blessed by the Pope on the Fourth Sunday in Lent (Rose Sunday) and presented to the queens of Catholic countries.

11 Giulio Raimondo Mazzarino (Pescina 1602–61 Vincennes) was naturalised as Jules Mazarin in 1639, created a cardinal in 1641

and succeeded Cardinal de Richelieu as first minister of France in 1642.

12 Constantine I was held responsible for the Greek catastrophe in Asia Minor in 1922. A few of the tens of thousands of Greek refugees settled in a small fishing village which is the port for Mt Athos, 'the Holy Mountain'. They named it Uranopolis, 'the Celestial City'. A Quaker from Melbourne, Joice Mary Loch, established an industry there to make knotted rugs with Byzantine patterns. In Albury on Australia Day 1973 the corrupt Premier of NSW, Bob Askin, the impeccable Premier of Victoria, Dick Hamer, my great Minister for Urban and Regional Development, Tom Uren, and I agreed to create a new regional centre between Canberra and Melbourne at Albury and Wodonga, where Australia's largest highway, railway and river intersect. When the premiers and I modestly declined to name the new centre Askenville, Hamerton or Whitlamabad, I suggested Urenopolis; the others thought it too vulgar.

13 In 1867 a 26-page pamphlet was written by 'A Colonist' and printed in Melbourne and Sydney with the title 'A Proposal for the Confederation of the Australian Colonies with Prince Alfred, Duke of Edinburgh, as King of Australia'.

14 Maria Carandini and her daughters were the most acclaimed singers in the Australian colonies. The daughters made notable marriages. A son, Cristoforo Palmerston Caradini (Melbourne 1859–1897 Malaya), is remembered as the legendary explorer and prospector in northern Queensland, Christie Palmerston.

ITALIAN HERITAGE SITES

1 In 1436 on the walls of the Cathedral, Paolo Uccello painted the equestrian fresco of the English *condottiere*, Sir John Hawkwood,

who, as Giovanni Acuto, was the captain–general (1378–94) of Florence.

2 When Carlo VII became Carlos III of Spain (1759–88), his second son Ferdinando (Naples 1751–1825 Naples) became Ferdinando IV of Naples and III of Sicily. Sir Joseph Banks (1743–1820) sent kangaroos and Australian plants for the gardens at Caserta through Sir (1772) William Hamilton (1730–1803), who was the British envoy to Ferdinando from 1764 to 1800.

3 The Franciscan (1220) Saint (1232) Antony of Padua (Lisbon 1195–1231 Verona), Doctor of the Church (1946), is buried in the basilica known as Il Santo. Millions of pilgrims visit it every year. Edward Courtenay (1526–56), Edward IV's great-grandson whom Mary I created Earl of Devonshire in 1553, is also buried in the basilica. A plaque in a cloister identifies the burial place of the *interiora* of the great art connoisseur and patron Thomas Howard (1586–1646), the second Earl of Surrey and the most significant Howard to join the Church of England; his Arundel Marbles are in the Ashmolean Museum at Oxford. Edward Wortley Montague (1713–76), Fellow of the Royal Society (1751), the talented and erratic son of Lady Mary, was buried in the cloister of the Eremitani, bombed in World War II.

4 The mausoleum of the Emperor Diocletian and Empress Prisca attained its most gorgeous condition as a Catholic cathedral during the turbulent years when Marc'Antonio De Dominis was its archbishop (see Chapter 3). A long Latin inscription records that the lavish Austrian restoration was dedicated by Crown Prince Rudolf (Vienna 1858–89 Mayerling).

5 The town and castle of Este are 27 km south-west of Padua. The House of Este traces its Lombard origin to marchese Alberto Azzo II in the late 11th century. His son Welf IV (Guelfo IV in Italian), Duke of Bavaria, was the ancestor of the dukes of Bavaria, Brunswick and Lüneburg. The Italian and German branches were reunited when Rinaldo I, Duke of Modena and Reggio

(1694–1737), married Charlotte Felicitas of Brunswick-Lüneburg, the cousin of the future George I, Duke of Brunswick-Lüneburg and King of Great Britain, France and Ireland. The English Hanoverians used d'Este as their *incognito*.

6 Giulio Romano was the most important pupil of Raphael (1483–1520) and his heir. In 1524 he made sixteen drawings of various heterosexual couplings to illustrate the *Sonetti lussuriosi* of Pietro Aretino (Arezzo 1492–1556 Venice). He sought employment outside Rome because a pioneer engraver in Rome, Marcantonio Raimondi (Bologna 1480–1534 Bologna), was imprisoned for making engravings of the illustrations. The engravings made Aretino a favourite subject in English poetry after the restoration of Charles II in 1660. Aretine rhymes with intertwine.

7 Felix Arnott, an Englishman, was Warden of St John's College within the University of Queensland from 1939 to 1946, Warden of St Paul's College, Sydney, from 1946 to 1963, founder of the Blake Prize for Religious Art in 1951, Co-adjutor Bishop of Melbourne from 1963 to 1970 and Archbishop of Brisbane from 1970 to 1980. In 1974 my Government appointed him and Anne Deveson to be members of the Royal Commission on Human Relationships chaired by Justice Elizabeth Evatt (see *The Whitlam Government*, pages 518–21). In 1980 the Anglican Bishop of Gibraltar in Europe, John Satterthwaite, appointed him the honorary chaplain in Venice. His church was St George's in the Campo di S. Vio. We all called him the Vicar of Venice. He retired in 1985.

8 Born in Cassano in 1915, Belgiorno-Nettis was educated in Turin at the Royal Military Academy before World War II and at the University after it. He was captured by the British in North Africa and interned in India, where he studied English, engineering and the arts. In 1951 he married and migrated to New South Wales. He pioneered the transmission of electric power

over long distances and built the Sydney Harbour Tunnel. I came to know him as a patron of the arts. He asked me to open the first Biennale of Sydney in 1973. Twenty years later I visited him in Fiesole, where he had acquired and restored Poliziano's house. He has been awarded the Order of Australia and is Grande Ufficiale (1989) nell' Ordine al Merito della Republica Italiana.

9 Britain not only introduced Constitutions for Corsica in 1794 and for the Ionian Islands in 1817 but also for the Kingdom of Sicily in June 1812. The Constitution for Sicily was adopted in Palermo by a British-style parliament consisting of a House of Peers, both Spiritual and Temporal, and a House of Commons. It was inspired by a Whig aristocrat, Lieutenant-General Lord William Cavendish-Bentinck, who had been sent in 1811 as envoy to the Kingdom and commander-in-chief of the British forces in the island. Until 1813 he acted as the virtual governor of the island. King Ferdinando's son Francesco (Naples 1777–1830 Naples) was installed as *vicario* in January 1812 and the hostile Queen Maria Carolina, the grandmother of Marie-Louise, the new Empress of the French, was exiled in 1813. The Constitution was discarded when the British withdrew. Francesco briefly succeeded his father as Francesco I, King of the Two Sicilies (1825–30).

MOROSINI'S LEGACY

1 Ivor Thomas, the successful Labour Candidate at a by-election for the House of Commons, was sworn on 17 February 1942. The Loeb Classical Library published his two-volume translation of *Greek Mathematical Works from Thales to Euclid* in 1939 and 1941.

ITALIAN NAMES OF FOREIGN OR
HISTORIC PLACES

1 In the battle of Lepanto (7 October 1571) Thomas Stukeley, thought to be a son of Henry VIII, commanded three galleys in the victorious fleets of Venice, Spain and the Holy See commanded by Don John of Austria, the illegitimate son of the Emperor Charles V.

CORRIGENDA

In *The Whitlam Government 1972–1975* at page 510 I stated that Prime Minister Lyons and his widow were elected for the division of Darwin. I should have stated that he was the member for Wilmot and she was the member for Darwin. Darwin was renamed Braddon in 1955. In 1984 Wilmot was abolished and a new division of Lyons was created.

In the same book at page 706 I stated that Sir Tasman Heyes, on retiring as Secretary of the Department of Immigration under the seventh Menzies Government, became a director of a shipping company tendering for the carriage of migrants. I should have cited Sir William Dunk who, on retiring as Chairman of the Public Service Board in 1960, spent two decades as chairman of Navcot Australia Pty Ltd and its successor, Sitmar Line Pty Ltd.

In *Abiding Interests* at page 220 I stated that in April 1939 Prime Minister Menzies refused to appoint ministers from the Country Party until it elected another leader. I should have stated that Page, who had been appointed Prime Minister on the death of Lyons, announced that no Country Party men could accept appointment as ministers if the UAP elected Menzies as its leader.

In the same book at page 58 I stated that Governor William Scranton destroyed whatever chance he may have had of winning the Republican nomination for the Presidency by his indiscretion that he

had been 'brainwashed in Viet Nam'. I should have cited Governor George Romney. On page 269 I should have stated that Michael Duffy introduced the enactment clause 'The Parliament of Australia enacts'.

ADDENDUM

On 6 February 2002, as this book went to press, the London *Daily Telegraph* published the first of three articles commemorating the 50th anniversary of Queen Elizabeth II's accession to the Throne.

The Australian media were especially entranced by the paper's 'astonishing story' about the dinner to which my wife and I were invited at Windsor Castle on Good Friday 20 April 1973. I mentioned the visit on page 79 of this book.

As the dinner was being held on the eve of the Queen's birthday, the Australian Wool Board suggested that an Australian sheepskin rug would be a suitable present. The *Telegraph* reported:

When the sheepskin rug had been spread on the floor of the Great Drawing Room, the Queen said, 'It's so big, I could get into it'; and proceeded to do so. She was in a very playful, teasing mood and Gough made an effort to wrap it around her.

The story was hilariously embellished by the Queen's secretary, Sir Martin Charteris, the prince of courtiers. It was too good a story to check with contemporary accounts. On May Day 1973 I reported to the House of Representatives on my official discussions with the Queen and her British ministers on many matters, including the Royal Style and Titles.

Margaret's weekly columns for *Woman's Day* were published in a small volume called *My Day*. She reported the Queen's and Princess Margaret's enjoyment of the rug:

You would have loved the sight of the sisters sitting side by side on the deep-piled cream sheepskin we gave Her Majesty for her birthday. They looked like 'The Little Princesses' on either one's teenage birthday.

It was Lord Snowdon who was wrapped in the rug. He was wrapped by his wife's relatives. I observed to Sir Martin Charteris, 'Lord Snowdon is probably the first royal to be rolled in a rug since Cleopatra presented herself to Julius Caesar'. The merry wives performed well at Windsor.

In *The Truth of the Matter* I reported a less joyous conversation I had with Sir Martin Charteris on 11 November 1975:

After the drama of the day I telephoned a good friend in London, Sir Martin Charteris, soldier, diplomat, sculptor and private secretary to the Queen. It is a fact that the Queen's representative in Australia had kept the Queen in the same total ignorance of his actions as he had the Prime Minister of Australia.

BOOKS QUOTED

Claudio Alcorso (1993) *The Wind You Say*, Angus & Robertson, Sydney

Gillian Appleton (2000) *Diamond Cuts*, Macmillan, Sydney

William Bundy (1998) *A Tangled Web: The Making of Foreign Policy in the Nixon Presidency*, Hill & Wang, New York

Barry Cohen (1996) *Life with Gough*, Allen & Unwin, Sydney

H.C. Coombs (1981) *Trial Balance*, Macmillan, Melbourne

Alexander Downer (1982) *Six Prime Ministers*, Hill of Content, Melbourne

Rupert Godfrey (1998) (ed.) *Letters from a Prince: Edward Prince of Wales to Mrs Freda Dudley Ward*, Warner Book, New York

Robert Kennedy (1962) *Just Friends and Brave Enemies*, Harper & Row, New York

William Stewart Logan (2000) *Hanoi: Biography of a City*, University of New South Wales Press, Sydney

Robert McNamara (1995) *In Retrospect: The Tragedy and Lessons of Vietnam*, Random House, New York

Paul Ormonde (2000) (ed.) *Santamaria: The Politics of Fear*, Spectrum Publications

Cassandra Pybus (1999) *The Devil and James McAuley*, University of Queensland Press, St Lucia

William St Clair (1998) *Lord Elgin and the Marbles*, Oxford University Press, Oxford

B.A. Santamaria (1981) *Against the Tide*, Oxford University Press, Melbourne

Bernard Smith (1976) *The Antipodean Manifesto: Essays in Art and History*, Oxford University Press, Melbourne

Leon Stubbings (1992) *Look What You Started Henry! A History of the Australian Red Cross 1914–1991*, Australian Red Cross Society, East Melbourne

Joan Sutherland (1997) *A Prima Donna's Progress*, Random House, Sydney

Gough Whitlam (1979) *The Truth of the Matter*, Penguin, Ringwood, 2nd edition 1983

——(1985) *The Whitlam Government*, Penguin, Ringwood

——(1997) *Abiding Interests*, University of Queensland Press, St Lucia, three reprints

Margaret Whitlam (2001) *My Other World*, Allen & Unwin, Sydney

INDEX

An * indicates that the subject appears in the photo section.

This book could not have been written without the technical and archival skills of Elaine Haigh PSM (2000), who was my secretary from 1984 in Paris until 2000 in Sydney, and the New South Wales Parliamentary Library.